Described variously as a 'gr
inferiority complex', **Jessica** .
Writing for national newspapers and magazines, s..... n
New York and Los Angeles, but is now based in England where
she is happily married to a Ford Capri.

Accused by the *Daily Mail* of 'corrupting the morals of the
nation's women and betraying civilised values', London-born
Kerri Sharp has been the editor of Black Lace women's erotica
at Virgin Books since the series was launched in 1993. A film
school graduate, her chequered career includes stints as a shep-
herdess, topless ice-cream seller, cricket coach, ambulance driver
and pornographer. Her love of English surrealism, medieval folk-
lore and Japanese horror movies makes the inside of her head a
'collision of fruity enchantments'.

Inappropriate behaviour

Prada sucks! and
other demented descants

Edited by
Jessica Berens & Kerri Sharp

Library of Congress Catalog Card Number: 2001092087

A complete catalogue record for this book can be
obtained from the British Library on request

The right of the individual contributors to be
acknowledged as authors of their work has been
asserted by them in accordance with the
Copyright, Patents and Designs Act 1988

Copyright © 2002 of the individual contributions remains with the authors
Compilation copyright © 2002 Jessica Berens and Kerri Sharp

First published in 2002 by Serpent's Tail,
4 Blackstock Mews, London N4 2BT
website: www.serpentstail.com

Set in 10½/13 pt Platin by Intype London Ltd.
Printed by Mackays of Chatham plc

10 9 8 7 6 5 4 3 2 1

Contents

Prada sucks!

Jessica Berens and Kerri Sharp

Super-successful businesswomen flick their Pantene-glossy hair about and move with the times in dust-free corporate environments; petulant über-bitches dash champagne glasses on the mirror-polished floors of their super-lux apartments then drive off in top of the range coupés; self-satisfied broadsheet readers witter *schadenfreude* at dinner parties. He, sexless, reads *Men's Health* and walks the gormless labrador. She tosses desperate little salads. These are the idiotic icons from which no one can escape; absurd entities invented by ad-people labouring to deliver narratives about oneupmanship.

A new collection of archetypes has emerged: the successful female neurotic; the lantern-jawed sensitive winner; the smug New Labour dinner-party animal; and the young wacky dressed-down designer. They are archetypes rather than stereotypes because they come with fully-fleshed behavioural traits and ambitions. The ad industry – ever aware that we can spot two-dimensions a mile off – has done its homework. In these post-ironic times, they've gone back to the primary condition: conservatism.

The successful female neurotic will be looking for love/husband/baby; the lantern-jawed winner will have previously shirked his responsibilities but is now facing up to fatherhood; the wacky young designer will be heading up her own media company by the age of thirty, and let's not forget the hardy perennial – the domesticated woman. She's still there, making the stains vanish.

The fact is, some of us have disappeared from the story – only the perfect, the well-behaved, the thin and the smug remain. We have looked long and hard at these narratives and we can't spot ourselves in there. We are not all svelte or coiffed or dull. We do not want the Fiat Punto, or the Estée Lauder, or the Prada because we are inured by the knowledge that these things will make us neither happy or wise.

But the collective Western sub-conscious is busy running a checklist on stuff it has not acquired yet. It is incarcerated in a constant state of wanting while conversely being told to live for the moment to gain spiritual reward.

The result of this paradox is that everyone is trapped in a vacuum that says everything will be alright when they have bought the goods . . . but, of course, it never is. As soon we have acquired one item another will take its place. We just keep wanting more and more stuff.

This perpetuated unfulfilment is having its golden jubilee. The narcosis of high-level acquisitiveness has been mainlined into our psyches. Imprisoning consumers in the twin emotional states of depression and neediness is an effective way to castrate individualism and net vast fortunes through our complicity in the process. The worldwide cost of advertising is currently estimated at 435 billion dollars, with the USA accounting for almost 200 billion dollars. That's a lot of billboards.

Our imaginations, the best thing about being human, are becoming atrophied. We are getting to a state where we can define ourselves only through what we own and whether we are communing with the latest 'viral-marketing' catchphrase of branded goods, from beer to cars and back again. Now there are three movies, two chords and no choice. We all look alike, eat alike and watch the same shows as everybody else – and their kids. Burgers, baggy clothes and PlayStations for all.

Statistics and the rise of direct action politics are revealing that something is very rotten in the state of WorldWide International Inc. There is a growing underclass whose

fabricated desires are not being satisfied, and these people are feeling mighty pissed off. When winning the National Lottery is seen as being the only way out of your severely reduced circumstances, we've reached a desperate situation: the eradication of fun without money.

As we are expected to aspire to be well-behaved consumers so we also have celebrity mania to combat. That moronic culture of macho lunkheads and pap music fem-bots has produced a conveyer belt of icons that are far, far more sinister than anything the Catholic church has managed to manufacture. And that is saying a lot.

It is taken for granted that we are in awe of celebrity. We want to look like them, spend like them and fuck like them. 'Twas ever thus, you could say: what about Beatlemania, Rudolf Valentino and Marilyn? Sure, successive generations have lost their souls to images of erotic beauty. Millions bought records, saw movies, put posters up. But nowadays this isn't enough; today we are all expected to ooze the same stuff, regardless of income or circumstance.

In the past beauty was a thing to be admired with the detachment of aesthetic perception; now it is not enough to appreciate the Venus de Milo: you have to cut your own arm off as well. We are desperate to experience ourselves being regarded as perfect, as having achieved the state of sanitised flawlessness prescribed by a visual culture dominated by implausible fiction. The result? Women have allowed their thinking to be perverted by thin, white Unawoman, an unthreatening construct who has done much to encourage the buying of handbags and very little to encourage independent thought. Look at the books that sell and the films that make money. What do they say? They say that the majority of women care about what their bottoms, tapenades and husbands look like. They say that the majority of women do not care that they have very little representation in the realm of world politics. Check G8. Not a skirt in sight.

So. Here we are in a world where self knowledge is a

dangerous thing, where individualism incurs isolation, and where Unawoman's taunting presence has hauled femininity into an apolitical climate of regenerative neuroses. The unique, the odd, the witchy, the talented – the people who argue and opine and who do not believe – they have all but disappeared from the currency of ideas when history relates that they are the very ones who have contributed so much to it. Originality of perspective, lest we forget, is the foundation of creative growth and the harbinger of change. The brave shout has long hailed everything from scientific invention to spiritual replenishment.

Resistance to the moribund mainstream is there, however – and it is growing, among the kind of people who have had just about all they can take of po-faced poltroons; those who would rather provoke anarchic carnival than suffer more bland hegemony. We are revisiting duality, reaction, opposition, resistance. Our imaginations seek to disrupt the rigid order of social conditioning that is still being imposed. Throughout history, and across cultural boundaries, carnival has been a place of subversion, realised through humour and ridicule. Where something is held as sacred there will always be blasphemy. Where there is smug complacency, there will be disruption. Bring on the masked pranksters who laugh in your face. We invoke the spirit of the world turned upside down, the orgy-cum-uprising, the Lords of Misrule and the dancing dead.

The malevolent mavericks have not died out. They lurk about, waiting for the chance to subvert. We have found some of them, leering and laughing and hoity-toity. We bring them to you here in all their weird uncommercial pride – a collection of writers with deviant perspectives and adverse ideas. They are not a target group and nor do they wish to be. They are real people.

Some mothers do 'ave 'em

Matricidal mayhem

Are Friends Electra?
Helen Hastings

Just what is my problem?

'Look at you. You're continually wracked with guilt and inadequacy. You're an emotional cripple who's mentally incapable of forming normal healthy relationships with either men or other women. You're hopelessly obsessed with your own failure, verging on obsessive-compulsive and you have the most severe self-destructive streak I've seen outside the Japanese Kamikaze pilots' training campus. In many respects, Helen, you have the psychological maturity of an eleven-year-old.'

Thank you. That's the sort of personal critique only a trusted friend and confidante can really deliver. Unfortunately it's not being delivered by a trusted friend and confidante, but by a poker-faced individual with a Hitler moustache who sits bolt upright beside the couch in a large, uncomfortable-looking leather chair. Her name is Doctor Goldmann, and she is currently charging me a hundred and fifty quid for the privilege of being deeply insulted in a slightly foreign accent. No wonder it didn't take her more than three minutes to spot my talent for self-sabotage.

'So . . .'

For that price, she'd better give me someone to blame for my fucked-up life – other than myself. What I get is a classic straight out of '101 Chat Up Lines For Psychoanalysts'.

'. . . Let's go back to your childhood.'

I was eight. Old enough to be intrigued when I found a vibrator in my mother's bedside cabinet; young enough to wonder why she needed to whisk eggs in the middle of the night (illicit midnight feasts, presumably: when you're eight, that's

the kind of perk which makes adulthood seem so enviable). The house was empty but I, being an eight-year-old dragged reluctantly through Montessori school, force-fed Usborne Junior Encyclopaedias and given a Speak'N'Spell when what I really wanted was a Sindy pony, was not up to no good. I wasn't raiding the fridge or my mother's make-up drawer. I was attempting to expand my Inquiring Young Mind by raiding the bookcase. I'd often raided the bookcase before, but tonight I was really going for it – above the Conan Doyle, above the Agatha Christie and the Edgar Allan Poe, loftier even than the Jerome K. Jerome and the P.G. Wodehouse. I found myself mountaineering up the shelves to the very top, to the highest literary pinnacle where, I was sure, some forbidden delight lay. And that was where I had my innocence cruelly shattered.

The shelf was full of soft porn. High quality soft porn, to be fair – not your typical thirty-something Single Mother fare of Jilly Cooper and Black Swan. This little library included *Lady Chatterley's Lover*, *Fanny Hill* and *Tropic of Cancer* by Henry Miller, along with a smattering of sex manuals in the 'Joy of . . .' mould. But those didn't interest me. I was far too horrified by their sordid tales of throbbing love muscles and red-hot nubs of womanly passion. The cover of this book bore a picture not of some dashing rogue in riding breeches ripping the bodice from his swooning Mistress, but of a small boy and a large, well-developed organ.

It was a human brain – and above it, the title: *Give Your Child A Superior Mind*.

That's when I knew I was going to have a lousy childhood. I wasn't my mother's beloved daughter at all. I was just a chance for her to redeem all the academic failure that had landed her – once a promising student – on the single parent scrapheap at the age of thirty. Now it all made sense: why the reports I trotted back from school with concerned her so much more than the grazed knees I hobbled home tearfully nursing. Now I understood: why it was so imperative that, every Christmas, shitting myself even more than the average infant, I stood up and recited stumbling tracts of pre-rehearsed Kipling to paralytic pervy uncles.

Now I knew why she never let me go to tea with children who lived off trashy cartoons and Alphabetti Spaghetti. It wasn't bad for my health, it was bad for my BRAIN. Goodness knows how many spelling mistakes I might be exposed to in a single forkful of such a pestilential pasta product.

Some women have dogs as a baby substitute. This bitch had to be different: she had a baby as a degree substitute. I just wish she could have left ME out of her evil masterplan to mould every part of a child, like some kind of low-budget genetic engineering experiment. She groomed me to be the BSc she never was; sadly for her, my own qualifications are now best summed up as 'sweet FA'.

> Lizzie Borden took an axe
> And gave her Mother forty whacks
> And when she saw what she had done
> She gave her Father forty one.

Oddly, that was one nursery rhyme I never remember my Mother using to lull me to sleep. Which isn't that odd, actually. I never remember her using ANY nursery rhymes to lull me to sleep. I never remember her kissing me, cuddling me, reading me a bedtime story or, indeed, showing any outward sign of affection towards me. And I never once called her 'Mum'. Nor 'Mummy', 'Mam', 'Ma', 'Mama', 'Momma', 'Mother' or even the princessly 'Mater'. No, it was always 'Janet'.

If life's eternal Karmic wheel ever spins me back onto this nasty little planet as something other than human (like a rat, or a pig, or a Belgian) I pray to Buddha that it's one of those spiders I read about in my Interesting and Informative *Junior Animal Encyclopaedia* which once sat under the Christmas tree for three weeks of December 1982, silently convincing me it was a much-coveted *Beano* annual or *3001 Jokes For Kidz*.

Some arachnids repay their female parent for painstakingly bringing them into the world by eating her. Claws buried in her back, mandibles munching away, they gorge themselves silly on her juicy innards until she's nothing but a dead, drained greeny-brownish husk. But Little Miss Spider doubtless recalls her

Spidermum with nothing but fond memories – a selfless provider of food and transport. More to the point, the murdered and mutilated mother spider then STAYED THE FUCK OUT OF HER KIDS' LIVES and let them grow up the way they wanted to.

My therapist told me I'm probably in denial. From, she said, a repressed urge to return to the womb. And she could well be right: I'd love to return to the womb. Not because this might encourage the rekindling of emotional bonds, but because I'm now three inches taller than my mother and BOY would it hurt her when I forced entry.

I can only assume I must have hurt her like hell on the way out; that would presumably explain her desire to get revenge by fucking up my life for the subsequent two decades. Or maybe she doesn't need a reason. Maybe she IS just a bitch.

I wish I'd been a stillbirth. Nine months of misery, all the pain of labour and all she'd get out of it would be an extra-large helping of placenta pâté. The Ancient Egyptians had the right idea: they dumped their Mummies in formaldehyde, bound them head-to-toe in those Tennis Elbow bandages and locked them in a tomb for a few thousand years. I wish I'd thought of that when I was twelve: it might almost have muffled the sound of her carping and castigating. Almost.

Possibly the only mother I can think of who would have been worse than my own is the Queen Mother. Discounting for the moment the minor fact that I'd have to be the Queen (bit of a bum job, all things considered), having Ma'am as a mum would mean that she'd continually upstage me by the simple fact of possessing teeth in the colours of the Celtic FC home strip (yellow and green, for those who follow neither Scottish football nor the even more tedious activities of the British Monarchy).

Further similarities with monarchical hierarchy are reflected in my own mater's behaviour. She, too, glories in the success of her female offspring whilst displaying no discernible talent of her own. She also drinks too much and is too lazy to walk anywhere, though unlike my mother she can't get away with lying about her age: it must be a real bitch having every-

one point out that you're 'Oh, a hundred, you know – Gawd bless 'er!'. Mine's about to hit the big five-oh . . . should I inadvertently fail to avoid the wretched woman during the next twelve months, I'll make a point of proclaiming 'Oh look, she's FIFTY, you know – Gawd 'elp 'er!' as often as possible just to piss her off.

When MY mother becomes too infirm to look after herself (and trust me, I'm working on it) you can bet your bottom dollar I won't be having a hideous granny-flat tacked onto the side of my bijou London pad and wheeling her down to the Co-op and the Bingo on a daily basis. I might, I suppose, lock her up in the attic like one of those mad old spinsters in Brontë novels – but not necessarily MY attic. The idea of inflicting her on a hated ex-boyfriend rather appeals, like leaving prawns in the curtain rods and forcing him to puzzle for months about the source of the horrible stench.

Why couldn't she have been one of those ghastly, gormless Sloaney types who lose all interest in their offspring after it ceases to be a mewling fashion accessory small enough to secrete in a Louis Vuitton? The type who call their kids 'something Italian' like Ciabbatta and Foccaccia (Chubby and Fucky for short), drop them off at the school gate on the first day of term, return six weeks later to pick them up in the customised People Carrier and only then realise that it wasn't a boarding school after all. But, thank God, the little poppets have subsequently been taken into Council care ('We did TRY to call, Mrs Ffarquar-Mall, but your mobile always seemed to be engaged . . .'). Parents who, once reunited with Mummy's Darling Girlies, spend the summer holiday sewing name tags onto all their school uniform so they can (a) remember the little brats' names and (b) distinguish them from everyone else's children. That's the kind of idyllic upbringing I'd really have appreciated . . .

Oh, how eagerly I anticipated my eighteenth birthday when – (in my pitiful young fantasy) she would finally take me aside and break the news to me that I was adopted and she WASN'T my real mother. Tell me I had been found in a wheelie-bin on some piss-soaked council estate, callously dumped by my

teenage smack-fiend prozzie parent after accidental impregna-
tion by the maths master. Of course, she didn't. Though since
I'd left home three years before my eighteenth birthday, she
might have had a job tracking me down to pass on the glad tid-
ings.

Nowadays she has another source of disappointment: my
persistent refusal to produce any visible grandchildren. The
fact that she disapproves of every boyfriend I ever had (too old,
too young, too fat, too unemployed, too mad, too married . . .)
doesn't come into it. I swear she wouldn't mind if I hung
around in a Budgens carpark and swiped the first unattended
pram that came along, if it meant she could call herself
'Granny' and inflict unwearable hand-knitted garments on
some wretched infant. I suspect, having abandoned all hopes
of seeing ME achieve anything worthwhile, she's hoping to
transfer the burden of her unfulfilled ambition onto a second
generation of innocents.

No wonder Quentin Tarantino, searching for suitable
obscenities to rival the likes of 'cocksucker' and 'fucking prick'
came up with 'You . . . Mother!'. Comparing me to my mother
is one of the most hurtful insults anyone could hurl at me. I've
spent my whole life trying NOT to be like my mother. I used
to consciously avoid using motherly phrases, like 'I suppose
you think you know what's best for you?', 'you and your
grumpy face are ruining this holiday, you selfish little madam'
and 'Of course people will make fun of your hairstyle if you
don't keep your head still when I cut it'.

I've only seen her a few times since I left the family home.
Most memorably at a funeral: she, in mourning dress, was
looking even more witch-like than usual; I was the one desper-
ately resisting the urge to throw her the wreath and beam 'Ooh,
you'll be next!'

'You don't LIKE your mother??!' colleagues boggle, seem-
ingly unable to grasp the concept that someone with whom I
never chose to associate, have nothing in common, am over
two decades younger than and who has been single-handedly
responsible for my life being a bed of neuroses – is NOT top
of my Friends And Family list.

I have barely seen the evil woman since I left home. Now our sole communication is a one-way process: the annual arrival of the Family Christmas Newsletter, diligently word-processed and touchingly personalised with the help of Microsoft Word's mail-merge feature which she clearly hasn't quite mastered.

> Dear [HELEN]. Phew! Another eventful year for the Hastings family draws to an exhausting close. It has certainly been an Annus Nonstoppus(!!!!) As you probably remember from last year's Newsletter, Helen is still off in the 'Big Smoke' doing her own thing – but the others are still regularly popping back to check upon us oldies and make sure we're not overdoing it!! Rebecca got the promotion as expected, and . . .

I sometimes expect her to lapse into Reader's Digest mode:

> You will be delighted to hear that you, yes YOU, Ms [HASTINGS, HELEN] have been selected from more than ONE [1] daughter in the [LONDON E 14] area to receive [A GUILT AND INADEQUACY COMPLEX] from your mother . . .

But, you're saying, she doesn't sound any different from any other mother. They all carp. It's a survival mechanism for carrying on the family line: antagonise any female offspring so that they hitch their wagon to the first bloke. It's just another of Mother Nature's devious little devices – she can be a real Mother sometimes, can Mother Nature. But if all mothers do this, why am I the only one who wants revenge? Well, as she would put it, possibly because I'm a self-centred little Missy who thinks the whole bloody world revolves around her.

I don't personally think I have a problem. I don't remember at exactly what point I became a matricidal maniac. I suspect it was some time between that unhappy convergence beneath the maternal duvet of Mr Testicle-Tadpole and Ms Soft-Boiled

Ovum and the point at which I emerged bawling into the NHS ward having spent the most satisfying nine months of my existence doing nothing but kicking my mum and ruining her figure.

Perhaps someone should set up a Support Group for it by now. Matricidals Anonymous, or 'Ma' for short. It would be like Alkies Anon, I guess, but they wouldn't make such a point of getting your relatives 'involved'.

I would not want people to think my mother's murder was an impulsive act of madness. I may be a dangerous psychopath, but I can bide my time. As the years go by I will gradually start to mimic that same, patronisingly chivvying tone she so kindly acquainted me with during my tortured teens. 'Come on, mum. Are you just going to mope round the house all day doing nothing? Haven't you got FRIENDS you can call? What do you mean they all say you SMELL and wear funny clothes? You're ninety-three, you know! And I suppose you failed your kidney-function test JUST TO SHOW ME UP, didn't you? Hmmmmmm? Yes. Charlotte's mother didn't fail HERS, did she? If you don't pull your bloody socks up – I mean, your surgical socks up, old lady, it'll be straight up to your room in the Twilight Towers Nursing Home with NO supper for you.'

Having never murdered anyone before (despite the temptation presented by several ex-bosses, ex-boyfriends and ex-Tory Ministers) I haven't decided yet on my actual weapon of choice. Poison? Cyanide pills could easily replace her Mothers' Little Helpers in that old brown glass jar, and it would be great payback for the years of clammy Tesco Economy Chicken-Roll baps I was forced to take for school lunch – despite every other kid within our Local Education Authority's jurisdiction being permitted pizza from the tuck shop. I could beat her to death with a rolled-up copy of *Give Your Child A Superior Mind*: 'Thwack! Take THAT! That's for the haircut and the second-hand school uniform.' 'THWACK! That's for making me watch Interesting Documentaries About Indonesia instead of *EastEnders* and *Grange Hill*, thereby denying me my rightful education in early eighties pop culture.' 'BASH! BASH! BASH! And THAT'S for the string of

revolting men you dated once you'd packed me off to some hard-faced childminder for the evening, despite my being unable to sleep properly anywhere except my own bed and thus developing a prolonged bed-wetting dysfunction.'

Hanging's too good for her. A hitman could probably be arranged (but I wouldn't waste my money on one). A traffic accident, maybe. It's so easy for old ladies to get disorientated in the middle of the road and mown down by a passing Juggernaut: the only trouble is, I don't have an HGV driver's licence.

I think I'll plump for starvation. It's a satisfyingly long drawn-out process: cheap, too, and everyone knows how careless those disorientated Old Folk are about eating properly. More to the point, it'll be deliciously ironic: revenge for the continual, heavy-handed hints she dropped about my weight which subsequently drove me into a four-year battle with anorexia, threatened sectionalisation under the Mental Health Act and eventual hospitalisation when I tipped the scales at four stone. I suppose she was just disappointed that I never managed to shake off that final puppy-fat and return to the weight I was when she first 'met' me: a svelte 7 lb 8 oz, according to my birth certificate.

If I really couldn't wait for the starvation to run its course, I could always finish the slag off with a sawn-off. Would I miss her? Not a chance. But just in case I did, I'd keep another bullet in the chamber for a second shot. Then, the dread deed done, I'd hack her lifeless bony corpse limb from limb – not methodically, not carving the joints in a careful 'Shall I Be Mother?' family-round-the-table-for-a-Sunday-roast sort of way – but stabbing and swiping at random, amply demonstrating the clumsy, haphazard way of doing things which she's never missed an opportunity to castigate me for. Then I'd feed her to the cat. She never liked the cat. I think she was jealous of it because I used to prefer its company to hers, even when it vomited in the bed. I could grind her bones up – 'Fee, fi, Fo . . . fuck you, you poisonous old hag' – to make some glue. Then distil it into an aerosol can, sniff her, and get high as a kite on my own matricidal bliss.

It will be the perfect crime. No evidence (unless that cat vomits her up in the bed). No witnesses, no concerned colleagues reporting her sudden disappearance to the police. But if it did come to a trial, I'd just plead guilty, as I have spent twenty-four years feeling guilty, thanks to her.

I reckon I would get off. It's not as though I have any OBVIOUS motive for bumping off the old bitch. The last thing I want is to inherit any of her revolting accoutrements. I suppose I could burn them as a cathartic funeral pyre, but I could happily do that when she was still alive.

To give the shrew her due, she was never negligent. Far from it. Ignorance is bliss, and being left alone would have suited the teenage me to a T. What I resented were her attempts to turn me into a Mini-Mum – a smaller, uglier (yes mother, you really buggered my self-esteem too) and yet infinitely more academically successful version of herself. I would become 'the Cambridge graduate that she had – narrowly – never been'. This had been clear to her ever since I reached the age of four and was producing some particularly articulate work with fridge magnets.

I don't think I'm being particularly greedy. All I want is to massacre my mother. My father, I can take him or leave him. In the end he just left ME, which shows that for all our differences we do have something in common: a mutual dislike of my mother. I'm not saying I wanted to be an orphan, despite the obvious advantages (sympathy vote, enigmatic Period Drama-heroine status, getting off really easily at Parents' Evening) this entails. My father, with his ongoing bankruptcy proceedings, string of failed post-mother relationships and irritable bowel, is quite clearly capable of fucking up his own life with no intervention from me.

I do hope my dear mama doesn't take this the wrong way when she reads it. It would be very easy to confuse a serious statement of matricidal intent with a light-hearted, flippant essay – nothing more than a gentle bit of fun-poking. But this ISN'T 'just a bit of fun'. This is deadly serious – and I just hope she realises so she can make the most of her remaining time in the land of the living. Enjoy herself: dig out those old

family photos and remember how I wasn't in any of them because I resolutely refused not to wear 'a face like an inside-out laundry bag'.

Maybe what I'm suffering is the female equivalent of the Oedipus Complex. A similarly frustrated desire to perpetrate that most basic of primal urges upon one's begetter? Not sex, but death. And OK, maybe I DO come across as some sort of soulless, psychopathic bitch from hell. What can I say? I blame the parent.

Helen Hastings is an outpatient.

It's not compulsory

Breedin' 'ell
Lydia Lunch

He is nineteen months old, pushing a fire-engine-red go-cart across the driveway. Perfectly formed almond eyes bespeak the mystery and intrigue his limited vocabulary will never mouth. Our eyes lock upon each other. Instant hypnosis. His motor functions freeze. He drops his toy and barrels at me as fast as his little feet will fly. Grips my thighs. Attempts to crawl up my body and with a little boost, my two hands cradle him under his arms, raise him to my face, and kiss his nose. He wraps his pudgy baby legs around my hips, pets my hair, burrows his head in my neck and coos. All is motherly bliss, until he shits his diaper. The smell rises. My clothes reek. His real mommie is headed our way. She wants him back. Thank God. She can have him. At least until he is twelve.

I love children and they love me. Years of plane, train, and bus travel have helped me to master the secret of forging an unspoken allegiance with babies of all ages. On interminable ten-hour Trans-Atlantic journeys, for the sake of not only myself, but the rest of my fellow travellers, if I hear a child crying, I will immediately seek out the source of the yowling little nipper, and take matters into my own hands. I can assure you peace will quickly be restored. The once ferocious battle cry, whose very resonance threatened to break the sound barrier, is instantaneously replaced with a soft chuckling, a tender purr, a benign smile. Baby Love.

It could be the colour of my circus-red hair, the pheromones I excrete, or the look of pity, empathy and total understanding that emanates from my very own baby blues, but infants (not to mention dogs and men alike) have an

uncanny urge to please Big Momma and usually do so by drooping down to all fours, crawling around at my feet, quickly quieting down and burying their runny little snouts under my armpits, between my legs or at my breast. Then comes a soul-shuddering sigh so completely neutralizing it borders on a mild neurological orgasm. I need a Lithium douche to feel half human again after my own chemical make-up has been momentarily skewered by the lingering afterglow of baby drool sponged up and onto my shirt collar. Now, isn't that cute?

My maternal instincts kick in to spite me. I hate to hear babies cry. Hell, I hate to hear anyone cry. It's the most obnoxious form of noise pollution. And if all it takes to temporarily abate this skin-crawling caterwaul is a quick tight squeeze, and a peck on the cheek, who am I to argue? After all 'Mother' knows best. This both amazes and horrifies the real birth mother, who simultaneously enjoys the respite, yet whose first instinct is to grab the little critter and flee as far away as humanly possible from this obviously over-sexualized babyfreak, but, fearing an even louder rendition of The Terror of Tiny Town's latest lung-busting operetta, mommie usually gives in, baby wins out and I'm stuck playing bouncey wouncey with the twenty pound flesh ball for the next eight hours. Not a problem. I understand children. It's their mothers I can't fucking stand . . .

Every new mother believes her little cherub is the most awe-inspiring angel to ever be shat forth upon this ungodly planet. The endlessly exaggerated delight over the little darling's first coo, goo, drool, burp, barf and poop becomes a tireless tirade whose glorification of the most foul bodily functions insults not only the intelligence, but the patience of every ear within a ten mile TOYS R US radius. A non-stop daily update tumbles forth in fits and starts from the lips of the first-time mother's mundanity-strewn mouth, as if the size, smell and consistency of the little shitter's latest bowel movements is in itself news, and not merely the sandwich meat of seagull roughage down at your local landfill, where disposable diapers by the tens of millions (which have a half-life of about ten thousand years, in a flagrant disregard to future generations) will forever swelter

and billow in noxious sky-blue-pink clouds, further contaminating an already toxic landscape whose single most environmentally hazardous threat to the planet is the NINE BILLION other greedy babies – who live to eat, shit, piss, consume and make waste enough to result in a non-biodegradable garbage barge piled sky high from here to the moon and back again.

And I thought the smell of one of the little poopy troopers was befouling enough to behold. Hold your breath and smile. The average four-year-old has already soiled more than 2,595 Pampers before they hit kindergarten. And then the real fun: bed-wetting kicks in. At least bed sheets are recyclable.

I shot out my biological timeclock before it even punched itself in. The mortifying thought of actually having an alien life form develop inside my body terrifies me. I can barely stand to live inside my own flesh myself. Call me inhuman, but childbirth gives me the creeps. It seems the single most unnatural act that a woman would ever consciously perpetrate against herself.

As if the ritual abuse of sex itself isn't grotesque enough, a nine-month long gestation period follows, which begins after a single sperm cell worms its slimy way in and infects a fertile egg, resulting in the glorious wonder that is morning sickness, vomiting, insatiable craving for junk food, a sore back, ballooning breasts, weight gain and funny-looking clothes that don't fit. This honeymoon from hell is capped off with the eventual expulsion of a nine-pound sack of blood and mucus with the vocal range of a shrieking demon, who will, for the next three years, be forever demanding tit, diaper changing and constant affection. I can't even afford to pay that much non-stop attention to myself. It would make me sick. I'd turn homicidal and go fucking postal in about three days.

Let's not even begin to discuss the horror of the possibility of an eighteen-hour long delivery, where shitting out a watermelon would, by comparison, be a cakewalk in the park. My theory is if it doesn't fit in, it won't come out. And until you've seen a live broadcast of a C-section you have no idea just how medieval modern medicine really is. After the evil smiley face incision is carved in the lower abdomen, the mad doctor

removes your uterus, as in LIFTING IT OUT OF YOUR BODY, brushing aside the blood and guts with a Betadine hosedown, painting an even more gory picture of the real meaning of the Hippocratic Oath, as he forces the little devil out of its morbid hiding place, restitching the permanent damage already done, as casually as darning an old sock with size ten knitting needles, inside the epicentre of your most sensitive nerve centre. Heinous. Horrible. Count me out.

Besides, the truth of the matter is, all the men I know ARE STILL FUCKING BABIES. They all demand to be coddled, handled with kid gloves, spoon fed, sent to obedience school and even on the odd occasion, spanked in a way that only a REAL MOTHER would truly know how. These services I am more than happy to provide. It is a part-time job, not a lifelong commitment. Or, as the New York Subway System once so astutely promoted in an ad campaign against teenage motherhood, 'It's like being grounded . . . for eighteen years!' And at least I know that none of them will grow up to one day hate my goddamn guts because, try as I may, I just couldn't supply the parasitic lechers with every little thing their greedy little hearts desired. Men may be babies, but they – unlike the little leeches – thrive on neglect, abuse and abandonment. They may cry and stamp their feet in order to suckle on Mother's Milk, but they won't starve to death if they don't get it.

One word of advice: next time 'the urge' to procreate kicks in, close your legs, shut your mouth, grab the closest man, stick his rashy ass in an adult-sized Depends Diaper, hold him in your arms and feed him your left tit for forty-five minutes, every three hours, for the next week. I hope it forces you to reconsider exactly what the 'joy of motherhood' is really all about.

Lydia Lunch has been assaulting the public for over twenty years, using a variety of mediums which include the spoken and written word, music, and video.

Hope springs maternal

Mothers and Daughters
Haji

My mother was from another world. I don't mean that to be silly, but she really was from another world. She was extremely well educated. My grandfather was a dean so he was very strict on education. Manners were very important to her. As well as loving nature. She got very involved with Chinese medicine and astrology. What parent of that time, in the fifties, would have dragged you off to a yoga class? She would serve us raw vegetables. Most parents tell their children to go and brush their teeth, but my mother would tell me to breathe and eat properly. There wasn't anyone who I hung out with who knew what she was talking about. They thought she was so off the wall.

My father was called Harry. I don't know much about him. I was raised by my mother. I was a love child. I never knew I was supposed to have a father. I had a brother who was eleven years older. He took care of me and taught me how to fight. Believe me, it came in handy, oh boy! I used to win all my fights because of my brother. He used to protect me.

Do you know how many men would come up to me and say, 'Hello little girl?' And they would play with themselves. I would go to the park with my dogs and there would be a man behind the tree, playing with himself. I was always running from these vulture men and there were so many of them. Maybe that was why I changed my hair from blonde to black. When I look in the mirror I don't feel that I am me when I have blonde hair. I put black shoe polish on my hair when I was ten years old because I didn't want my hair blonde – and all the boys, even the girls, used to like my blonde hair.

We spent a lot of time in Canada. Then, when I was about

six, my mother wanted to get lost in New York. She was running away from the Immigration. We were always running away from the Immigration, and in those days it was difficult; our names had to be changed. My mother was an amazing woman. I don't know how she got us children into schools with no birth certificates. After she passed away, we had a serious problem. My sister ended up with a lot of money, from her lover, so she was able to hire a lawyer to find out where she was born. It took over a year or so.

My mother always taught me, 'Don't make friends with your neighbours because they always want to know your life business.' I think that was to do with running from the Immigration. She was warm and friendly but she did not go out of her way to make friends, and that is how I am too. We are to a certain point a copy of our parents.

She was as lovely inside as out and she taught me so many things. I would have a problem with people, earthlings, but my mother would always talk to them in a beautiful soft manner as though she had stepped out of another world. She understood jealousy, fear, envy, dignity – and she taught me all these words. I think that is missing today in children.

She always wore stockings and high heels. She was glamorous. There are so many beautiful women here in Hollywood but I watch the awards shows and I see them coming up with dresses that cost a fortune, and they look like they didn't wash their hair. The make-up is fine but the hair! You know how your hair looks when you're wet and sweaty. Greasy! That's what the hair looks like today! I know times have changed but . . . Check it out. Look at the talk shows. Jay Leno brings on these beautiful women and their hair! Where is the beauty and the glamour? I am used to the most beautiful glamour. My mother wore garter belts, she wore high heels, seams! She used to say, 'Baby, are my seams straight?'

My mother had a drinking problem because the world said one thing and then did another and that didn't make sense to her. If you plant an apple tree you know you are going to get apples. If a dog wags its tail it is happy, and if it shows its teeth you run. She taught me that you will never know people. They

are so complex. They will smile, but as soon as you have left they will talk nasty about you.

I had a daughter, Cerlette, when I was a teenager, sixteen or so. I danced in nightclubs to support her. I opened Circus Circus in Vegas. Then I was in an all-women revue, downtown, doing all the latest dances – the twist, the dog, it was wild. I was very tan. I had very fine hair. My girlfriend gave me a permanent and all my hair fell out, so with my features and a dark tan everybody thought I was black. My mother always said, 'Honey, keep them guessing. When they stop talking about you then you've got something to worry about.' My mother was a smart woman.

I never had an urge to be an actress. Russ [Meyer] found me dancing in a club. I was a witch in *Supervixens* and did the make-up and costume myself. I sprayed some leaves silver then stuck them onto my G-string with double-sided Scotch tape. Russ would say, 'Do whatever you want.'

When I started doing films for him I didn't like the way I looked. My girlfriend had had her nose fixed. She said, 'Go to this doctor. He is wonderful and he likes show-girls so he won't charge you much.' I went, 'OK, but only if he doesn't give me a cute nose like yours.' So I went into his office off Hollywood Boulevard (he moved to Beverly Hills later). He didn't come on to me or anything like that. I paid $400 for my nose! I said, 'OK, make it simple, just slim it down but don't give me a turned up nose because *I am not cute*. I don't have a cute personality!' He *promised* me he wouldn't make it cute.

I went home with the bandages for a couple of weeks, came back into the office, took off the bandage. Then I stood up and looked in the mirror. My God, you should have seen the scene. They could hear me down the hall. The nurse came running because I went, 'Aaah, I look like a pig!' I turned around and I was screaming. He was backing up, saying 'OK, OK'. I was screaming, 'I told you I'm not cute!' He says, 'There is a stitch in your nose. I can take it out, but it may fall down.' I told him, 'I don't care if it falls on the floor.'

I was a good mother but I was very strict because I was scared. I envisioned my daughter going out with all the men

who had been hiding behind trees. I yelled a lot from fear and frustration. 'You are going to study and go to classes.' I kept her busy with music; she became a great ice skater. She was a good girl and I don't know why I was so strict. I was too protective. I would yell and say, 'Go to your room and stay there.' It was terrible, really terrible, but we have a wonderful relationship now. My daughter calls me on the telephone now and says, 'I don't know how you did it! How did you raise me? I can't even do it with my husband and me . . .' And she doesn't work so now she knows why I was so strict.

But you can't yell at your children. My mother never yelled at me. I only wish I was the same mother as mine had been. I don't know what happened. I restricted my daughter too much and suppressed a lot of her natural instincts. I am good at admitting when I am wrong and say sorry. I have to admit to mistakes because I don't want to keep making them.

Haji appeared in five Russ Meyer films, including Faster, Pussycat! Kill! Kill!, Beyond the Valley of the Dolls *and* Supervixens. *She has one grandchild and lives in Malibu, California.*

Performance art

Blood on the Tracks
Tama Janowitz

Some time ago I was invited to a movie premiere followed by a dinner at the Museum of Modern Art. Tim was out of town so I invited a friend of his – who had become my friend, too – to be my date. I was very pleased to be invited to a film premiere and to have a friend to go with. I didn't feel so good, bloated and a little queasy, but I dressed carefully and put on black tights and a miniskirt and top and went to meet my friend. The film wasn't particularly good but it wasn't unbearable and later it won all kinds of prizes. Afterwards, everyone walked the block or so to the Museum and we showed special passes to get in.

It wasn't the most glamorous evening, though it might have been if you had never done one of these things before. It was entertaining in a peculiar New York sort of way – to be at a party in a museum that was closed to the general public, at night-time, only neither of us really knew any of the other guests. Then my friend bumped into someone he knew and introduced me, and the three of us stood chatting near the top of the escalator, going down.

Suddenly I realized my black tights were soaked. They were completely wet. Then I realized my shoes were sodden, like two sponges. It seemed very peculiar. I looked and saw the shoes were full not of water, but blood. For a moment I didn't move. Drops of blood now began to dot the floor. The floor was shiny and the dots of blood were very red. 'Excuse me,' I said, and I went down the escalator towards the women's lavatory.

By the time I got to the bottom of the escalator my shoes were almost overflowing and in the toilet I started to bleed more; there was blood everywhere, I couldn't control it.

Finally, I mopped myself up a bit with toilet paper, then the floor and toilet. I went out and bought a sanitary napkin from the machine with my only dime, dripping blood everywhere.

Back in the toilet stall I bled through the sanitary napkin. There was blood on the walls, and all over the floor: it looked as if someone had been murdered. In a way it was sort of cool, I thought, even though I couldn't figure out how this had happened. I was getting a lot weaker. Women were going in and out and it seemed a bit peculiar that no one called, 'Are you all right in there? Do you need help?'

Suddenly there was a commotion at the door; I peered out the crack in the toilet stall and saw that three men had entered with buckets and mops as well as two women, all five were in janitor uniforms. 'Somebody cut themselves?' one of the men was saying.

'There's blood all over the floor,' a woman said. She sounded furious.

'Going up on the first floor, too,' another man said.

They began to mop and scrub. 'Who did it?' said a woman. 'The blood led down here.'

They must have known it was me, I thought, since I now saw there was a pool of blood leading directly to my toilet stall. Surely one of them might ask if I was OK. It was true I had made a mess and was very ashamed, but, after all, what if I was trying to commit suicide and was bleeding to death in here? That would be a lot more work for them. It occurred to me it might be amusing to put on a couple of different voices: in a high voice I could scream, 'Stop! Stop!' and in a deeper voice I would say, 'I'm going to kill you!' Then I could bounce back and forth between the walls as if I was being throttled. This was a long time before the O.J. Simpson case. How surprised the cleaners would be when they finally burst open the door to my stall and found only me, covered in blood: it would be like a Sherlock Holmes case, the attacker mysteriously vanished.

They finished mopping and left. The women's lavatory was quiet and empty. Once in a while some woman came in to use the facilities but I guess nothing appeared amiss. I tried to wring out my stockings and clean up my shoes. Each shoe was

so full I tipped out the contents into the toilet. I was still bleeding, but not as heavily and I went out and got a lot of paper towels since I didn't have another dime to get anything out of the machine. In the mirror my face was absolutely blanched. There was blood all over my hands and some had gotten on my face. I had never seen so much blood in my life.

'You were gone for forty minutes,' my friend said. 'I thought maybe you left. Where were you?'

I don't know why I didn't tell them I was having a miscarriage. 'I was in the lavatory,' I said. 'It's not that much fun, being female.' I was maybe three-quarters embarrassed and about one-quarter amused. I don't know why it amused me, that I could so easily have been left for dead in the lavatory of the Museum of Modern Art, but it did. We went to the bar to get another glass of wine.

After this, whenever there was some dumb girl in the newspapers who went into a bathroom and gave birth and left and then was accused of murdering her infant I always had sympathy for the girl. I was a lot older than my teens, but at that moment if a full-term baby had slipped out into the toilet and drowned, along with all the blood, I probably wouldn't have known what was happening. If I was in my teens and nobody said, 'Are you OK? Are you alive?' then I don't think I would have felt it mattered whether or not a baby was alive, if I even thought to look. And it would have served the lavatory attendants right if the next day one of them had found a dead baby.

Tama Janowitz is the author of six books for adults, most recently A Certain Age *and a book for very young children entitled* Hear That? *She lives in New York.*

Pets' corner

Squiddly diddly

The Relationship of the Octopus to Human Sexuality

Penny Birch MSc MA

To the majority of humanity, the words 'octopus' and 'sex' do not belong in the same sentence. Certainly we won't be seeing an article in *Cosmopolitan* on how to achieve orgasm with your pet octopus. In fact, most people will probably go through life without ever so much as considering that a link might exist.

Nevertheless it does; proof of the amazing richness of the human mind and, in particular, of human sexuality. Not that the octopus needs to be real, any more than the male figures in female fantasies of forced sex are real. Rather, the octopus is an image, and one ripe with sexual symbolism. Eight strong arms, the turgid dome of the body, the long, firm siphon expelling a gush of water or ink, all of it is very male and very phallic. It is true that all of this comes from the tendency of humans to see other creatures in their own terms. Octopuses would doubtless see the subject very differently, but that is not relevant to the sexual power of the images. They exist in the human mind, and that is what matters.

It must be because the sexual imagery of the octopus is male that images of octopus sex always involve women. It is not always a female fantasy, but it does seem to always be a fantasy that relates to the female. Sexual imagery involving contact between men and octopuses is very rare, and when it does exist it is within a context of submissive homosexuality. To put it crudely, you can't fuck an octopus but an octopus can fuck you.

Thus we are discussing not reality, but a product of the human imagination, or at least, most of the time. Personally I see the sexual image of the octopus as something powerful,

able to hold me and fill me all at once, also to provide the extra pleasure of a broken taboo. Octopuses hold no fear or horror for me, and the pleasure of the fantasy does not come from ideas of being violated.

Still, it would be arrogant of me to assume that my own concepts reflect those of the rest of humanity. Different people think in different ways, and a survey of the internet and other liberal-minded individuals has produced a wonderful variety of takes on octopus sex.

Most were simply bemused by my question. Others saw the octopus only in terms of groping adolescent hands (women); or as symbolic of gold-digging women (men). Several mentioned James Bond. A few understood more deeply.

Among men, especially on the internet, the octopus tends to be seen as a monster, a rapist forcing its attentions onto a helpless, and invariably nubile, female. She may be exposed, penetrated, even devoured, while his pleasure may come from watching or, as her rescuer, taking his reward of her body. We did find one guy who had fantasies about fucking octopus, which shows that if you think you understand the breadth of human imagination, you are wrong.

For women, the fantasy was seldom coercive, but concentrated on the thrill of the perverse and the forbidden. Another common theme was the ability of the octopus to reach every part of a woman's body, eight arms, each stimulating a different place. In Nancy Friday's *My Secret Garden*, a fantasy is given from the viewpoint of a woman called Sondra which combines these two, with a huge black octopus penetrating her in every orifice while Jesus watches. Lastly, there is the octopus as a detached symbol in sexual fantasy, variously phallic, of strength, of the gentle caress.

The great bulk of modern sexual octopus imagery, both artistic and literary, fits the male model. Much is made of the octopus as rapist, a thing of horror, especially with reference to H.P. Lovecraft's *Cthulhu Mythos*. Lovecraft's work has no overt erotic content, yet it has spawned a whole genre of horror/sex centred on the octopus. Much of this is available on the internet, both pictures and stories. The majority of the pictures are

in the Japanese *hentai* anime style and typically show girls with exaggeratedly sexual bodies wrapped in tentacles. The victims are often bound, and from their expressions it is clear that these are intended as grotesque rape fantasies, with the octopus, or as often a Cthulhu-like man/octopus, substituted for the violating male. Stories follow similar lines, with titles such as 'Cthulhu Date Rape', 'Cthulhu Cheerleader Massacre' and 'Plaything of the Damned'.

The bulk of this material comes from the US, and derives from the resentment of sexually unsuccessful adolescent males, which fuels so much of the erotic writing on the net. The victims are often cheerleaders, and this passage from 'Retribution 4' gives a pretty good idea of what it's all about, as well as of the standard of writing . . .

> Suddenly, a pair of tentacles arced into the air and came down, one burrowing into Peggy's tight T-shirt while the other sought and found an entrance into her shorts. In an explosion of fabric the tentacles ripped Peggy's clothes off of her, leaving her only in a bra and panties. Peggy struggled at the attack to no avail. Eyes wide in horror Peggy watched as the monster brought up its remaining left arm toward her. As if to clear the way a tentacle shot down out of the writhing mass and ripped open Peggy's bra almost as the beast grabbed her large breast. Peggy's melon-sized breast measured 36D, but in the huge beast's claw it looked little larger than an orange. Peggy gasped and screamed as the horror squeezed her breast while yet another tentacle burrowed into and ripped away her panties. The thing pulled Peggy up to its face.

The monster in the above passage is a tentacled alien rather than an actual octopus, but it is from the octopus that the imagery ultimately derives. The influence of the *Cthulhu Mythos* is wide, with more than one organisation taking the name of his (Lovecraft's) fictional Esoteric Order of Dagon. Unlike the

original, they do not indulge in human sacrifice, but they do worship tentacled, deep-sea gods and, on the face of it, are no more foolish or fantastical than any other religious group.

An interesting by-product of one of these cults is the pamphlet *Eight Arms to Hold You* by Ian Blake, which discusses the subject and includes a variety of octopus sex illustrations. This includes what is supposed to be the sketch of a photograph of a woman with an octopus on her lap. It is stylised and of only moderate anatomical accuracy (the octopus, not the woman), so is probably not genuine. Yet what is intriguing is the way only seven arms are visible, allowing the imagination to decide where the eighth is.

Both *Eight Arms to Hold You* and the Esoteric Order of Dagon from which it derived dwell strongly on the horror aspect of octopus sex fantasy. The octopus is viewed as predatory, devouring, with those who follow the fantasy seen as affected by a self-destructive madness. At best, the octopus is depicted as a source of extreme and exquisite sexual experience, but also madness. Again, the octopus is being portrayed in anthropomorphic terms, and not as a real creature.

The horror image of the octopus in European culture predates Lovecraft. Not only are there stories and pictures of giant octopuses and squid attacking boats, but the creatures are regarded as inherently evil, even being named 'devil fish'. This is very unfair, as octopuses are no more aggressive than the next sea creature and considerably less so than some. Certainly they don't lie in wait in the hope of raping and devouring female swimmers.

Female octopus sex fantasy is much rarer on the net, but what does exist takes a very different viewpoint. The creatures are seen as benign, even playful, although few women are prepared to come to grips with the fleshy details of their imaginations, at least, not openly. Rather, the tendency is towards the abstract, dwelling on the erotic symbolism of the octopus rather than tentacles and orgasms. An exception is Aishling Morgan's *Black Tide*, which is not internet porn, but a published story, and British. This not only makes the female the initiator of the act, but leaves nothing to the imagination . . .

Eight arms took her, holding her, pulling her in. Two
were behind her back, two around her waist. The fifth
cupped her bottom, much as a human lover might
have held her to mount her body on his. The sixth
and seventh held her thighs, spreading them to the
point of pain, opening her for exploration and fertili-
sation. The last, the elongated sperm arm, had
already begun its work, caressing her, stimulating her
to the point where she became receptive.

Epiphany writhed in the arms of the octopus, sob-
bing and whimpering with reaction, her whole body
engulfed in an ecstasy far beyond anything else she
knew, the horrid thrill of the black tide, with her body
locked helpless as the slime covered sperm arm
stroked her naked flesh. With her nipples aching
beneath suckers, her vagina gaping as it leaked the
taste of the female into the water, she could only lie
back, moaning and sobbing, crying in her ecstasy,
heedless of the waves breaking over her body.

Black Tide is also rare in that it is anatomically accurate,
with the octopus using his sperm arm, the hectocotyl, as a pen-
etrative organ. Next to the US, the main source of modern
octopus sex is Japan, and it is Japan that is the real home of the
fantasy. Nowadays, most Japanese octopus sex shows cartoon
monsters molesting white-pantied schoolgirls. Far more
appealing to me are the older Japanese representations of octo-
pus sex, which show it not as a horrifying rape but as a sensu-
al pleasure. The most famous of these are *Pearl Diver* and *Two
Octopuses*, made in 1814 by Katsushika Hokusai. The latter
shows a female diver in the embrace of two octopuses, one at
her mouth, one between her thighs, while her back is arched to
push her belly into prominence. To me it is an extremely pow-
erful image, and deeply sensual. The woodblock print was orig-
inally published in a *Shunga*, the equivalent of the European
pillow book, and so seems to have been intended to arouse.
Personally I rather like to imagine a Japanese couple enjoying
a little straight sex, going on to play with an octopus and

perhaps finishing the evening with a little *tako sushi*. Japanese erotic art contains many similar examples on the same theme.

The inclusion of a pearl diver, or *ama*, as the female figure in these pictures is typical. The fantasy relates to the tendency to eroticise women who take active roles in society. Much as eroticised images of female motor mechanics are common in modern Western culture, so it is with female pearl divers in Japan. Genuine *ama* dive for sea food, mainly abalone and octopus, as well as pearls. The job must be cold, wet and exhausting, and about as erotic as . . . well, as lying under a car with smelly old engine oil dripping all over you.

Nevertheless, the job exerts an erotic fascination for Japanese men, to the extent where annual *ama* beauty contests are now held, the irony being that the competitors are merely pretty young girls in traditional *ama* costume, not divers at all. As a link with Western culture, in Ian Fleming's *You Only Live Twice*, Mie Hama (as Kissy Suzuki) plays an *ama*, or rather the eroticised image of one. She has long hair and not a lot of muscle, both drawbacks to the profession.

Traditionally, *ama* worked naked or semi-naked, and although this was true of many female Japanese agricultural workers at the time, it can only have added to their erotic appeal. At the end of the nineteenth century a costume of light white cloth was adopted, initially at a pearl farm where *ama* where employed to gather the pearls, purely for the look of the thing. Visitors were said to have been shocked by the girls' nudity, and so the costume was introduced. It is see-through when wet and it can be argued that this gives the men watching the thrill of having glimpsed something the woman did not want to reveal, a common feature of erotic display.

Ama hunt octopus, which already carry erotic symbolism, so it is a short step to picturing them indulging erotic whims with the beasts. Doubtless the bulk of the resulting erotic imagery comes from men, but that is not to deny the women a connection between the octopus and sex.

There can be no doubt that these pictures are intended to be erotic: the subject is too intimate for any but the most determined Bowdler to admit otherwise. How they are interpreted

is a different matter. What is clear is that people find it hard to come to terms with these images as frankly sexual, and tend to interpret them according to their own philosophies. While researching this article we have come across analyses of Hokusai's classic painting that variously see it as a depiction of female sensuality, of rape, of vulgar humour and of male fantasy accentuating the grotesque. Others think of it as erotic yet see the octopuses as purely symbolic, which to my mind denies the real power of the work.

Though Hokusai is long dead and so unable to tell us the true intentions behind his work, the same is not true of another Japanese artist. Masami Teraoka is a Japanese American who is influenced by Hokusai and has produced a series of pictures showing detailed scenes of women making love to octopuses. I say 'making love' advisedly, as this is the artist's intention. To quote . . .

> My *Tattooed Woman and Octopus* series was directly influenced by the arousing beauty of the sea creatures in Hokusai's *Pearl Diver and Two Octopuses*. I included modern accoutrements in my work to evoke America's lust for commercial merchandise, from tampons to condoms to Kleenex.

Thus, while his work does contain symbolism, it is also intended to be frankly erotic. His symbolic features include a comment on US censorship. This shows the disapproving face of a middle-aged American male peering at the vulva of the woman who is with the octopus, inspecting her with a view to censorship. By Masami's own admission this is a detail of the painting, no more. Despite this, I have seen a critique stating the comment on censorship to be the primary intention of the work, thus denying its very real erotic impact. I suspect the same is true of Hokusai's picture.

If Hokusai's work is open to interpretation, then this is less true of the next example. Netsuke are ornamental carvings, generally of ivory or fine wood, designed to hang from the purse cords of traditional Japanese costume. These come in an

impressive variety of designs, among which the image of the diving girl and the octopuses is by no means uncommon. Some depict the same scene as Hokusai's painting, with the girl penetrated orally and vaginally by two octopuses. Others show different scenes, but in every example I have found the expression on the girl's face is of unalloyed bliss. My favourite shows a girl on her back with her legs rolled up and the octopus perched on her shins. The beast's tentacles writhe around her body, holding her wrists and legs while from underneath we can see that one is busy in her vagina. Her expression leaves no doubt that she is enjoying the experience.

As always, critics might claim that these images are merely the product of male fantasy or that they are purely symbolic, yet they clearly show women taking pleasure in octopus sex, and to claim otherwise is to lose credibility. They express an erotic fantasy, strange, yes, perverse, yes, and from my research more female than male. As to whether they give pleasure, this must be a matter for the individual. They may titillate or they may evoke revulsion; they may arouse or they may horrify; but it is hard to imagine a reaction of indifference.

The next question then, must be to ask if these could be depictions of real events. Unfortunately the answer is no. Whether any *ama*, or other Japanese women, have ever actually indulged in octopus sex we do not know. Human nature being what it is, they probably have, but this is not what is shown in the imagery. For one thing the octopuses are not anatomically accurate. The siphon, or funnel, is shown protruding not from below the mantle edge, but from below and between the eyes, rather like a human nose. Less accurate still, it is the siphon that is often shown as the organ of penetration, while its true functions are breathing, propulsion and defence. An octopus with its siphon in a woman's vagina would risk suffocation.

So, what can you do? For a start, there are over seven hundred species of cephalopod, the class to which the octopus belongs. They've been around since Paleozoic times, long before the first proto-amphibian crawled out of the sea, and show as much variety of form as do mammals. Aside from the

archaic nautilus, there are three groups, cuttlefish, squid and octopuses. I imagine that having a live squid in my vagina would be quite an experience, but it's not really fair on the squid. On the other hand the idea of descending several thousand feet below the ocean surface to try and have a sexual encounter with a fifty-foot *Architeuthis* makes anything the Cthulhu freaks can throw at us look tame.

Even in warm, shallow coastal waters things could get dangerous. Some species are venomous, notably *Hapalochlaena maculosus* – the blue-ringed octopus of *Octopussy* fame, which produces a neurotoxin that can kill an adult human in twenty minutes. Other species have hardened rims to their suckers, which can easily damage skin. It would also be unwise to attempt anything during a dive, while an octopus will not live long out of water.

The only realistic option would be to find a private 'make that *very* private' tidal pool in which an octopus lives. Having chosen your octopus, the first thing to do is to make friends. This is not as unreasonable as it may sound, as many species are as intelligent as dogs, including the Common Octopus, *Octopus vulgaris*. They are shy creatures, but with patience and effort it should be easy to establish a rapport. Trying feeding him a few crabs, or perhaps even a spot of lobster.

So you've met and you've had dinner together. With a man the next step would be bed, but with an octopus you can be absolutely certain that he will not perceive you in sexual terms. So, ask not what the octopus can do for you, but rather what you can do for the octopus.

For a start, you need to be sure that you actually have a male, at least you do if you want the full experience. Mature male *Octopus vulgaris* may be identified by the structure of the sperm arm, which has a longitudinal groove running between the suckers and a spoon-shaped tip. Sexual arousal in the octopus relies on a combination of vision, touch and chemosensory stimulation. You don't look right and you don't smell right, but if you play with a female octopus first, then her taste will be on your skin and the male may well get interested.

Once he is, it's all fun. Octopus foreplay lasts hours, gentle

stroking and probing with the tentacles, particularly the sperm arm. No two-minute wonders here. To mate, the tip of the sperm arm is inserted into the female's mantle cavity, which is not so very different from a human vagina. There is more tentacle than is going to fit inside you, but think being licked out by a man with a three-foot tongue – a man who never tires and demands nothing in return. Some of the other seven tentacles will be used to grip you, maybe around your thighs or middle, under your bottom, even on your breasts. You probably won't get any attention to your clitoris, but that is really best left to your own fingers anyway. Finally, you'll get flooded with sperm. That's the time to come, and if the feeling is right and you can handle what you're doing in your head, then it should be some orgasm.

If your octopus happens to be a girl, do not despair. With a little imagination it is perfectly possible to play lezzie games which you will both enjoy, if for different reasons. She may not want sex, but food is always welcome, especially crab. Smear a little on your pussy, between your bottom cheeks, on your breasts, anywhere you want to be touched, and you can be sure of plenty of tentacle attention. What you mustn't do is allow her beak anywhere near your flesh, otherwise you risk a nasty bite. Octopus are remarkably strong, so a rigid wire cage over your pussy is a good idea, allowing the tentacles in but not the body.

As with mating, you'll be gripped and your pussy will get plenty of attention. Putting crab meat inside your vagina will certainly get you penetrated, while plenty on the vulva should guarantee attention to your clitoris and hopefully a truly mind-blowing orgasm; and that, after all, is what it's all about.

Penny Birch has two degrees in zoology and at one stage in her career was aiming to become an expert in molluscs. She is founder member of the BB&L *(Birched Bottoms and Love It) Pony-Girl club. She has written numerous novels for Nexus and contributed to* Fetish Times. *www.pennybirch.com See also www.hades.nixnet.com*

You sexy beast

Lapdogs and Other Perversions
Kathleen Kürik Bryson

I should probably mention that I am not a zoophile, per se. I have never yet had sex with an animal. I have, however, once masturbated when a dog was in the same room and at the time I reached out and patted its back – a single pat – but I'm not sure if that counts. That is as far as I've gone. There. I am not a zoophile; I have drawn a concrete line between the real animal-shagging furverts and myself. Now I can talk about the subject in an oh-so-friendly, chatty way, and you can feel relieved that I'm not really . . . well . . . one of *them*. That's why we have these tidy psychological definitions, to make us feel relieved: there's *you*, of course, who in a weak moment might once have looked at a horse with something more than fraternal feelings, and then there's those *other* people, the people who have real problems, the sick ones. Completely different.

Still, the thought of fucking wolves is a strangely intriguing one (some Red Ridinghood residue in my brain, I'm sure). I've written sex scenes that have involved wild animals; I can see how someone could fancy a giant tawny feline like a tiger or a mountain lion, randy, on heat; I can understand the attraction some people have for those Überbisexuals of the sea, the dolphins; I've watched wildlife programmes of shagging primates and been aroused. A junior-high school friend once piqued my curiosity with an offhand and off-colour comment about French aristocratic ladies and their lapdogs. And I felt pretty peculiar after reading Bruce Bagemihl's marvellous *Biological Exuberance* and its descriptions of sexual behaviour, homosexual, heterosexual and bisexual, in the animal kingdom. (It was kind of a zoo voyeurism, if you will – I didn't really want to get

involved, but the imagery of male elephants twisting their cocks around each other, horny and sticky, or the mutual clitoral mounting of hyenas – well, you know, it was kind of hot.)

I hope that's not too disturbing. I hope that doesn't make things too fuzzy; make you worry that I *might be one of them after all*. Because you see, that's really the point of this whole piece. We humans have a terrible fear of being one of them. We have a terrible fear of being what we are – animals. And bestiality calls into question that fear. We fuck ourselves. We fuck them. We are them.

We spend a lot of time and cultural energy trying to convince ourselves we're not. In our interpretation of animal behaviour, for example, a recurring pattern is seen which serves to support Western mores. When animal behaviour is seen to uphold 'mainstream' cultural values: monogamy, heterosexuality, patriarchy, then mainstream academia embraces it, i.e. the perceived 'naturalness' of heterosexual animal behaviour upholds our culture's mores of heterosexual dominance. 'Just look at the animals,' people say, 'Noah's ark!' and so on. But if animal behaviour does not uphold the dominant culture's mores (and everything points to the fact that it doesn't – the majority of mammal and bird species are bisexual), the urge then is to explain away the behaviour as animalistic: 'We are human, after all, and on a higher level – not animals.' In short, we separate ourselves from them.

Indeed, our easy acceptance of biological explanations for differentiated male/female behaviour; our wholehearted and non-questioning acceptance of sexuality as biological rather than looking at sexual orientation as learned behaviour; questions of race and histories of anti-semitism and racism; the push towards essentialist explanations for race and sexuality by both radicals and bigots – all of this has to do with the need to codify otherness into two cosy, catch-all categories. Factors such as 'miscegenation', hybridism, bisexuality and inter-species fucking show this type of shorthand classification up for what it really is – the human fear of blending into the other to such a degree that one's own identity is threatened: bestiality as fear of the animal called human. And often at the same

time, the feared group itself is hell-bent on exclusionary self-definition – probably a necessary part of the process of politics, as well as a step towards eventual and mutual assimilation on both sides of the divide.

The catch is that with animals, we don't consider them intellectually capable of self-definition, or even a sense of self (though it should be patently obvious that dogs recognise other dogs, cats other cats, and so on). No, conveniently for us, animals don't attack back too often these days, at least not in the abstract sense of a political challenge to our hierarchical culture, where humans rank high above the beasts in the pecking order. We've bureaucratised other animals straight out of the picture: they don't play our game, or speak our language – and thus we feel we have a right to exploit them – mainly for food and through the destruction of their (and our) natural environment. They also can be exploited sexually and emotionally, and this will be discussed later. Our assumption that we can use animals in myriad ways for our own benefit is thought of as a God-given right, for this sentiment is backed up by our laws and our religions. Church and State both have a big investment in perpetuating this line of thought – how else could we have social approval for the industrial mass slaughter of other animals for food? How else could we as human beings feel that we are somehow special and therefore divine, not beasts at all?

The hierarchical Judeo-Christian religions, in particular, seem to have a big problem with animals altogether, which coincides – not too surprisingly – with their dichotomised views on masculinity/femininity: male = head, intellect, reason, structure, human; female = body, primal, passion, uncontrolledness, animal. This Us/Other division can be credited with a lot of present-day misogyny. Evil in Western culture is associated with both women (occasionally men) and animals – and takes its forms in a multitude of human/animal 'monstrous' hybrids: succubi, werewolves, gorgons, sirens, vampires, silkies, satyrs etc. In other cultures, however, animals often are hybridised with gods – the religion of the ancient Aztecs with their jaguar-humans; the cat-gods of Egypt; even shape-shifting

Greek gods doing time as bulls. The Old Norse religion featured lots of divine/animal hybrids, amongst them Loki, who spent time as a salmon and begat both a wolf and a snake child (as well as Hell herself, but that's another story). The idea that our minds are holy (read: intellectual, male) and that we should strive to separate ourselves from the carnal (read animal, bestial, female) body is a common early Christian theme, illuminated by early Church doctrine and particularly by the anti-sex, anti-female, anti-body fourth-century writings of St Augustine. It's not a coincidence that in Christianity, Judaism and Islam women are considered unclean, dirty . . . more *animal*.

We might be socialised through religion and culture to think that Animal is the ultimate Other, but the hard biological truth of the matter is that Animal is also the ultimate Us. Thus, our relationship with other animals is a problematic one, and this is highlighted in a discussion of an act such as bestiality: sexual contact with a species other than our own. Sex means intimacy: physical or emotional or both.

Yet bestiality is not a new, post-industrial perversion, nor are we the only animals to engage in cross-species diddling – Bagemihl has compiled numerous examples, both heterosexual and homosexual, from bonobos (pygmy chimpanzees) with redtail monkeys; seals with sea lions; walruses with seals and, added to the fact that 'male Chimps have been observed copulating with female Savanna Baboons in the wild', we can rest assured that we're not alone in this. And that's just regular species behaviour in the wild: Bagemihl also points out that a wide range of interspecies sexual interactions in captivity has also been observed, including 'a female Rhesus Monkey soliciting copulations from a Dog'.

So it follows that in Judeo-Christian societies where a heavy emphasis is placed on *not* behaving 'animalistically', humans are going to try to avoid the general 'licentiousness' of animals. Animals have sex when and where they please, unashamed – unless beaten by humans into being shamed or at least frightened, as some pet dogs are (in 1999 in the US, for example, a man shot and killed his dog for 'being gay'). The

afore-mentioned cross-species licentiousness is also prevalent (who hasn't laughed embarrassedly when a dog humps a person's leg in 'polite' company?), which brings with it a human fear of blending, of mixing. For already in Early Modern Europe, the culture from which many of our current Western social and religious mores stem, the fear of such a blend was present. As Erica Fudge says in *History Today*, '. . . bestiality came to be perceived as a danger, and one that must be severely dealt with. Central to this reaction was the belief that bestiality caused a pollution of the species. This pollution was not merely due to illicit sexual contact, but rested on the belief in the possibility of reproduction across species boundaries.'

Fudge argues that a change in the attitude regarding bestiality occurred in the sixteenth century as a result of science and exploration: faced with the discovery of new beasts and new peoples, as well as medical advances in the field of anatomy that emphasised similarities between humans and animals, Europeans' sense of self suffered, and as such the fear of cross-pollination and co-mingling grew. Hence the resultant fears of pig-women, dog-men, dog-bears – or anything that blurred the lines between previously distinct categories (although all the combinations mentioned are biologically impossible). Fudge gives as an example Edward Fenton's 1569 translation of a French text which describes '. . . a child who was conceived and engendered between a woman and a dog, having from the navel upwards, the form and shape of the mother, so well accomplished, that nature had not forgotten anything unperformed, and from the navel downwards, it had the form and figure of the beast who was the father . . .' Indeed, by 1533, bestiality in England was regarded as a felony 'without benefit of clergy', and was punishable by death.

Perhaps with such a fear of co-mingling, it was inevitable that animals would be considered dirty and sinful, and it was also during this time of advances in natural science that the number of unusual court cases – the infamous Animal Trials – soared. There had been previous but sporadic judicial

proceedings where animals were criminally tried for offences such as being accomplices to murder, and then usually sentenced to banishment or capital punishment such as hanging, but in Early Modern Europe the number of cases peaked during the sixteenth and seventeenth centuries, and thereafter continued more infrequently until well into the nineteenth century. The interesting fact here, of course, is that animals were temporarily raised in status to that of humans – although only for the purpose of punishment, not to allow them the other social benefits of humanhood.

The anthropomorphism found in the Animal Trials (a serious slur in biological research, by the way: don't ever accuse a biologist of it) is present nowadays in popular culture when you can find orang-utan 'adoption' ads in the back pages of weekly magazines. These are identical to 'Save the Children' human 'adoption' sponsorships in every way, and come complete with adoption certificates. Like a glacier, we seem to be edging closer, even as we desperately try to simultaneously edge away from, the definition of the human animal. Theories of language and abstract thought are designed to separate us from our animal selves; we make more and more specific boundaries to distance ourselves from animals.

Yet there are still movements to raise the status of animals to our own level, such as the current push in the New Zealand parliament to give the non-human Great Apes (gorillas, bonobos, chimpanzees, orang-utans) human rights – on the basis that the 'human' qualities of intelligence, compassion and language are all qualities which apes have been shown to exhibit. Apes have proved embarrassingly close to us even on human-slanted IQ tests (one gorilla scored close to a hundred, even when she pushed the incorrect button marked 'tree' when given options on where she should run to in a storm – rather than the 'correct' answer, a 'house'). Every time we set up new criteria to separate ourselves from animals, it's proven that we somehow share this yardstick with other animals (usually with other primates, but occasionally with more surprising creatures, such as parrots, which have the ability to count).

When I was an undergraduate in the early nineties, my

professors were getting nervous about the fact that chimps and gorillas used sign language, since at that time language was the defining element of humanity (interestingly, Bagemihl details how our closest genetic relations, the bisexual pygmy chimps, have over ten different signals for particular positions that they want their sexual partners to assume). Twenty years before, the yardstick had been modified tool-making, before anthropologists found out the extent to which primates and many birds do exactly this. But when it became apparent that apes could use language, anthropologists quickly qualified the entrance requirements to include such arbitrary distinctions as the need to show awareness of time displacement, or to use grammar as opposed to 'word salads', etc. It was all getting a bit too close for comfort and perhaps this is why the proposed legislation in New Zealand makes people laugh nervously. Again, we are not intolerant – we just don't want our daughter to marry one.

Long before medieval Animal Trials, long before Christianity even, the practice of bestiality was taking place. This act was already represented over 5,000 years ago, according to Timothy Taylor, author of *Prehistory of Sex*, who theorises that bestiality may once have been a common feature of life. We have no way of knowing however, whether humans considered themselves just another type of animal, or whether they saw themselves as separate beings altogether – though the archaeological evidence of animal-based shamanism suggests that animals were accorded much more respect then than they are in the present day. Some artefacts are less obviously spiritual: a piece from 3000 BC Italy, for example, shows a detailed rendering of a man having sex with a donkey. Taylor notes that, 'part of the novelty of this scene is that donkeys were a recent introduction to Alpine Europe at the time the image was created'. From Siberia at around the same time, there is one especially memorable depiction of a male on skis attempting to penetrate a moose with his erect cock.

In Bronze Age Scandinavia, there are numerous rock art drawings of bestiality. Later, in the Iron Age, Vikings had two very similar words for sexual intercourse: *samlag*

(human/human intercourse) and *tidelag* (human/animal inter-course). And although *tidelag* meant severe punishment under Viking law, the fact is that the act itself was culturally – and lin-guistically – recognised. Even to this day the region retains some recognition of zoophilia: Denmark is to date the only nation on earth in which bestiality is to some extent legalised – with a proviso against cruelty to animals, and provided the ani-mal, too, is eager for the act.

Which brings us to the subject of consensuality – a discus-sion central to many *modern* zoophile websites, for of course the practice of animal-loving is as common today as it was 5,000 years ago. In our consent-focussed post-feminist world, we want to know whether the animal is enjoying it, too. Amongst larger domestic animals such as horses or dogs, it is more evident when animals are on heat or sexually aroused. Domesticated canines, in particular, frequently solicit sex from humans. But having penetrative (penile or object-based) sex with animals which are unable to protest, not in heat, not obviously sexually interested or too small to be physically comfortable with the act is quite obviously non-consensual, like rape. This type of behaviour with unwilling or uninterest-ed animals is cruel and exploitative, similar to *droit de seigneur* historical inequalities, where women, children and animals were socially regarded as property and sexually available regardless of consent. In a non-sexual context, animals, more often than older children or women, are placed in this 'silent' role. An animal can only yelp or cry or bark or perhaps not even react; an animal cannot go to the courts and state that it has been kicked or raped. Although the RSPCA and the NAPCA do pursue prosecutions for the physical and emotion-al abuse of animals, the sentencing of a human who has abused an animal is not equal to that of a human who has treated another human cruelly. Animals can be favoured or abused, but the point is, they belong to someone else, with limited protection. We *eat* them, for Christ's sake. We also subject those species we choose to eat – in most cases – to intolerable lives.

So I have yet to be convinced that modern zoophiles are

entirely above the level when it comes to consent. And judging from the many pages of discussion on various zoophile websites, many self-professed zoophiles have similar misgivings, as they try to negotiate a code of honour regarding an act that is fundamentally illegal in most countries.

There are emotional issues, too. Sex writer/columnist Pat Califia's (now Patrick Califia-Rice) agony-aunt advice to one reader was the most level-headed I've yet read: if you're going to have a mutual sexual relationship with a pet, you had better be aware that you also have an emotional responsibility. The animal might well become jealous or depressed if you break off the relationship in favour of a human partnership, and this is something to be conscious of when embarking on a human/animal relationship. This sage advice acknowledges the feelings of the animal as well as the human. Sex *is* used as a means of control – the power differentials involved between humans and animals may well be insurmountable. That's why this subject is such a hot topic amongst the online zoophile community – you're going to find as much of a range of opinions and differing ethical systems there as you will anywhere else. Some aficionados even make a distinction between those who *fantasise* and those who *do*.

There are also, apparently, distinctions of terminology. Generally, bestiality is a much less loaded term than *zoophilia*. Bestiality can be the occasional fancying of four-legged or feathered friends – something fairly common in rural areas, with nearly half of all men reporting having had sex with an animal at least once, according to the Kinsey report. In non-rural areas figures are lower: 8% of men and 3.5% of women report similar acts. Occasional, one-off bestiality sessions are not an indicator of ongoing sexual problems, according to the official American psychology board. It might be a *moral* problem in the community, but it is not a *sexual* problem. It is when a sexual act – and that means any sexual act, by the way – becomes exclusive and obsessive that it is considered a paraphilia. The distinction made here is between occasionality and 'obsession'. Nor is relatively common sexual behaviour such as SM play considered to be a sexual problem – it's acknowledged

that most 'normal' people engage in mild versions of paraphilia to some extent, whether it's kinky leather sex or voyeurism, and are not classified as paraphiliacs. Similarly, a drunk med student shagging a corpse as a prank is not considered to be 'suffering' from necrophilia.

What *is* considered 'atypical and extreme' is also irretrievably enmeshed with a culture's current social mores: until the early 1970s, homosexuality was classified as such by all official American and British psychology boards. The Sinclair Family Institute, makers of educational sex videos, define a paraphilia this way: 'condition in which a person's sexual arousal and gratification *depend on* fantasising and engaging sexual behaviour that is atypical and extreme [emphasis mine]'.

In the interest of research, I did a little internet surfing on the subject, in order to find out how zoophiles defined themselves, not merely how they are defined by psychologists. The zoophile internet community includes people of all sexual orientations (het, homo, bi and some who are 'zoo-only'). They consider themselves a sexual minority and their politicised language is similar to that of other marginalised communities: 'You're not alone . . . For those out there who may be zoosexually inclined, zoophilia is not an illness, and you're not alone. Wander around enough about the internet and you'll probably find the rest of us'; 'Zoo by nature, Proud by choice.' The bible of these self-labelled zoophiles is a book entitled *Dearest Pet* (one reader review states, 'it provides for us zoo's [*sic*] a thorough description of our heritage, as it were, dating back to medieval times'). *Dearest Pet* is readily available on most of the larger book-buying sites.

This book, along with others such as *The Horseman: Obsessions of a Zoophile*, discuss the physical, moral and emotional issues that go along with having sex with animals, not purely the physical. *Dearest Pet* makes the interesting point that, whereas love for animals 'is extolled as noble and "natural", all erotic elements in the relationship between humans and other species are vilified and proscribed' – an interesting parallel to the platonic love that is by necessity supposed to

exist in all-male communities such as the military, as long as it remains platonic.

There are still the physical logistics of the whole matter, and for those who are really keen for the nitty-gritty details about how to actually go about having sex with animals, this information is also available online. But don't make the mistake of thinking that it's a scot-free process: it might be OK in Denmark, but it's legally proscribed against nearly everywhere else (of course, some places are worse than others – punishment is more severe in parts of the US, say, than in Australia, which distinguishes between types of bestiality, i.e. anal penetration of the animal versus vaginal). Along with sections on zoophilia and the law and discussions on keeping your pet emotionally safe and the ever-present consensuality debates, you also come across how-to sections detailing the avoidance of contagious animal diseases. You can find out how to have anal sex, fellatio and masturbatory pleasure with your mini-stallion.

There are similar sections on canines (oral, vaginal and anal sex, giving and receiving, what dog semen actually contains) and dolphins – including how to tell a male dolphin from a female one, how to know if a dolphin wants to have sex with you, how you can invite a dolphin to be masturbated and how you can go about finding said dolphin in the first place. We're coming for ya, flipper.

It's pretty clear from a cursory and superficial flick through the variety of zoophile sites accessible to the layman that in the beginning of the twenty-first century, we are still attempting to negotiate the nuances of our complex relationship with other animals – sometimes in graphic detail.

In closing, I should mention that I have not been able to confirm the veracity of stories of small dogs bred and raised and trained solely to give their aristocratic pre-Revolutionary French female owners pleasure through cunnilingus. I'm not sure that it matters. The cultural division we insist on between humans and all other animals is really the issue here, not whether you can shag a bonobo chimp. (Though if you did, you'd probably have a pretty good time – they spend most of

their time having sex with each other in every possible combination of twosomes and threesomes and aggressive behaviour is usually diffused with sex – unlike humans, who like to use violence.)

Despite our desire to draw a clear line between humans and beasts, our connections to other animals persist in so many ways, from the problematic issues of consensual cross-species sex vs exploitation discussed in this essay, to shamanism and dog shows, from naming sports teams after animals to living in smelly houses full of two hundred kitties. Animal symbology is of prime importance in many religions (lions, lambs, tusked elephants) – even if it's just to separate us from them – like the Chasidic sash called the *gartel*, worn around the waist to separate the human half of the body from the animal half. What's this about? It's about denying, and at the same time acknowledging, our animal nature.

Yet we share 98% of the same genetic make-up with pygmy chimps. In every other animal, that means inter-fertility. Not just sterile offspring such as mules (horses and donkeys are more distantly related than we are to chimps), but real, live, viable fertile offspring. You know what that means? It means the great fear of sixteenth-century society – that of the human/animal hybrid – could become a reality, after all. It means that according to the scientific establishment, we won't be separate species any more. Horse and donkey, for example, are considered separate species because when bred they produce *infertile* offspring. That's the definition of a species: the fertility barrier. Chimp/human interbreeding has not been known to have been tested in a laboratory yet, by the way – although a former professor of mine once alluded to forced experiments between women and gorillas in Russia in the forties and fifties, we don't share enough genetic make-up with gorillas to be interfertile. The same professor referred to a potential chimp/human experiment as 'the most interesting – and most damnable – experiment conceivable'.

If interfertility is the case, does this mean bonobos are human? Will we finally call ourselves animals? I don't want to frighten the horses, but is that such a damnable thing in itself?

BIBLIOGRAPHY

alt.sex.bestiality newsgroup

amazon.co.uk

Bruce Bagemihl, *Biological Exuberance: Animal Homosexuality and Natural Diversity*

Jared Diamond, *The Third Chimpanzee*

Erica Fudge, 'Monstrous Acts: Bestiality in Early Modern England', *History Today*, August 2000

Halsbury's Laws of Australia #9, p.247

June M. Reinisch, Ruth Beasley, *The Kinsey Report on Sexual Attitudes Vol 2*

Timothy Taylor, *The Prehistory of Sex: Four Million Years of Human Sexual Culture*

Kathleen Kiirik Bryson was born in Alaska in 1968 and grew up on the Kenai Peninsula. Since then she has dug up Viking graves, performed in a Riot Grrl band, exhibited her paintings in a brothel, and received an MA in Independent Film and Video. She has lived in Stockholm and Seattle and currently makes her home in London. Her novel, Mush, *was published in 2001.*

Free legal advice

In Fairbanks, Alaska: there is a law against two moose having sex on the city sidewalks.

In Kingsville, Texas: there is a law against two pigs having sex on Kingsville airport property.

In Ventura County, California: there is a law against cats and dogs having sex without a permit.

In Iran: a man is required to perform his ablutions if he ejaculates while having sexual relations with an animal.

In the Middle East: a law reads: 'After having sexual relations with a lamb, it is a mortal sin to eat its flesh.'

Bear Hug

Queen Adrena, professional wrestler and dominatrix, had to wrestle a bear to prove she could get in the ring and last. There were no females large enough to give her any competition until she met Smokey the Bear. She lasted over fifteen minutes without injury.

Fighting back

Thanks . . . it's been a riot

The Anti-Corporate Backlash
Jade Fox

'We can . . . reasonably anticipate that what is right for the people of the world will only by the remotest accident conform to the plans of the "principle architects" of policy. And there is no more reason now than there has ever been to permit them to shape the future in their own interests.'

Noam Chomsky

'With rocks in our hands and spray cans in our pockets, we converge on a truly offensive department store . . . A man comes up to us, looks at the mini black bloc and says, "Hey, cool." We laugh. "Hang on, are you girls? . . . Waaaayyy cool!!"'

B.B. Gurlsroch, British activist, quoted in *We are Winning! The Battle of Seattle - a Personal Account*

OK, I admit it: I was taken in when the first All Bar Ones slid perfidiously onto the streets of London. I remember one lunchtime in the mid 1990s sitting with my friends at a wooden table in a cavernous stripped-pine room decked out with ceiling fans and waiters in white aprons, nibbling on bruschettas and sipping glasses of white wine. We talked about how nice it was to be able to go somewhere without sticky carpets, warm Liebfraumilch and 'Ploughman's' on the menu. Er-hem. Ouch. Cringe. Run and hide.

I have confessed to this embarrassing incident in the hope that you too might be guilty of a similar crime. And I'm hoping that you too might be as pissed off as I am. Pissed off about the way in which All Bar One and other 'themed' pub and

restaurant chains have, in less than a decade, smeared them-
selves all over most of Britain's high-streets. On their way,
they've gobbled up most of the pubs with sticky carpets and
perhaps your local Italian (Remember? The places run by peo-
ple you used to know). And fellow high-street munchers will
likely have had most of your other local shops for breakfast too
– greengrocer's, butcher's, hardware stores, bike shops, you
name it. What they belch out is all too familiar – your Dixons,
your MackerD's, your Starfucks, your Virgin one-stop disen-
tertainment shop. Plastic, plastic, clone, clone.

Much more interesting than anything these businesses sell
is the tangled web of ownership that actually links lots of them
together, right at the top. Did you know, for example, that the
Aroma coffee-shop chain is a subsidiary of McDonald's, which
now also has a stake in Pret à Manger? That Arcadia is behind
Topshop, Warehouse, Dorothy Perkins, Evans, Wallis AND
Principles; or that Kingfisher (ever heard of them?) owns
B&Q, Comet and MVC, among others. By the time you read
this, some of these businesses may have been divested (sold off,
probably to another conglomerate), merged with other compa-
nies, or even demerged (floated separately on the stock mar-
ket). The point? Maximising shareholder value – in other
words, squeezing as much profit as possible out of a company's
assets, including its workers, so that rich investors will buy the
shares and directors will get their performance-related bonus-
es and make a killing on their stock options. Yes, it's just one
big party, but most of us aren't invited.

As journalist Naomi Klein describes in her nifty exposé of
the global consumer melting pot, *No Logo*, the cloning of our
high-streets and the fanatical branding of our everyday lives
has been perpetrated under the entirely false promise of
greater diversity. By the early 1990s, big corporations had
realised they couldn't win over shoppers who weren't white
middle-class men unless they got a bit more touchy-feely with
their marketing strategies. So they developed what Klein dubs
'a kind of market masala' or 'mono-multiculturalism': 'the
pitch is less Marlboro Man, more Ricky Martin: a bilingual
mix of North and South, some Latin, some R&B, all couched

in global party lyrics'.[1] Think Benetton's 'Universal Colours', think Nike's 'Just Do It'. Think Geri Halliwell.

As Klein explains, the idea was to appeal to 'global citizens' with a 'global message' so that no one felt left out. And it worked until some people started to realise it was just a means of flogging the same old products to the whole world without being accused of wholesale takeover. They also got wise to the fact that many big transnational corporations (TNCs) were behaving no better than colonial governments across large swathes of the developing world where their products were often being made. But the TNCs were too busy making money and expanding to realise that they didn't have universal approval for their actions. By the time they finally woke up and smelled the skinny wet crappucino (decaff) at the end of the nineties, some 30,000 direct action groups were gunning for them around the globe.[2]

WINDOW SHOPPING WITH A DIFFERENCE

The chorus of anti-corporate protest has grown louder over the past few years. It's partly a backlash against the never-ending pressure to consume more and the increasing homogenisation of, well . . . everything. It is also a backlash against the global 'free' market that has supported the TNCs' rise to stardom. That encompasses international financial markets, so-called free trade, and the institutions – including governments and international organisations such as the International Monetary Fund and the World Trade Organisation – that make the rules of the game. The regular international meetings between political leaders and globocrats required to coordinate this massive carve-up have provided the perfect opportunity for activists to shout about the fact that they don't like what's happening. And sometimes it gets a bit messy.

At anti-corporate demos in rich industrialised countries these days, you may well come across a group of protestors, masked up to disguise themselves from the police, wearing black and calling themselves – not surprisingly – the 'black

bloc'. They'll kick in the windows of stores operated by global retailers – Starbucks, McDonald's, Nike. They might daub a few slogans, and even do a bit of looting. But that'll be about it – they certainly have no intention of hurting innocent bystanders. There might also be thousands of other protestors there, making their point in different ways – singing, dancing, shouting, acting, gardening, boozing, puffing, whatever. But the mass media coverage will almost certainly focus on the few 'mindless thugs' (pet phrase of the British government) who dared to rearrange a few shop fronts.

Heaven forbid, some of these nasty creatures are even women. Fuck the Prada shoes, the DKNY dress, the La Perla lingerie, all those things we're supposed to lust after. What better way to subvert the Wonderful World of Window Shopping than to lob a brick (imaginary or real) through its shiny façade? No, it's not what nice girls do. But there are lots of ladies out there who aren't afraid of a bit of civil disobedience, either violent or non-violent. After all, we're the ones who are supposed to shop the fastest and consume the hardest, so we can deck ourselves out in clothes that have been sewn together by women working for slave wages in poor countries. These women can't afford to feed their families, let alone buy a fancy dress or a pair of fuck-me shoes. The global shop window is a prison for us all in one way or another.

Activists who dare to try and expose this truth using any method more extreme than waving a placard or shouting will likely end up in deep trouble with the law. Property damage, ranging from tearing up genetically modified crops to smashing up McDonald's, is a highly emotive issue, for protestors and juries alike. But often those passing judgement on the action – whether in or out of court – fail to give sufficient consideration to the motive: the moral crimes committed by the corporations whose property has been damaged. As Amory Starr observes in *Naming the Enemy: Anti-corporate movements confront globalization*,

> . . . violence is, after all, the dominant mode of international relations (arriving also in the forms of

structural adjustment . . . modern agriculture . . . and biopiracy . . .). Corporations take particular advantage of people of colour and women. It is the third world 'other' who can be dumped on, worked blind at 30, policed by his or her own nation's military in service of the corporate elite and starved within view of export crops.[3]

There is a wide range of material that documents the abuse of human rights and the environment by global corporations. Sorry, there's just no room for a comprehensive list here. But some of the worst allegations have been and still are levelled at the globalised rag trade. That means corporations such as Gap, Nike and Adidas-Salomon, which have often sourced their products from overseas contractors operating sweatshops, mainly in the southern hemisphere (the South). Workers at these factories are often forced to work longer hours than junior doctors in Britain. They suffer physical and psychological abuse of the most degrading kind. And to top it all off, they're paid sod all.

Other major perpetrators of corporate 'crime' include billion-dollar-profit oil companies, such as Shell and Chevron, which have caused irreversible destruction to the environment and lives of local people in countries such as Nigeria. In some cases, their employment of the military and/or mercenaries, such as those rented out by companies like Executive Outcomes and Sandline Plus, and their collaboration with less-than-scrupulous governments have resulted in the murder of those who dared to oppose them. The most internationally renowned case is perhaps that of Nigerian activist Ken Saro-Wiwa. Ken was famously framed and then executed for his attempts to protect the lands of the Ogoni people and obtain some financial redress for their suffering at the hands of oil giants.

And then there's agro-business. In *Big Business, Poor Peoples: The Impact of Transnational Corporations on the World's Poor*, John Madeley sets out how TNCs, such as Cargill and Monsanto, are threatening sustainable agriculture in developing coun-

tries.[4] Their weapons include genetically modified crops, mono-cropping, herbicides and other funky-sounding but lethal chemicals. One particularly stunning case is that of a Texas-based company called RiceTec, which has taken out a patent on an aromatic rice variety grown in the US and labelled 'Basmati'. Hang on a minute, isn't that what Indian and Pakistani farmers have been growing for centuries? As Madeley stresses, these farmers have suddenly got to start worrying about whether their crop varieties will end up in the hands of corporations far away.

How about that for a bit of real 'violence' (and that's just for starters)? What's more, TNCs are extremely reluctant to defend the injustices they commit in the pursuit of profit, beyond trotting out free-market platitudes about 'constructive engagement' and 'economic development'. At least the black bloc operating at the N30 (30 November, 1999) protest against the World Trade Organisation (WTO) meeting in Seattle had the decency to issue a communiqué explaining its actions:

> After N30, people will never see a shop window or a hammer the same way again. Along with the broken windows are the broken spells cast by a corporate hegemony to lull us into forgetfulness of all the violence committed in the name of private property rights and of all the potential of a society without them. Broken windows can be boarded up and replaced but the shattering of assumptions will hopefully persist for some time.[5]

I know who scares me most.

AT LEAST THEY HAD A GOOD TIME

I've attended lots of meetings at which activists have talked about the N30 events in almost reverential tones. Seattle has assumed a kind of legendary status among participants and

non-participants alike. It worked because protestors managed to join up the dots, both in theory and in practice. The successful attempt to shut down the third ministerial meeting of the WTO, intended as a launch pad for a new round of global free-trade talks (imaginatively dubbed the Millennium Round), was a tangible demonstration of the growing power of international anti-corporate politics. With access to the conference centre blocked by thousands of grooving demonstrators, and delegates from developing countries pissed off about their inferior representation within the organisation, the stuffed shirts had no choice but to scuttle home with their laptops between their legs.

Seattle stood out for several reasons. Firstly, it brought together a large number of activists (some estimate as many as 100,000) with different political backgrounds, from environmentalists and anarchists to labour and human rights campaigners. They made the trip from across the first, third, fourth and any other worlds you might have heard of. Secondly, its message was in no way reformist (liberal Anita Roddick-style crap), but more along the lines of 'burn it, motherfucker'. Gulp. And finally, it was even well organised – based on a loose coalition of independently formed groups that volunteered to undertake certain tasks and came together every night to discuss developments through a spokescouncil of representatives. Sure, it wasn't perfect, but it was a good shot at the kind of democratic, non-hierarchical decision-making that gives globocrats non-profit-making nightmares.

Even the *Economist* magazine, bible of the TNCs, was reduced to lambasting its own übermensch: 'it is hard to say which was worse – watching the militant dunces parade their ignorance through the streets of Seattle, or listening to their lame-brained governments respond to the "arguments". No, take that back, the second was worse. At least the rioters had a good time.'[6] Ignoring the obvious stuff about militant dunces, the magazine had a point: many demonstrations these days are also about having a laugh. In the same way as our politicians chortle at their colleagues' fart jokes while pushing through

more cretinous legislation, many anti-corporate activists like to have a giggle while trying to trip up the New World Order.

The credit for this 'get out on OUR streets and party' approach to demos goes mainly to British ecological and political movement Reclaim the Streets (RTS). The first RTS public party was held in Camden, London, in 1995. It featured loud music and dancing. It featured ravers pissed off by the British Government's attempt to quash their dance parties with the 1994 Criminal Justice Act, anti-road protestors and other activists. It was a new way of expressing frustration with the modern-day corporate state. It was free, funky and quickly found to be an effective method of blockading traffic, conference centres and police. Which is why RTS-style organising spread so quickly around the world, becoming a common feature of the international direct action days that have proliferated over the last three years or so. As part of N30, street parties and protests took place in more than seventy cities worldwide – not that you'd have guessed from the mass media coverage. Even the tooled-up legions of robo-cops with their random tear-gassing, beating and arresting didn't spoil the fun and games entirely. One protestor summed it all up neatly in a message posted on a Seattle cinema: 'THANKS WTO. IT'S BEEN A RIOT'.

DO WE WANT A FUTURE OR NOT?

International resistance network Peoples' Global Action (PGA) held its first official gathering in Geneva in February 1998. Three hundred delegates from seventy-one countries attended, including bods from Earth First! and Reclaim the Streets, anti-nuclear campaigners, trade unionists from Korea, French farmers, and representatives of various indigenous peoples. The aim was to form 'a global instrument for communication and coordination for all those fighting against the destruction of humanity and the planet by the global market, while building up local alternatives and people power'.[7] Rooted in the 1994 Zapatista uprising in Southern Mexico, the plan

for PGA was cooked up by activists from ten social move-
ments, many based in the South.

The first clutch of actions coordinated by PGA were held
over four days in May 1998, targeting the G8 summit in
Birmingham, UK, and the second ministerial meeting of the
WTO in Geneva. And in spring 1999, an 'Inter-Continental
Caravan' of around four hundred farmers and activists from
the South set off in buses on a tour around twelve countries.
Their aim was to share experiences and create links with local
activists, as well as to target Monsanto and other TNCs with
direct action. The trip culminated in Cologne on 18 June,
where the G8 summit was taking place. 'Carnivals against cap-
ital' were organised in financial centres around the world
'aimed at the heart of the global economy'.[8]

The City of London got a large piece of the action. The
London Metal Exchange was paint-bombed and Tower Bridge
and London Bridge were blockaded and festooned with ban-
ners boasting messages such as 'Life Before Profit'. A 'Critical
Mass' bike ride stopped the traffic and individual companies
were targeted for their involvement in animal rights abuses or
arms exporting. The London International Financial Futures
Exchange (LIFFE) had some of its entrances bricked off and
others smashed open. One participant described the scene: 'I
ran into the LIFFE building, smashed a few mirrors in the
foyer and then looked around to see this masked-up figure light
a distress flare and hurl it up the escalators towards the offices.
Fuck, I thought, this is *really* full on.'[9] Not surprisingly, at this
stage, the cops got heavy-handed and started to drive protes-
tors out of the City. As one participant put it: 'The "J18
Carnival" was over, but for sure, a new mood of resistance is
rising.'[10]

PGA's success in mobilising anti-corporate protestors from
both the North and the South reflected its call to action: 'Our
resistance will be as transnational as capital!'.[11] What else if the
battle is to be won against the TNCs and the international
organisations that baby-sit them? Faced with the growing
power of this elite, un-elected and more-or-less unaccountable
global 'government', activists have realised they've got to

indulge in economies of scale too. And it's not too difficult to motivate people when TNCs have done such a fine job of running around the world in search of the cheapest, most submissive labour forces, boasting about their huge profits. Now we all know what they're up to.

But the reality of what's going on out there is messy and complex. There are a huge number of groups and movements that would describe themselves, at least partially, as anti-corporate. And this diversity is confusing. The 'movement', as it is sometimes referred to, doesn't have rules and regulations, it doesn't have a formal structure or leaders, and it doesn't have a list of members or a manifesto. That, of course, is the point. But it has left many outsiders wondering exactly who the hell these people are and what it is they really want.

Academic and anti-corporate activist Amory Starr has made a damned good stab at sorting out the stew into three 'modes' of anti-corporate 'ideology'.[12] Under 'contestation and reform', she groups peace and human rights movements – people who basically think it's up to governments to rein in the naughty TNCs and slap their collective ass. The second category – dubbed 'globalisation from below' – consists of movements that think they can go one better than existing government bodies. They're busy trying to develop popular internationalist movements, and include environmental and labour dudes, anti-free traders and the Zapatistas, among others. The third group – generally dedicated to a process called 'delinking' – is made up of anarchists, small business proponents, and sustainable development and sovereignty movements. According to Starr, these people are working towards 'a radical restructuring of the globalised political economy', which involves localities getting off the global market bandwagon and more or less going it alone.

It's the 'delinkers' that have cooked up the most concrete alternatives to corporatised life as we know it. These alternatives might take the form of cooperatives, workers' collectives, farmers' marketplaces or local currency systems that use non-monetary forms of trading and payment. And they tend to be built around the principles that local communities should sup-

ply most of their local needs using local resources, while retaining the right to self-government.[13] But, despite all the demonstrations and alternatives already in existence, it seems that there's still no comprehensive, global vision for dismantling the current world order and moving towards a more equitable and sustainable system. Aha, trumpet the critics, doesn't all this talk about global strategies directly contradict the movement's principles – all that stuff about keeping things local and the rest? In an answer to that, many anti-corporate activists are quick to point out that they're not against all forms of globalisation – only those that impoverish people and restrict choice. And, as the PGA organisers realised, when it comes to fighting global capital, only global resistance will do.

Early in 2000, it offered this advice to its supporters: 'The future has probably never been so uncertain, yet it is such moments of crisis, when everything is in disarray and disorder, that change is most likely to occur . . . One thing is certain, the future will be what we make of it, and there seems to be a very simple decision to be made, do we want a future or not?'[15] A simple question maybe, but one to which a global response is still in the process of being formulated.

A WORLD GONE MAD

The stakes were raised at the EU summit held in Gothenburg, Sweden, in June 2001, and then again at the G8 summit in Genoa, Italy, a month later. By guns. By the Swedish police wounding a demonstrator with live ammunition, and the Italian carabinieri shooting dead twenty-three-year-old protestor Carlo Giuliani. During the G8 summit, more than 200,000 people took to Genoa's streets to expose the anti-democratic farce of leaders from eight of the world's richest nations sheltering behind concrete barricades and steel fences, defended by armed police. Before and during the summit, the Italian government, led by arch-capitalist media tycoon Silvio Berlusconi, tried to hermetically seal Genoa by cutting transport links. But activists managed to get there. The irony of

'Fortress G8' was only enhanced by TV pictures of police using water cannons to hose protestors off the fences round the 'Red Zone' in which the leaders and their entourages were holed up, together with the world's entire supply of Ferrero Rocher chocolates. And then there was the tear gas, the batons, the vans driven at full tilt down narrow streets full of protestors, and the live ammo.

Someone was bound to get killed sooner or later. The shooting at Gothenburg, where police weren't even required to use rubber bullets or water cannons before resorting to the hard stuff, suggested that so-called 'democratic' European governments had shifted up a gear in the level of state violence they were prepared to perpetrate. Just a few weeks earlier, arriving home knackered after being detained by British police in central London for several hours at the Mayday protest, I had switched on the TV. I saw Philippine protestors being shot at by the army as they demonstrated in front of the presidential palace in support of deposed president Joseph Estrada. At least one died. OK, so Estrada may have been a dodgy geezer, but I remember thinking that politics was a different ball-game in many other parts of the world. We, here in Europe, were lucky. For sure, that day the British cops had tried their usual tricks: using Section 60 to squeeze names and addresses out of people, taking pictures and detaining us for breach of the peace and property damage that hadn't taken place (well, not until after they'd wound everyone up). But at least we didn't get shot for going out on the streets.

Fast forward a couple of months to Giuliani's death. It blasted away any final threads of 'democratic' legitimacy clinging to the cash-bloated apparatus of our 'elected' leaders. Sure, we all know politicians lie when they bang on about representing 'the people'. UK Prime Minister Tony Blair, for example, was re-elected by only a quarter of the nation's voters in June 2001. But, in public at least, we expect them to make a show of sticking to the rules. Unarmed civilians do get shot and beaten up on a regular basis, but it's usually presented as an accident that can be blamed on the victim; something they deserved. At Genoa, the spin didn't work.

After the brutal police raid on the Genoa Social Forum headquarters, in which peaceful protestors were beaten to a pulp in their sleeping bags, even the corporate-controlled media started to make critical noises about the behaviour of the Italian police. So a few top carabinieri bods were 'transferred' and Berlusconi launched an investigation into the police violence. Tony Blair will be remembered for moaning that 'the world has gone mad' because the media coverage of Genoa had, in his view, been skewed ten to one in favour of the 'riots and protests' instead of 'the issues that matter', such as world trade and Africa. He really didn't get it, did he? Furthermore, his government, which didn't even bother trying to contact injured and detained protestors until a couple of days after the events, was left looking like a bunch of nasty heavies.

Among activists, the debate about violence escalated. Licking their wounds (literally) in the wake of Genoa, many protestors embarked on a bout of soul-searching. The black bloc put out a statement saying it didn't condone the trashing of small shops and cars. But that had happened, and sometimes at the hands of people who appeared to be part of the group. There was much speculation about police infiltration, backed up by photographic and video evidence – some of it even shown on Italian television. It was suggested that, as a tactic, 'black bloc' could be modified; why not switch to white, or even blue? The police might then show up wearing the wrong colour.

Others started to question the effectiveness of following leaders from one meeting to the next – what's now known as 'summit hopping'. The pros? It draws attention to what's going on behind closed doors in smoke-filled rooms: there must be something horribly wrong if huge numbers of people make huge amounts of noise outside every time. It highlights important issues and campaigns. And counter summits are often held alongside the meetings, at which activists get the chance to exchange ideas and build links. But there are also drawbacks, including the cost of attending meetings and the potential for violence to top the agenda (which not all would regard as a bad

thing). Oh yes, and nowadays there's the likelihood of getting injured or even killed.

Politicians may help protestors solve this dilemma. The annual World Bank Development Conference set for Barcelona in June 2001 was moved to the internet. Suggestions for future gatherings include ships, military bases, and a 'made-for-leaders' fortress. The world has certainly gone mad, but not quite in the way Tony Blair envisaged.

BLACK BLOC AS THE NEW . . . ER . . . BLACK

The behaviour of governments, international institutions and TNCs in the face of anti-corporate protest implies that they have at least been forced to take note of what the shouting is all about. In a speech made in October 2000, WTO Director General Mike Moore acknowledged that 'many people dislike the fact that seemingly impersonal forces hold sway over their lives . . . And there is a widespread distrust of the profit motive . . .'[16] Clever boy! But he made it quite clear what he thought of those who dare to turn these abstract fears into action, stressing: 'We must not allow the zealots and self-serving privileged people to discredit liberalism among the wider public.' That comment left little doubt about the real meaning of his apparently conciliatory tone at the end of the speech: 'Of course, we need to put our case better. We also need to listen to our critics more. They are not always wrong.' For that, read: 'We've made a bit of a public relations fuck-up. If we want to put the silencers on the people that don't like us, we've got to look as if we're tuning in and doing a bit of what they want. Piece of piss, really.' Otherwise known as co-opting.

In reality, it's business as usual. The WTO is busy hatching plans for the next round of talks, and negotiations on the international liberalisation of services (the General Agreement on Trade in Services) proceed apace. Little or nothing has been done to curb the power of TNCs around the world. But to make sure it stays that way, companies have realised they need a strategy to fight anti-corporate protestors. And,

surprise, surprise, they're commissioning consultants to help them do it.

Communications analyst Denise Deegan recommends that companies should 'learn to think like their "enemies" before engaging them in negotiation'.[17] She seems to think that a bit of empathy is just about all it takes: 'Learning to manage activists involves learning about activists. If dealt with in the right manner, activists have been shown to change their approach from aggressively confrontational to cooperative. Activists often move from direct pressure to a more trusting attitude at the first sign of an organisation's willingness to negotiate.' This ridiculously simplistic assessment amounts to a gross underestimation of many activists' intelligence and determination not to let their targets off lightly. But so far corporations have been behaving as if they think this kind of approach can work.

Shell, for example, has commissioned reports on 'the movement', pretending it wants to understand protestors' agenda for some other reason than to take the sting out of them. And in the last few years, we've seen a big rise in TNC sponsorship of non-governmental organisations. This should be seen for what it is: a thinly veiled attempt to tone down criticism of big business. And even if companies can't have a direct hand in the work being done (some are made to promise they won't interfere), what the heck. It's money well spent if they can get a sneak preview of information that could impact negatively on their business. Another common tactic is to shut up critics by actually bringing them on board as staff members. The activists may be tempted by the challenge of making a difference from the inside. But once they're in, it's like pissing in the ocean. They're drowned out completely.

All this is nothing new. Companies are, in fact, using the same set of tricks they conjured up to deal with activists in the late eighties and early nineties. As Naomi Klein describes, then they responded to the call for better cultural representation for women and minority groups by co-opting the message.[18] They ingested the arguments, mixed them together and dished up the 'market masala' referred to earlier. This was an easy solu-

tion because it could be achieved through advertising – perfect because, while deflecting criticism, it could also be used to bump up sales. But this time round, it's not so simple. Anti-corporate activists are gunning for the TNCs themselves – not just for one aspect of their behaviour that can be glossed over with some clever publicity. And so far, corporations' attempts to PR their way out of trouble have been largely met with the derision they deserve.

Take the example of social and ethical auditing. In November 2000, a report by the London-based New Economics Foundation argued that companies had failed to adopt these techniques (which the NEF claims to have pioneered) for anything other than marketing purposes.[19] Only 1% of all companies listed on the London and New York stock exchanges had even bothered to complete a social report. And their half-hearted efforts were largely dismissed as 'just PR gloss with little real substance' (a comment made by more than half of UK business and financial journalists). The foundation also criticised the reports because they did not address 'the biggest sustainability issues associated with the company's activities' and ignored 'the most important facts'. And it pointed to 'huge discrepancies between what some of the leading reporting companies say compared to what they actually do'. Good old Barclays Bank was singled out as a culprit here, after promising in its social report 'to make a positive and lasting contribution to the communities in which we operate' and then closing 172 branches in rural areas. Whoops.

On the environmental side, activists are so used to companies' misleading attempts to market themselves as ecologically friendly that they've come up with a term to describe it: greenwash. Kenny Bruno, writing on the Corporate Watch website in December 2000, did a great job of exposing BP Amoco's 'Beyond Petroleum' ad campaign.[20] He pointed out that when environmental groups use the concept of 'moving beyond petroleum', it means shifting communities away from dependence on fossil fuels towards renewable energy sources. But when BP uses it, it means fudge. In its adverts, BP claimed to be 'a global leader in producing the cleanest burning fossil

fuel: Natural Gas'. Bruno explained that, while natural gas isn't of course petroleum, if leaks are added to the equation, only a slightly smaller amount of carbon dioxide is released as when producing the same amount of energy using oil. BP also bragged about its position as 'the largest producer of solar energy in the world'. True, perhaps, but Bruno pointed out how BP has achieved that position by spending $45 million to acquire the Solarex solar energy corporation – just a tiny fraction of the $26.5 billion it shelled out for Arco in order to increase its production capacity in oil.

Bruno slammed BP's attempt to re-brand itself as the 'Beyond Petroleum' company as 'perhaps the ultimate co-optation of environmentalists' language and message'. In that sense, it is deeply worrying. But it's still far from clear whether companies are going to be able to get away with this kind of blatant blagging. At this stage, their crude efforts to co-opt the agenda of their opposition seem largely ineffectual. They haven't yet managed to persuade the public that they're not doing anything wrong. And you don't have to go to a demo to find evidence of this. It's everywhere. Pop into Waterstones – *No Logo* was one of Britain's favourite Christmas presents in 2000, staying on the top-ten bestseller list for weeks. Switch on your telly and have your tonsils tickled by the clever japes of alternative comedian Mark Thomas, who's built up a dazzling career by exposing naughty companies and corrupt politicians. Or take a trip to the theatre: fellow chuckle merchant Rob Newman has played his anti-corporate gig, 'Resistance is Fertile', to packed houses at various trendy venues around Britain.

Trouble is, it's no laughing matter. The question of whether the anti-corporate movement can actually retain control over its own agenda is deadly serious. And the battle lines have already been drawn. Back in 2000, when I heard that tits-and-arse mag *Loaded* was trying to commission a piece on the Prague protests against the International Monetary Fund and the World Bank, the alarm bells started jangling. It suggested that the marketing men were no longer scared shitless by anti-corporate slogans, that maybe black bloc was about to become

the new black. A fashion: something that can be used to sell things and abandoned when it has lost its appeal.

It hasn't happened yet. But, if the TNCs get their way, it could. The corporate media have done their best to portray anti-corporate protesters as a bunch of fucked-up kids throwing bricks. And that's the simplistic level on which the TNCs are currently trying to engage with 'the enemy'. They'll tell you they understand and offer you a few sweeties, hoping you might be distracted enough to drop your brick (imaginary or real). Or they might even join in. Make out it's cool. And before you know it, they'll be telling you what shape and colour of brick to go for. Don't fall for it. Whatever they say, nice boys and girls – especially girls – don't throw bricks. Never have, never will.

NOTES

1. Naomi Klein, *No Logo*, p. 117
2. Denise Deegan, *Managing Activism*
3. Amory Starr, *Naming the Enemy: Anti-corporate movements confront globalization*, p. 214
4. John Madeley, *Big Business, Poor Peoples: The Impact of Transnational Corporations on the World's Poor*, pp. 26–47
5. N30 Black Bloc Communiqué, 4 December, 1999, 'We are Winning! The Battle of Seattle – a Personal Account'
6. *The Economist*, 'Clueless in Seattle', 2 December 1999
7. Peoples' Global Action, Bulletin 5, February 2000, p. 7
8. Ibid., p. 10
9. *Do or Die*, No. 8, p. 21
10. Peoples' Global Action, Bulletin 5, February 2000, p. 12
11. Ibid., p. 10
12. Amory Starr, *Naming the Enemy: Anti-corporate movements confront globalization*, Introduction, p. xi
13. Ibid., p. 12
14. Interview, *In These Times*, Volume 25, Nos. 1–2, p. 34
15. Peoples' Global Action, Bulletin 5, February 2000, p. 29
16. Mike Moore, Director General, World Trade Organisation, Speech made in Ottawa, Canada, 26 October, 2000

17. Denise Deegan, *Managing Activism*
18. Naomi Klein, *No Logo*, pp. 115–118
19. New Economics Foundation, 'Corporate Spin: The Troubled Teenager Years of Social Reporting', November 2000
20. Kenny Bruno, 'BP: Beyond Petroleum or Beyond Preposterous', Corporate Watch website, 14 December, 2000

Jade Fox is under deep cover.

'*In early modern Europe women were generally regarded as more disorderly than men, when they figured centrally as organisers of the violent festivities of Misrule and commonly acted as instigators of food riots in eighteenth-century England.*'

Geoffrey Pearson: *Hooligan –*
A History of Respectable Fears

Because I'm worth it

Fur Cuff

I reject:-

Your sanitised and puerile orgasm quests
Your diets for sexual health
Your slimming but smart business suit hegemony
Your depilation fetishism
Your stay-fresh panty-liner politics
Your six-pack chisel-jawed hunk consumption
Your perpetration of permanent disappointment
Your undying body fascism

I don't want:-

Your cover-mounted cleansing fluids
Your lemon-fresh dry-all-day armpit paranoia
Your 'how to surprise him' nights in
Your 'shall I shan't I?' career/baby dilemmas
Your cocktail-sipping swivel-head blonde worship
Your all-day lasting foundation smugness
Your hair and teeth roadshow
Your 'will he won't he be my hubby/have my baby' terrorism
Your babe-magnet drop-dead-gorgeous prescriptions of
 conformity
Your failure to criticise the lack of a Duchamp retrospective
Your mediocre brainwashing misery machine
Your thin and vacuous editorial policy
Your fraudulent unprincipled scaremongering
Your thinly-disguised recipes for suicide

You're 'my boyfriend thinks I look crap in swimwear'
 pathology
Your petty-minded denial of the imagination
Your lack of the marvellous, numinous and magical
Your inability to credit individuality to any male or female
 human
Your endless spew of trite bollox

Women's magazines . . .

I want your auto-erotic fatality
Your blood on my hands
Now force the hand of chance
Don't give 'em your hard-earned cash

'Free yourself from the debilitating distractions of the inauthentic world.'

Martin Heidegger, 1889–1976

You're never alone with a clone

The rise of fuckwit fiction
Debbie Barham

Single? Thirtysomething? So desperate for a ring on your finger that you'd even marry a member of the Royal Family? Calm down – there are plenty of agencies positively gagging to sign you up. Not dating agencies, obviously. Literary agencies. Thanks to the sacred cult of Bridget Jones (Peace And Cellulite Be Upon Her), millions of women are now convinced that they're exactly like you. And they're spilling their guts onto sheets of foolscap quicker than an inaugural meeting of Bulimics Anonymous. These days, every female author – and a fair few male ones, to boot – wants to be Keeping Up With Bridget Jones.

There's no denying that Bridget was a big advance for the Modern Woman. The modern woman in question was Ms H. Fielding, and the big advance was somewhere in the region of half a million quid. Not bad for someone whose heroine made a career out of chronic self-pity and abject failure to achieve 'personal goals'. Then again, it's a good thing Bridget wasn't an exact reflection of her creator's lifestyle. I can't see many Miss Averages relating to 'Helen Fielding's Diary'.

Monday (Pounds gained today: 500,000 – not v. poor. Positively rolling in it, in fact. Units of alcohol: 24. Units of *Bridget Jones* sold by Waterstones: 30,000. Calories: 1,250. Salary: 12.5M. Editor's opinion of new book – v. v. good. Public's opinion of new book – aaargh!)

9 a.m. Wake up. Argorblurryhell! Still pissed from yesterday's lunch with film producer. Bugger. Shit. Fuck.

Bollocks. Looked in thesaurus for more expletives to pad next book out. Discovered I'd used them all, except 'arse'. Arse.

9.30 a.m. Try to locate clean apparel which doesn't render self reminiscent of back of bus, or hideous Anne Widdecombe-type person. GAH! Cannot get rid of ghastly unsightly bulge in top of new boot-cut Joseph trousers. Bulge finally identified as wallet. Uuurgh! Can see huge great rolls of excess poundage spilling out of zip. Am clearly horrible, overpaid, greedy cow. Hence reason everyone hates me.

9.45 a.m. – Self-loathing thoughts today: 12. V. v. good. Should fill at least three minutes of film script.

10 a.m. – Look in mirror – disgusted to see no eight-page serialisation of new Bridget Jones book. Ring agent in panic. Agent reminds me I have exclusive deal with *Telegraph*, not *Daily Mirror*. Phew!

10.15 a.m. – Drop into Coins Coffee Shop in Notting Hill for triple-skinny half-caff no-whip Viennese Mocha Java latte macchiato with soya milk, drink-thru lid, wings, two-way dry-weave top-sheet, five Chocolate Croissants (Aaargh! Oooops!) and a quick product-placement for Coins Coffee Shop . . .

10.25 a.m. Stroll casually past bookshop. Pleased to note presence of twenty *Bridget Jones* copies in window. Disappointed to note that none of them are written by me. Make mental note to send poison pen fan letters to A. Weir, A. Jenkins, J. Green, I. Knight, J. Lloyd etc etc . . .

Yes, they're everywhere – first came Dolly the Sheep (and equally bleating); now we're witnessing the invasion of the Bridget Jones Clones. Legions of DNA-identical Singletons who can't get a shag but somehow manage to breed like herpes, infecting every bookshop from Land's End to John O'Groats.

The same scene is being played out in editors' offices nationwide. Prospective authoress tippy-toes in, clutching example of previous work (e.g. a 'What I Did In My Holiday' composition that her infant school teacher was really proud of, or something she painted in the rehab centre as part of the

therapeutic process). 'So!', leers the moneygrubbing agent, 'you're twenty-something?' Check. 'You work as a temp in a Soho PR company?' Check. 'You've got big boobs, a little black dress, all your own teeth and preferably an adolescent tragedy to reveal in post-publication interviews?' Check. 'Can you write? No, bugger that. Here's a cheque.' Check. And, within a month, her drivel has taken its place in Tesco's alongside its identical paperback siblings. All of them replete with aquamarine, lime-green and neon-pink covers and big bouncy lettering, preferably featuring a cheap cartoon of a stick-thin, tousle-haired grinning girlie in a boob tube doing something 'wacky', probably astride a Scooter, with legs akimbo, a ladder in her tights and a selection of boutique bags protruding at unlikely angles from the crook of each elbow. An optional Batman-style speech bubble reads: 'Aaaaaaargh!' or for the sake of variety, 'Gaaaaaah!'.

This is our heroine, and she is Something In The Media. She has a name ending in 'a', a Walnut Whip fixation and a conveniently alliterative surname. She exists on a staple diet of Shapers Snacks With Amusing Brand Names complemented by Too Much Tequila (or Chardonnay, after which she has a little whine) and shares a flat in either Notting Hill or Hoxton with her equally shrill, man-less mates. And despite being educated in a prestigious public school, she cannot speak English – Jemima and chums jabber incessantly in some unfeasible hybrid of *Mizz* magazine-goss-column-copy and substandard-American-sitcom-speak, as spoken nowhere else on this fucking PLANET.

They date, in rotation (or sometimes at the same time) the same succession of Unsuitable But Dashing Rogues until the nauseating Jemma J. or Mella M. or Laura L. finally settles down with the Friendly, Laconic, Labrador-Like flatmate whom we've known since page frigging one she was destined to marry because she stated categorically in the opening paragraph that, 'of course I didn't fancy Tom/Luke/Mark/Dave/Fido AT ALL!!!!'. Oh – and there's probably a death, cancer and/or miscarriage thrown in as well, just in case 'you, dear reader' might accidentally mistake this incisive piece of Swiftian social

satire for one of those crappy pappy novels that everyone else is churning out.

If only Anne Frank had been around today, she'd have been a millionairess. Once she'd pitched her magnum opus on the back of the Bridget bandwagon. 'Anne! Sweetie! You want to write a diary? Abso-LUTELY! Keep it jokey, keep it pacy, lots of shagging, mmm? Oh, and do make sure the Bloke is a real shithead, yah? He's called what? Adolf Hitler? Ooh, FAB!'

At best, this is low-cal literature: the Philadelphia Lite of fiction. At worst, it's literary Ex-Lax. Every page sees Jemima/Amanda/Freya/Victoria/Vagina/Labia/Pudenda, or whatever her miserable name is, striving to redeem another of her multiple female flaws. She waxes her legs, ladles on her L'Oreal and does unnatural things with cucumbers – like slicing them up and putting them over her eyes to improve her complexion. Even being old constitutes a personal fuck-up: sadly, Bridget's biological clock never came with a 'Snooze' button.

And she diets. Boy, does she diet! Unsuccessfully, of course. She has had more weight-loss regimes than most people have had hot dinners. 'I can actually feel the fat splurging out of my body' whines Jilted Jones, on a day when she tips the scales at a positively elephantine . . . 130 pounds. If any publications should take the blame for the recent swell in eating disorders, it's not the pages of *Vogue*, it's the pages of these infernal journals which incessantly spew out negative body-images. There is probably a medical term for their psychological purging. Bullshittia nervosa.

The real tragedy is that these atrocities sell like hot cakes (the fat-free, sugar-free, calorie-free, taste-free, Free-Self-Help-Manual-If-You-Collect-Ten-Tokens kind purchased by their protagonists). Just as light, gassy beer was advertised in the mid-nineties with the boast that 'It's Got A Widget!', so these light, gassy books are flogged on the fact that they've got a Bridget. Or at least, someone very like her.

She's even on the GCSE syllabus, for crying out loud – presumably as a dumbed-down alternative to Jane Austen. To bor-

row a Bridgetism: Ye Gods! As if the average schoolgirl didn't have enough hormonal shit to deal with during puberty without having to shoulder Bridget's pre-menopausal miseries as WELL? We're breeding a nation of thirteen-year-olds with a reading age of THIRTY-something. No doubt the pre-schoolers will soon be weaned onto her solipsistic doctrines as well. 'Where is Spot? Spot is on chin before vital date with The Man who might be The One! Aaargh! Shit! Am ugly grotesque dog-type woman doomed to end up in spinster-flat full of cats having not found Mister Right by age of three!'

Or *Janet and John* – Book One, John Dumps Janet For Not Being Able To Get Into An Age Ten Gingham Frock. Book Two, Janet Checks Into The Priory . . .' When I was that age, I was reading Nancy fucking Drew. Sure, all that sleuthing around stalking strange men late at night wasn't exactly the best role model for a nice young lady. But at least Nancy sometimes had a clue: and she was inevitably trying to pin the guilt on the Bad Guy, not on her own pitiful inadequacy.

So I'm single. I have a job in the 'meejah'. I have an insecurity complex, an email addiction and I used to have an eating disorder. I am, surely, Bridget personified? Why, then, am I not gobbling up Literature Lite the way Bridget and her cloney cronies snarf the Hob Nobs (before psychoanalysing each guilt-ridden gobful in the saloon bar of the Slag And Lettuce?) Well, for a start, I also have a life. A life which happens to revolve around activities OTHER THAN getting drunk. Yeah! There's getting stoned, for a start.

We've had the book, we've had the sequel, we've had the tossed-off rip-offs and for those of us who've not yet mastered reading, we've had the film. The real Bridgetaholics amongst us can probably get the T-shirt if we look hard enough: in a range of sizes (S, M, L, XXL and v.v.-Poor-Diet-Day, depending on how big you think your bum looks on any given occasion). These will have suitably BJ slogans: 'My Boyfriend Went On A Mini-Break And All I Got Was A Weekend Of Self-Loathing', perhaps, or maybe just the angst-ridden classic 'D & G' – Desperate and Grotesque?

Next up: Bridget Jones, the Computer Game? I can picture her now: another Lara Croft but with canapé crumbs down her silicon-enhanced cleavage and a bit of spinach accidentally stuck between her virtual teeth, smashing up unfaithful exes with a variety of appropriate weaponry (broken Bolly bottle, Wonderbra catapult, witheringly sarky retort) and getting gradually more pixillated as the game progressed. 3D-digital-surround-sound FX would enhance the action with realistic 'Gaaah!'s and 'Ye Gods!', and obviously you'd never complete the game's aim – 'to develop inner poise, lose thirteen stone and Get A Man' – because that would constitute personal success, a concept completely alien to the Bridget way of thinking. Naturally, it would be Single-Player Mode only. I'm not being cynical: this could be the breakthrough the computer games companies have been seeking in their quest to attract female buyers. And the title? A toss-up between 'Menstrual Combat' and 'Womb Raider'.

I'm sure the marketeers haven't exhausted Bridget's potential yet. For one thing, Ms Fielding and her bevy of imitators are in danger of being forced off the shelf (isn't that what Bridget always wanted?) by BJ's male counterparts. Yes girls, now your Bloke – if by some rare accident you've managed to snare one – can have a BJ every night as well, courtesy of all the introspective Neurotic Lads cashing in on the success of *Fever Pitch* and *About A Boy*. A football crowd of Nicked Hornbies and other unremittingly sensitive male specimens populate Mike Gayle's *Mister Commitment* and Tony Parsons' *Man and Boy*. Wimps to a man: they probably go on 'Ironing John' weekends and compare the size of the prosthetic strap-on stomach they wear to 'share the pregnancy experience' at pre-natal classes.

If all the Mister Commitments would only fucking get it together with their respective Miss Joneses, settle down and have Marks And Spencers 'Serves Two' Cook-Chill Broccoli Mornay together, instead of writing depressive chronicles of their failed relationships, it would spare us all a lot of tedious reading. Fuckwit Fiction isn't just undermining women, it is undermining men as well. No wonder us chicks can't find any

decent fellas: after thumbing through Nick Hornby's latest, they're all scurrying off early from the boozer to make their thrice-weekly therapy session on time. I'm not suggesting I want all men to model themselves on Roy Chubby Brown. But oh, for the days when Mister Softee was only found behind the wheel of an ice cream van. Mister Sensitive doesn't just offer to sleep on the damp patch: he IS the damp patch.

It's become a whole new literary skill: dumbing-down real novels into a format snivelling Singleton secretarial staff can digest in low-cal mouthfuls between their Prêt à Manger reduced fat Prawn-and-Pak-Choi Ciabattas. A modern form of abridgement – 'a-Bridget-ment'. The formula is simple: take one well-known classic, insert a full stop every five words if there isn't one already, add some premature ejaculations ('Aaaargh!', 'Bollocks!', 'Fuck!') and make sure you've got at least twelve recognisable brand names on every page. Even the doziest wannabe authoress can apply this technique – it's just a question of finding an original work that's not already been Bridgetted. Fielding did it with Jane Austen's *Pride and Prejudice*, Amy Jenkins with Noel Coward (plus a soupçon of Austen for good measure: starting paragraph one with 'it is a truth universally acknowledged . . . ' is surely a bit of a give-away?). You, too, can enjoy this profitable new hobby! So long as the writer of your source material is nicely deceased, it's as easy as scrawling off a log (oh, and the more cringeingly bad puns – like that one – which you can pad it out with, the easier it becomes).

Take the Bible, for instance:

Saturday (Loaves: 5. Fishes: 2. Calories: 300 (poor. split sandwiches between 5,000 so would have been less, but not humanly poss to eat tuna roll without mayo).

9 p.m. – Went down the Plague-Of-Rats And Carrot to meet best friend Jude (Iscariot). Got completely epistled as per normal. Arrrgod! (Ooops! I mean, aaargh Dad!!). Must stop turning water into wine. Moaned about Job (and Abraham, and Matthew, Mark, Luke & John – who are all writing Books, in manner of Helen Fielding).

10 p.m. – Methuzza turned up, so had long discussion about biological clock and hideous nature of being four hundred and thirtysomething.

11 p.m. – Mother rang. SO embarrassing – she is going round telling everyone she is virginal type person and claiming to have seen Holy Ghost (mental note: check out Holy Ghost dress in Selfridges, & see if it conceals cellulite making self less reminiscent of Mr Blobby . . .). Sunday (cigarettes: 50. Miles on exercise bike: 0 – but WAS supposed to be Day of Rest).

11 a.m. – Woke up. Felt like shit. Went to Church. Binged on red wine and wafers. Bugger.

11.15 a.m. – Went to confession. Had to wait ninety minutes for priest because bloody Bridget Jones hogging confession box . . .

Not convinced your readers will be quite mature enough to cope with the Good Book? why not 'Bram Stoker's Dracula's Diary'?

Number of times looked in mirror: 231. Number of times saw reflection: 0. Bugger. Am clearly Vampire. On plus side, appear to have love bite on neck.

These books aren't just a passing phenomenon, they are a genre all to themselves. Generation Ex literature; post Britfic, comes Bridget-fic. Mark my words, your local Borders will soon have a section entirely devoted to simpering Singleton scribblings. Somewhere between Self-Help, Sex Manuals, Diet Books and Autobiographies – Self-Obsessed, Helpless Fuckwit Fiction. Basket-cases by the remaindered basket-load, all of them pathetically slim volumes, but all convinced that they are literary heavyweights. Didn't these hackettes pay ANY attention in school Eng. Lit. classes? These days teachers presumably drum it into pupils at every girls' school that you must ALWAYS use words like 'good' and 'very' in place of more imaginative synonyms, and that every sentence has to end with a full stomach. I guess,

though, it's now perfectly acceptable to copy your neighbour's work.

And have these grovelling 'novelists' EVER actually met, or spoken to, a real living breathing man? Or do they just build them up, Frankenstein style, from bits hacked randomly off equally clueless rival writers' Leading Men? Their unsuitable-but-irresistible Darcies, Lorcans, Marcuses and other assorted New Cad stereotypes are all clichés, but not even clichés drawn from real life. To paraphrase the old female lament: in Literature Lite, All Men Are Bastardised. And they're still bastards: more likely to bequeath their girlfriend a bunch of neuroses than a bunch of roses.

But hey, as good old Bridge might say during one of her regular sessions freebasing Slimfast powder – lighten up! They're only books. What's my fucking problem? I'm just bitter, yeah, that I'M a young, female, single London-based journalist and nobody's offered ME a six-figure advance to write a book called *Honeymoon* with an almost painfully two-dimensional protagonist called, by some superhuman stretch of my razor-sharp imagination, Honey Moon? I'm getting broody because my biological clock is ticking relentlessly away towards the age when publishers decree me too raddled and hag-like (that age being, I believe, twenty-six) to adorn the flyleaf of my own chronically-desperate Singleton chronicle? Well yes, obviously – and all offers of such advances should be sent to me c/o this anthology's editor.

But in the same way that even the Jones Clones profess to have a 'serious side' (a mouthful of bulimia thrown in here, a subtle soupçon of paternal death there, just a hint-of-a-tint of an orgy of coke-fuelled domestic violence . . . in a jokey irreverent way, naturally) there's a deeper reason underpinning my diatribe against the diet tribe. Because what really worries me is that – 'Gaaaaah!' – normal, well-adjusted, mildly-alcoholic and occasionally angst-stricken British lasses are actually turning INTO Bridget Clones. In real life. Unable to find solace in tomes written by scary over-hyphenated Americans with titles like 'Women Are From Venus, Men Are Up Uranus' and 'Ten Ways To Love Feeling The Fear Of Fifty Too Much And Do

It Anyway For The Rest Of Your Life' (never mind the subtitle . . .) we've adopted BJ's Diary as a surrogate self-help manual.

I have friends who have convinced themselves that they CAN relate to her, despite all the evidence to the contrary. They want to walk like her (holding their tummy in to avoid all the 'flobbering flab' spilling out of their Control Top tights), talk like her (in manner of v. v. tedious thirty-something literary-giantess type with inability to employ personal pronouns), drink Chardonnay (when five years ago, they'd just have ordered a 'dry white') like her . . . just, basically, BE like her. That is why their boyfriends leave them – can you blame any guy for dumping a woman who wants nothing more between the covers than 250 pages of self-destructive witless wittering, since she's obviously far too ugly to have sex with?

Perhaps it's just something about the name 'Jones' that chimes out a death-knell for female empowerment. Miss Jones in *Rising Damp* was a frustrated spinster. Paula Jones was a woman with the face of Inflatable Ingrid from the Ann Summers shop. Catherine Zeta-Jones' biological clock was ticking so frantically she had to get hitched to a bloke almost twice her age. I know film stars like to do charity engagements for Help The Aged, but surely one needn't go as far as actually raising children with them? Sophie Rhys-Jones married the Artist Formerly Known As Prince Edward – a limp-wristed theatrical previously tipped as future Queen of England – hardly an achievement.

This whole, gender-undermining erosion of female self-worth began with one sentence. Bridget's original torrid To-Do list of New Year's Resolutions. 'Develop inner poise and authority and sense of self as woman of substance, complete without boyfriend, as best way to obtain boyfriend.'

So next January, if Helen Fielding, or any of the Jones Clones, are contemplating their aims for the next twelve months, I'd suggest they do the reverse of what I've been pledging every year since I was thirteen. Write down the following words: 'I will try . . . NOT to keep a Diary.'

Debbie Barham lives in London, where she works as a journalist and writes comedy for television. She has just finished her first novel and hopes to read another one soon.

Drag queens against breast cancer

Miss Kimberley

I launched Drag Queens against Breast Cancer in asso-
ciation with The Breast Cancer Campaign in January 2000.
The first event was held at Freedom Nightclub in London.
Pamela Goldberg, the executive director of the BCC, made a
memorable speech and there was one hell of a drag show.

I'm sure you're wondering why drag queens would be con-
cerned about breast cancer. After all, we don't have real breasts.
Some wear detachable silicone, some wear pads, some even stuff
a pair of socks in their bra. Drag queens never have implants
because they are not transsexuals – they are gay or straight men
who enjoy being flamboyant, original, creative and inventive.
They are also men who appreciate, cherish and completely
respect all women. The psychological support that I have
received from the women in my life was crucial to my sanity and
it is why I started this charity.

On my first day at high school in Michigan I turned up in a
powder-blue fitted suit. My hair changed every day, sometimes
it was purple and green, sometimes long, sometimes short. I
once put rollers in it for the Farrah look.

I made myself active because I wanted to fit in. I was in
choir, acting club, forensics club. I became vice-president of
the student council. I knew a lot of people, but deep down
inside I was alone. Just because I was a man, I did not see the
reason to do only Manly things. I did not want to play football
or join the wrestling team. I wanted to be a cheerleader.

I didn't have many guy friends so I hung out with the twins
Wanda and Rhonda Buyck, my friend Sulyn Holbrook, who
was very religious, Charlene Atkinson, who was active in

theatre and Sandy Abram, a dancer. These girls were always there to stick up for me.

My great-grandmother, Lula Shaw, was also my supporter and my best friend. A very tall woman from the South, she was a strong member of the church, with strong moral convictions. Sometimes we would sit together and I would read the Bible to her and tell her what I thought and she would listen and understand.

She always dressed respectably. I never saw her in trousers, always in a skirt or dress and always below the knees. Every Sunday she would make a big effort with hair, beautiful hats, suits and dresses, sometimes made for her by my grandmother, her daughter Velma. She would always wear a scarf and carried a handkerchief. Her make-up was minimal. She only wore powder and never any lipstick, because she was a natural beauty. At the age of ninety she passed for sixty with a smooth skin that was the envy of women her age.

Every Sunday she would look forward to cooking dinner for the whole family. She would wonder why I didn't eat so much, but I was always watching my weight so that I could fit into some skin-tight number. She knew it was not easy for me and that I felt isolated, so she did everything to make it better. Every time someone would comment on the way I dressed she would say, 'That's what kids do, he will grow out of it.' Her strong way of dealing with narrow-minded people stayed with me and made me the person I am today.

Born in Michigan, Miss Kimberley, aka Tatum O'Brian, is a performer and broadcaster working in London. Having appeared in Alberto Sciamma's Killer Tongue *(about a woman who finds herself with a ten-foot-long tongue and a compulsion to eat human flesh) Kimberley is now a TV presenter and DJ. 'Drag Queens Against Breast Cancer' can be contacted through mztatum@yahoo.com*

Meringue zizis and lost girls

The Trials of Women's Comix
Melinda Gebbie

In April 1985 I was invited by solicitors in London to attend a hearing regarding a vice raid on Knockabout Comics. I was visiting Cambridge at the time, from San Francisco. It seems an old title of mine, harking back almost ten years, was now involved in one Knockabout's semi-annual police grabs. The comic in dispute was *Fresca Zizis*. It depicted three women astride a giant green comedy penis. The title was taken from a strange-but-true graphic spot illo done several years before for a fly-by-night TV news station. This company was so low budget they couldn't afford more than one camera to cover local happenings, so instead they hired three guys and me to sit in a tiny room and draw the news as it happened.

My comic was named after an 'international' bit of reportage concerning one Italian pastry maker caught out selling obscene baked goods, replete in detail, on a Sunday. Above the meringue-topped penis was the hand-written pronouncement 'Fresca Zizis' – the Italian for 'Fresh Cocks'. Prosecution was swift, if not sensible. My comic had sold in trickles to a perplexed American audience but had never been subject to censure of any kind, to my knowledge. I was pleasantly surprised to think a comic my publisher had considered an unsaleable piece of arty wank, fit only for the French, was now about to enter the portals of Pernicious Pantheist Pulpdom – the Saturnine chamber of the Unforgiven, where it might lie for ten or eleven months or years till someone caught up with the creators and let the stuff back in again, this time sanctioned as Artistic Vision.

Arriving at Horseferry Road Courthouse, eight years after

the first publication of *Fresca Zizis*, I spied another woman from our Californian handful of Nasty Wimmen. Joyce Farmer was lighting a fag under the 'no smoking' sign. I still have a snap of her under the 'no photographs' sign. She was there for her book, *Tits and Clits*.

The first geezer on the stand was the arresting vice officer, who was not the sharpest peanut in the turd. He admitted to taking personal property from the publisher's private office, apparently unaware that he had perpetrated an illegal act. Because of this fact, our venerable (we're talking eighty years old, to look at him) magistrate let Knockabout off the hook with only a few slaps. Many titles bit the bullet that day. The judge had only been handed the material – a big stack of comics – about half an hour before the hearing itself. He had to make a decision that looked snappy to the members of his home team. He had the wrinkles. He had the moves. He had the gavel in his withered paw. He was a coiled, if rusted, spring, aching to strike.

I was unexpectedly asked to participate in the proceedings by taking the stand to defend my work. I began somewhat shakily. 'Your honour, this comic contains autobiographical material. The stories are about real people and relationships. The themes are adult. They deal with the cruelty of lovers, the excesses of youth, the states of depression and dreams in documentary form. They are meant as a form of communication about my life: a warning and a comfort to those who venture out too deep; that although my life has often been out of control, I have survived and so can others. If you find my work obscene then you must also judge the people within it to be obscene, for it is a chronicle of a life lived, not a work of the imagination.'

Thanking me for my 'well-considered comments', Judge B went on in a plummy voice to tell me that before I had spoken he had been prepared to judge *Fresca Zizis* a work of pure obscenity. 'Now, however, I shall look through the work seriously before considering judgement. Court will reconvene on Friday.' Flushed with victory, our apple-cheeked solicitor coughed up for champers all round. The following Friday all comics brought to court were summarily decreed illegal and

obscene, and all copies of my book were ordered to be burned and were from then on, illegal to possess.

How cool is that? I had only been in this country a few months and had already been judged a social pariah. This was not news to me, however. I'd been accused of two-dimensional licentiousness (dirty pictures on paper) going way back. In my snowglobe-perfect home town, aged seventeen, I had created a furore with a simple line drawing of Cupid and Psyche. 'Drawers – I did not!' read the headline in our local paper, when I was asked to defend my reason for forgetting to include well-delineated pants for Cupid for our High School Sweethearts dance poster. 'Change it or you won't be allowed in,' said the Dance Committee. A few teachers' letters championed my brave decision, including one from a fervid supply teacher who penned the following in support of my budding sexual depravity:

> *Oh rosy woman*
> *How could you know*
> *The double face of Janus*
> *Would inflect the glow*
> *Of natural desire*
> *And still the bow*
> *Of Cupid's fire.*

In 1976 the *Wimmen's Comix Collective*, which had been publishing *Wimmen's Comix* for Last Gasp Publishing in San Francisco, decided to vary the subject matter from mostly humorous autobiographical short stories to a much more radical single issue attempt. I had been involved with *Wimmen's Comix* for three years, having joined the collective from the second issue. It was just about the only comic in the underground to be produced by women in a community where the male/female cartooning ratio was sixty men to six women. Artist/writers like Justin Green (*Binky Brown Meets the Holy Virgin Mary*), Bill Griffith (*Zippy the Pinhead*), Jay Kinney (*Anarchy/Young Lust*), S. Clay Wilson (*The Checkered Demon*), Gilbert Shelton (*The Fabulous Furry Freak Brothers*) produced

rude, funny stuff. An indefatigable Robert Crumb (*Fritz the Cat*) in tandem with other artist/writers like Art Spiegelman (later of the Pulitzer Prize-winning *Maus*, a tale of Nazi atrocities told by mice about the 'katzen') produced a wonderful but short-lived anthology called *Arcade*.

In light of the many taboos being stormed by our male counterparts, we women seemed to be producing a rather sickly fare of household tales by comparison. It was a wonder *Wimmen's Comix* existed because, at that point, our publisher seemed to think he was being magnanimous by bothering to dedicate our efforts to ink at all.

There was a sexual revolution going on, and we had yet to declare ourselves to battle. As far as we knew, no pornography by women existed, so *Wet Satin* was our attempt to enter the so far one-sided fray. Clothed in mild and feminine cover, *Wet Satin* went looking for a publisher. Dennis Kitchen's Kitchen Sink Press had found a printer in the Midwest to produce *Bizarre Sex #7* – which featured a giant vulva engulfing the Empire State Building. This was a first peep at a formerly forbidden part of the female anatomy, and was the first UG comic to be sold wrapped in a white outer cover. Surprisingly the printer received an award for bravery in publishing for his efforts – and this from an American Midwest famous for its prudishness and Bible-slapping ethics.

We – Dot Butcher, Joey Epstein, Lee Marrs, Shelby Samson, Sharon Rudahl and Trina Robbins – felt that *Wet Satin* was a shoe-in. There was certainly nothing on the cover to offend: a wind-blown blonde on a skateboard scoots past a fit young Marlon Brando, eating a banana. Everyone knows you judge a book by its cover. Among titles like *Leather Nun, Amputee Love, Slow Death, Felch* and *Captain Piss Gums*, surely *Wet Satin* could be the subtle women's alternative erotic comic. After all, the brief had been to write and draw a little story based around one's most intense sex fantasy – as long as it was genuine, it was copacetic.

Joey penned '50 ways to Cleave your Lover', set to the Paul Simon lyrics but enhanced by a tinge of vengeful bloodlust. Other stories contained traces of bondage, Indian lore and a

unicorn. My contribution was *Cockpit*. It contained my then-favourite things: the French Revolution, Joan of Arc, Charenton Asylum and a melancholic sense of unreality enhanced by cruel bondage gear – all set within the confines of a *Cinderella*-style plot.

A young girl is treated badly by her stepmother and sisty uglers, and is not allowed to go to the ball because she is subject to violent and unattractive fits. Rather than waste a ball-gown on her, which would no doubt be soiled by midnight, the clan leaves her at home. At the height of the evening's festivities she arrives clad in straps, buckles (no clothes) and gains the attention of the Napoleonic elite. She is approached and bites the cock off one reveller, then shits on another. She then has a fit and is promptly hauled off to Charenton. Her new companions include the blind, the lame, the infirm, the dangerous and the elderly, all co-existing in a world of filth, pain, confusion, degradation and chaos. Amidst this, our heroine, Clara, experiences a sexual epiphany and becomes a sister of sexual mercy, attending to the penises of the needy. The only glitch is that she must not be penetrated. One inmate goes too far and Clara immediately experiences a fall from grace. Feeling spiritually sullied she is sure that she is no longer a holy vessel for the healing flame of sexual mercy and in a paroxysm of guilt and anger, drinks from a bucket of lye and expires.

I thought it was a really horny fantasy. It was certainly a genuine one. At any rate, Mr Bravery in Printing, back in Ohio, has received our complete book and is totally outraged. He deemed *Wet Satin* the most disgusting thing he had ever seen in his whole publishing career and sent it back to us in a plain brown wrapper. Last Gasp printed it by default and, as usual, the sales were minimal.

A few pornographic lithos, paintings and gallery shows later, I am now living in England. This brings me up to *Lost Girls*, begun in 1989 as an eight-page idea for a comic which failed to live. *Lost Girls* is the mutual love-child of mainstream comics veteran Alan Moore, and myself. Thought up over several consecutive brainstorming sessions, it grew and grew from

a one-shot to a monster. From my original desire to work with three female characters, Alan partnered his desire to come up with a fresh erotic idea for Peter Pan, and so made the gargantuan but beautifully simple leap to include not only Peter's and Wendy's world, but the worlds of Dorothy from Oz and Alice from Wonderland as well.

He calculated that, had the three actually met in real time, their age difference might work out quite satisfyingly. In the year 1913 Alice would be say, in her late fifties, Wendy thirty-five and Dorothy in her early twenties. The three ages of women tied up neatly in a pink bow. Next, where and how do they meet? Well, since 1914 was the starting year of the First World War, what better place than Europe? What could draw them together? Rest, relaxation, rehabilitation, perhaps? How about the beautiful surroundings of Lake Constance, near the Swiss border? A sanatorium where Alice can get away from troubling memories, Wendy can escape briefly from the confines of a loveless marriage and Dorothy can attempt to unravel a haunting secret's mighty pull.

It came together magnificently, like a chandelier lying broken and fragmented that has been drawn gracefully back up into the air, its twinkling teardrops reuniting with each tiny hook to form a tiered symphony of rainbow-fractured prisms. The hotel was designed from the meeting of Viennese modern and European Art Nouveau. Each character has a past and a function, from Rolf, the Austrian soldier, to the concierge, to Alice's mirror itself. Each character has an art style that announces her own past. Dorothy's is pale-layered crayon, always using autumn colours. Alice's childhood is dreamy, watery, using Easter colours and Wendy's is full of night shadows and shocking revelations, half hidden in the dark.

That's just a bit of the art of it. The three-volume, hardcover slipcase 250-odd-page full-colour part. The reason I'm talking about it here is because *Lost Girls* is also a pornography. From the vehicle of the White Book, found in each hotel room in a dresser drawer, to the sheer erotic infusion into everyday objects like a shoe, a pillow, a cup, a sunset-filled pond, *Lost*

Girls inhabits a world only the most sublimely optimistic dreamer could ever imagine. It is more than a pornography; more than a pretty piece of imagination. Full of cultural references, mostly made through the use of the White Book, we see the hidden side of many famous writers and artists.

With its painstaking pastiches (imagined lost writings by Wilde, Colette, or Pierre Louys; suppressed works by Schiele, Beardsley, Gerda Wegener and Frank von Bayros, *Lost Girls* is a self-referential treatise on pornography itself. In chapter ten, the three women arrive in Paris for the soon to be infamous debut of Stravinsky's *Rite of Spring*. This was an evening that would be well-documented in Parisian newspapers – not as a cultural event but a riot. Ballet had always been the most genteel of entertainments. Such confections could be depended upon to reflect the most rarefied of social sentiments. They were melodic, graceful and replete with twinkling costumes. Stravinsky, however, brought a savage, unrelenting rhythm to this arena. The subject matter was a pantheist rite centred around the sacrifice of a beautiful and terrified virgin.

I photographed a faithfully choreographed and costumed performance of the ballet from television. From over a hundred shots I put the central story together into a split-screen panel and set up the stage performance. I covered the top two-thirds of the page with the dancers and the bottom panel to show the audience from the stage, including Dorothy, Wendy and Alice in the plush red seats.

As the music began its hammer-like staccato beat, the audience found themselves rising in a trance. Some fled the theatre, screaming as they pushed and shoved their way out. Fights broke out between the maddened theatre lovers. One newspaper reported that a man in an almost hypnotic rage began pounding the bald head of the gentleman seated in front of him in time to the music. Surrounded by absolute pandemonium, the girls become erotically enmeshed in the strange, turgid nuances of the music and its effect on the audience. Entangled in the absolute protection of darkness and utter chaos, they are free to express their highly charged response to it all in a lavish display of lovemaking. Thus ends the first third of the book.

Going from the illegal in literature to the mainstream, our next port of call is *Tomorrow Stories* and a character devised, once more, by myself and Alan Moore. *Cobweb* hit the stands about a year ago. Her most arresting feature is that beneath her transparent lilac frock there seems to be no visible means of protection from either the passing zephyr or the goggling eyeball. Cobweb's MO is more elastic than Plastic Man. She has appeared in many guises: a crime-fighter, a child-detective, a space explorer, jungle girl and even a surrealist woman formed purely in collage à la Max Ernst.

In each eight-page story, Cobweb enters a different style, era and idiom. Out of nine stories so far produced, seven have not been censored. The most extreme case resulted in Cobweb's being thrown out of *Tomorrow Stories #8*. The story, 'Brighter Than You Think', was based on biographical material partially reprinted in *Fortean Times* concerning the life of Jack Whiteside Parsons. Parsons, in his short and breathtaking life as a rocket scientist and practising occultist, had a brief but dramatic friendship with the then science-fiction writer L. Ron Hubbard, who famously went on to found Scientology – a favourite cult of Hollywood folk. It is an organisation fond of litigation. Suffice it to say that our story harmlessly dramatized episodes involving Hubbard and Parsons' family that Hubbard did not like.

In order to avoid court costs, DC Comics sold 'Brighter Than You Think' to Top Shelf Comics for a dollar. They later discovered their company had previously published their own version of Parsons' life anyway. Cobweb's more laughable censure concerned the display of nude steel engravings in naughty poses which, in the end, got covered in steel-engraved butterflies. And all because the lady loves to draw smut. It's not like it's a field everyone else is aching to get involved in. Since England first began to have gallery shows there have been only about three devoted to the realm of the sexual imagination, even though vulgar sods like Hogarth were immensely popular among the hoi poloi. A couple of hundred years on and the incendiary becomes the palatable. I'm not worried. I've never really courted fame, the bitch of notoriety. I've only ever drawn and painted the subjects that bring joy to my life.

It seems that for every truly creative act there's an overwhelming response by people so terrified of the burden of their own humanity that someone capable of inner dialogue with their deepest self appears to be some kind of Devil. My Uncle Bud once told me he thought it was a shame that I had to draw dirty pictures for a living. Must tell you, dear Uncle, it beats the fuck out of engineering!

Melinda Gebbie lives in a three-sided folly constructed in the shape of a corset, which is finished in ruby glass panels. She has been producing pornographic stories and art for a quarter of a century, both in America and Britain. Earlier titles such as Young Lust, Anarchy Comix, Wimmen's Comix, Wet Satin, Slow Death *and* Fresca Zizis, *were published in San Francisco.* The Seven Ages of Women *and* 1963, Tomorrow Stories *and* Lost Girls *were produced in Britain.*

Looking good

No one knows the stubble I've seen

The Politics of Fur
Jessica Kinsinger

OK, let's break this down:
GOOD REASONS TO SHAVE:
1. Because you want to.
GOOD REASONS NOT TO SHAVE:
1. Because you don't want to.
Got it? OK, let's go further:
BAD REASONS TO MAKE *ANY* CHOICE ABOUT
HOW TO/NOT TO GROOM YOUR OWN BODY:
1. Because it's expected.
2. Because it's what your friends do/don't do.
3. Because your significant other likes it (unless you are *truly truly truly* OK with the decision, then it's all right. I have nothing against pleasing significant others, as long as you don't go against your own comforts to do it).
4. Because people will think you're weird otherwise.
5. Because you're afraid to be different/the same.
6. Because you just never thought about the possibility that you could do something different.

I'm sure there are many more. Are you getting my point here? Do what *you* want to do. Like shaving? Then have fun! If you truly like having shaved legs and/or underarms, then don't let anyone tell you that's wrong. Don't let anyone tell you that you can't be a feminist if you shave, or any other such nonsense. Shaving/not shaving is a personal grooming decision, not a political decision.

Don't like shaving? Then don't! It'll be OK, I promise. You won't turn into King Kong. I haven't shaved my legs in years,

and no one has mistaken me for a gorilla and tried to hit me with a tranquilliser dart. If you stop shaving your legs, the hair may be thick and prickly at first, but it'll get softer as it gets longer. The hair on my legs is long and silky; I love how it feels.

And as for the underarms – I realise that this can be a more difficult decision. I didn't stop shaving my underarms until over a year after I stopped shaving my legs. When I stopped shaving my legs, it was cold turkey: I just stopped. But with my underarms, I stopped gradually, getting used to how the hair felt as it grew in a little at a time. But now that I've stopped fully, I'm very comfortable with how it looks and feels. You won't be more sweaty and stinky, really. Just keep clean like you did before, and you probably won't even notice a change (I say 'probably' because everyone's body is different, and I can't speak for sure about anyone's experience but mine).

I don't like shaving (except occasionally my head!). I never did. I don't like accidentally cutting myself, I don't like getting rashes from my skin being stripped dry by the razor blade, and I don't like the little icky bumpy growth things that are sometimes caused by shaving under your arms. Ick Ick Ick. I just don't like anything about shaving.

I do like running my hands over my legs and feeling the soft hair. I like looking in the mirror and seeing myself as a full-grown woman with all of those spiffy secondary-sex characteristics in place.

Yes, I do think that shaving is a concept that was created to make women look like prepubescents, and no I don't like the implications of that. And yes, I do think that being fuzzy can be a good statement about women having power over their own bodies.

BUT the fact is that a political agenda is not a good reason to make decisions about your body. This is your body, this is where you live, the one thing that is really and truly yours. If you're the world's strongest feminist and you just plain like how your legs feel when they're smooth then shave, for crying out loud!

It isn't shaving itself that feminists should have a problem with, it's the *expectation* of shaving. All women shouldn't

feel as if they have to shave to be attractive. It should be an option, not an expectation. It shouldn't matter what choice you make, as long as it's because it's what *you* want.

Have I made my point? OK . . . then go out and throw all your razors away! Or . . . go out and buy some spiffy new razors and have a shaving party! Do whatever the hell you want! I don't care! Just be happy!

Jessica Kinsinger lives in Tennessee with one wife and two cats. She slings coffee for a living at a local coffee house, and is currently working on a degree in software programming. She would be very appreciative if you were to visit her website: http://www.jessworks.org

Scat: is it all filth?

Life Beyond the Bidet
Annabel Chong

'I cannot believe I have to deal with this shit,' the strip club manager groaned, and I shrugged. I was working for a week in Philadelphia as a feature performer under my *nom de guerre*, Annabel Chong, when a problem cropped up at the private dance booth. In this case, the shit that the manager had to deal with was literal: a customer of mine evacuated his bowels so that he could ingest them in front of me. Now the manager had to deal with the unenviable task of cleaning it up. 'Shit happens,' I offered, philosophically. 'Plus he gave me a huge tip.'

That incident could have been dismissed as the occupational hazard of being a stripper, but something about it continued to haunt me. It was not so much the depravity of the act, but the expression on the man's face when he got down on his knees and started gobbling up his steaming waste: he looked grateful. More importantly, there was a childlike solemnity about his gratitude that completely unnerved me. It was as if he existed in a parallel universe whereby my presence at his moment of humiliation could be conceived of as a gift of kindness, an act of emotional closeness. When my client came back to visit me the second time, I gave him my e-mail address.

Over a period of two years he sent me photographs of his anus in various stages of defecation as well as lurid accounts of shitting on and being shat on by various men and women. His accounts intrigued me because they seemed to exist in a hermetic universe that bore a disturbing resemblance to the logic inherent to what most people term as 'straight' sex.

I searched my mind for a point of entry into his world. I admit to being experienced in matters sexual but I do not

profess to have much knowledge regarding faecal eroticism apart from a few messy accidents during anal sex. During those incidents, the anal penetration is the focus of my fantasy, whereas the shit is merely an inconvenient by-product. I had to turn to literature to better understand the head space occupied by my client.

One of the better-known literary discourses on scatology and eroticism to date can be found in Milan Kundera's *Unbearable Lightness of Being*. In this book, Kundera cites theologian Erigena's assertion that it was only after the Fall that Man found shit repellent, speculating that, '. . . immediately after his introduction to disgust, he was introduced to excitement. Without shit (in the literal and figurative senses of the word), there would be no sexual love as we know it, accompanied by pounding heart and blinded senses.' He further implied that there is a relationship between the humiliation of defecation and sexual arousal when describing a female character's fantasy of her lover seating her on the toilet to watch her void her bowels.

William Burroughs takes scatological eroticism in a different direction by positing it as an emission that takes on an almost phallic property. In *Naked Lunch*, defecation is almost an exclusively male activity. The women in the book are either terminally constipated or have their anal passages occluded through disease. Shitting usually accompanies ejaculation, an explosion of genital and anal impulses. There is also a heavy overtone of egocentricity: 'Naked Mr America, burning frantic with self bone love screams out: "My asshole confounds the Louvre! I fart ambrosia and shit pure gold turds! My cock spurts soft diamonds in the morning sunlight!" To the homosexual Burroughs, the projectile act of defecation is conceived as a male prerogative, the assertion of phallic power over the gaping maw of the woman's cunt.

Georges Bataille lyrically calls the anus 'the bronze eye', the end point of the Cartesian Pineal eye, whereby the pristine constructs of human consciousness reveal themselves to be no more than the ecstasy of death and decay. In his essay 'The Pineal Eye', he revels at the image of 'an idiotic ape in his cage

and a little girl (who blushes at seeing him take a crap) to sud-
denly discover the fleeing phantoms, whose obscene sniggers
have just charged a rear end as shocking as the sun'. Bataille
sees the anus as a vehicle of liberation from the phallocentric
prison of Cartesian logic. In analysing Salvador Dali's painting
'The Lugubrious Game', he focussed on the shit-smeared bot-
tom of the man on the right hand corner of the painting, relat-
ing his emasculation with 'a new and real virility' that is being
'rediscovered by this person in ignominy and horror them-
selves'.

All these literary discourses were enlightening only so far as
to elucidate the roots of scatological eroticism. The lyricism
ascribed to the coprophilic urge was a far cry from the banal-
ity of the photos that were sent to me by my shit-loving client.
His images were more akin to pornography: a bald representa-
tion of physical acts made lurid by virtue of their clinical atten-
tion to detail.

A tour of the scat-sites on the internet revealed that he was
not alone in his revelry. Titles like 'Shitlove', 'Scatlover', and
my absolute favourite: 'The NYC Poop & Pee Club' feature
pictures of various men and women playing with their bodily
wastes. These include close-up shots of women munching shit
out of distended male buttholes, and vice versa. The images
function as visual one-liners, designed to deliver sexual satis-
faction in the most efficient manner by a reductivist condensa-
tion of various scatological fantasies.

A casual survey of the images reveals several sub-genres
within the sub-genre of scat porn. There are solo shots of men
and women pooping, many of them with a strong voyeuristic
flavour. The appeal of these images relates most strongly to the
fact that excretion is very much a highly private activity in most
civilised societies. After all we have been brought up to believe
that our shit is disgusting, and we should hide ourselves behind
closed doors, so as not to impose our bodily functions upon
others. There is thus a perverse thrill in witnessing this social
taboo, or performing it for an audience, for the former involves
a serious invasion of privacy, while the latter involves leaving
one's dirty little secret wide open to scrutiny.

The next category consists of people shitting and smearing their shit on their partners. Some of the pictures depict a free-for-all orgy, and remind me of some perverse form of regression therapy. Are we not taught as infants not to play with our faeces? What could be more infantile than wallowing in one's own waste, joyfully handling it like it was nothing more than chocolate-coloured Play Dough?

Other photographs depict defecation and shit-smearing as a means of humiliating and punishing one's partner. One particularly startling shot shows three men squatting over a woman, brown boluses hanging between their legs, like pendulous cocks belonging to large farm animals. I thought of a Burroughsian (albeit heterosexual) discourse on the phallic nature of male projectiles. Could shitting on somebody and smearing one's dung over one's partner's bodies be an act of territorial marking, in the manner of leopards and civets? In the case of us humans, the domination of one's partner is tied inexorably to our disgust with our bodily functions. It reminded me of the time when this very submissive fan of mine e-mailed me to request that I defecate onto a copy of the *Wall Street Journal* and post it to him so that he could smear it all over his body and know that I am the boss. (For the record, I turned him down.)

The last category of pictures shows the consumption of human faeces. Within this category there are two sub-genres, and they pertain to the style of shit consumption. Some people are apparently more into treating shit consumption as a gastronomical experience, much like the way we would perceive an evening at Le Cirque or Spago. The Germans call the faeces 'caviar', and the ritual surrounding their consumption would be akin to a black-tie event. The couple would be dressed formally, awaiting the waiter or the waitress to excrete the delicious turd onto a nice plate.

I had never seen a 'caviar' video before, and was fascinated by the sight of a well-dressed German couple working on their plates of faeces with forks and knives to the strains of classical music. It was like a scene from *Satyricon*, only better, because it trumps the Romans in the decadence stakes: shit eating is

merely another sensory experience, meant to titillate and amuse. Underlying the shit-consumption is a dialogue about class, the scatological equivalent of the upper classes engaging in 'rough trade'. In this genre, the people producing the shit almost always come from the 'lower' classes: waitresses, cooks, busboys.

The other style of shit consumption is the polar opposite of the former: the shit is given its due as the basest form of human produce, and the demeanour of its consumers reflects the animalistic nature of the act. The shit is not disguised as an entrée – it is allowed to exist in all its sordid glory: a hot steaming pile of human turd. The people are often shown eating it on their knees, like animals, suggesting a sort of degradation role-play. Although the photos do not give exact narrative details, one could almost fill in the blanks: 'You dirty little bitch, you just shat all over the floor. Now get down on your knees and clean up the mess with your potty mouth!'

Further trawling of the internet reveals that the genre of scat porn is sufficiently popular to produce its own superstars. These girls have their own websites specialising in scat pictures and videos, offering merchandise and 'shitty kisses'.

Alexia Cage, a twenty-three-year-old French porn star, seems to be the reigning queen of the genre. Chat rooms buzz with gossip about her exploits, and fans have written in to express outrage that she did a scat video when she was pregnant, because of the risks that she is taking with her unborn child. Other fans have written in to defend her decision, and the degree of vehemence with which they express their views are quite remarkable.

Amidst this debate, a burning question popped into my mind: all these fans are talking about her exploits as if they were real. What if some of the action is actually fake? After all, porn is all about simulacra: the representation of pleasure through a collage of cliché signifiers and low-rent camera trickery. I speak from my own experience, having lost count of the number of times I screeched melodramatically to loosely applied nipple-clamps in bondage videos. I read in Barbara Love's *Encyclopaedia of Unusual Sexual Practices* that, very

often, minced beef and barbecue sauce are used to simulate shit. The mixture is then introduced into the rectum via an enema pump. This would probably explain why the faeces in some of these scat photos tend to be on the runny side.

Porn requires the viewer to engage in the suspension of disbelief, in order to preserve intact the thin edifice of their fantasy. (To a scat lover, the idea of a woman eating minced beef is probably significantly less appealing, as it is a sight one could easily witness at your local diner.) The irony here is that in pornography, shit – which is the ultimate sign of the body's authenticity and abjection – is reduced to a simulacrum, an astringent performance of authenticity for the purposes of commerce.

Mario Vargas Lhosa's book *In Praise of Stepmother* describes the male protagonist, lost in reverie, recalling the minutiae of his beloved's body: '. . . the joyous cracking of a fart, the gargle and yawn of her vagina, or the languid stretching of her serpentine intestine'. It alludes to an individual withdrawing from the social realm in order to inhabit the cloistered world of the body. It was a poignant passage for me, in the context of the technological age we are living in, where our gadgets of communication serve to buffer us from having raw contact with the outside world. Within our wonderfully synthetic environment, it is easy to imagine that we, too, are machines – clean, efficient, streamlined and white. While many of us choose to march towards the bearable brightness of being, there are those who choose to retreat into the brown universe, the universe of ardour, intimacy and filth.

This brings me back to my client, and the appeal that shit holds to his psyche and the distress I felt when faced with his obsession. I think that my reaction goes beyond my basic squeamishness . . . it is about intimacy. Shitting is the most private and socially unacceptable bodily function. By voiding his bowels in front of me, he was putting himself in a vulnerable position: not only was he risking possible recrimination, he was risking rejection. He is saying: 'Here is my dirty little secret, and I would like to share it with you.' It was an intimacy I was not prepared to deal with; a tender revelation of the

unacceptable horror of the human body in all its messiness and mortality.

Annabel Chong lives in Los Angeles where she works as a writer under her real name, Grace Quek. She became a porn star after an altercation with her feminist theory professor in college, and is best-known for her record-setting video, in which she had sex with 251 men in ten hours. This was followed by a documentary about her life entitled, Sex: The Annabel Chong Story.

Belly magazine

Where Fat Chicks are Cool
Jenny Blythe

Fat is a dirty word. Be black, be gay, be disabled, and society will defend you, and your rights; be fat and you're on your own. From emaciated catwalk models to chick-lit heroines obsessed with the size of their bottoms, thin is in. Thin is seen as the ideal; anorexics are told how good they're looking and we've even got to the point where not having enough body fat to support a growing child is becoming a major problem for pregnant women. Fat is out, so much so that even to be a few pounds over the 'ideal' weight is seen as a major problem.

People are fat, though – plenty of people. And not all of them want to be thin, whatever the media might have to say on the subject. Girls like Jodie Kidd may be held up as the perfect female image by the fashion industry, but most men like their women a little more meaty. Some men like their women a lot more meaty, and some women *are* more meaty.

This is where *Belly* magazine comes in. Their tag line is 'where fat chicks are cool', and they mean it. There are no excuses in *Belly*; no diets, no sob stories about girls 'battling' against fat, no rubbish about how there is supposed to be a thin person struggling to get out of every fat one. In *Belly*, to be fat is to be cool, big, out and proud. Big girls are celebrated; big, fat girls, and not timid, embarrassed, tear-streaked wretches, but proud, confident, sexual women.

Belly is the creation of thirty-something media studies graduate Ricky Wells, who I met in his Islington offices. The magazine was launched in 1998, but its origins go back to the early nineties, when ginger-haired Ricky helped his then girlfriend – twenty-one stone Creamy Claire – set up 'Planet Big Girl'. This

was a monthly club, held in Leicester Square and designed for big women and men who like big women. It was a great success from the start, with transvestite maids, wonderfully outrageous costumes and men – more men than you could shake a stick at. 'Planet Big Girl' eventually lost its edge, but by then Ricky was the main (average-sized) man in a crowd of big, gorgeous women. He founded the magazine. What else could he do?

Since then, *Belly* has gone through four issues, featuring over fifty girls of between fourteen and thirty-five stone. These are not paid models, but unpaid amateurs, and Ricky has never had difficulty in finding suitable girls to pose. The content is pornographic, unashamedly so, but it is more than that. For one thing, the girls are allowed to wear as much or as little clothing as they feel comfortable with. The style is intimate, cheeky and friendly, never misogynist and abusive. In fact, a good way to answer the criticisms of those who claim that all pornography exploits women would be to send them a copy of *Belly*.

The photoshoots and stories make up the bulk of the magazine. Both are erotic, designed primarily to arouse, but *Belly* also has a more serious side. Most of the letters received deal with the fat issue, either praising the magazine for its forthright stance or discussing individual experiences of being fat or of liking fat girls. There are also factual articles, mainly contributed by female writers, covering topics such as big women on the internet, the appeal of stretch marks, (or tiger stripes), and the big girl scene in Mexico. Finally, there are Ricky's own editorial articles, which promote and explain his philosophy.

Belly also supports a website, *www.belly.co.uk*, provides a contact service and holds parties. As you'd expect, these parties are not quiet affairs. The last was sponsored by Cuervo Tequila, which was provided free, in syringes wielded by the Belly girls themselves. Half-naked girls danced on tables, men were smothered deep in cleavages, and most of the guests left not only in pairs, but even in threesomes.

It's at parties and through the contact service that it is possible to get an idea of the sort of men who read *Belly* and who

like fat girls. Yes, there is a proportion of inadequate people who simply see fat girls as an easy target, but only a small proportion. The average age of *Belly* readers is just over thirty, while a good half are black men, who seem to appreciate big girls. They are also not scared to admit it – or less often, anyway – which is presumably a cultural thing.

Men in general are often scared to admit to liking big girls in just the same way that bisexual men are often scared to explore their homosexual side, and for just the same reasons. For a man to tell his friends he fancies fat girls is a confession, and invites ridicule. More than one of the *Belly* girls I spoke to had been involved in affairs with men married to slim wives, and in every case it was the girl's size the men were fascinated with. Men who like big girls, chubby chasers, have to come out, and it can be an experience no less traumatic than coming out as gay.

So what is sex like for big girls, or with a big girl? The first myth to dispel is that big girls are sexually inhibited or lazy. Neither is true. The attitudes to sex I found among the *Belly* girls reminded me more of swinging and sadomasochistic scenes than of mainstream culture. 'Lie back and think of England' and 'I'm too sexy to bother with what you want' were quite definitely not on the menu. Instead, fat girls, or at least *Belly* girls, like threesomes, bisexuality, spanking, bondage and all sorts of other kinky games.

I was surprised at how common bisexuality is among big girls, and at how comfortable they are with this. Most of the girls I spoke to had enjoyed more than one lesbian experience, and several regularly visited lesbian bars and clubs. One comment I heard frequently was that very feminine lesbians, more often than not slim, enjoyed being mothered by big women, especially those who are also tall and powerfully built. The same applies to those who enjoy sadomasochistic relationships, which again is much more common than among the general population. True, *Belly* girls may not be perfectly representative of fat women, but this does not destroy the reality of their sex lives being far better and far more diverse than would ever be admitted in the mainstream media.

It is true that sex acts are not so easy for big girls. A quick knee trembler with the girl against a wall and her legs wrapped around the man's hips is not so easy when the girl weighs thirty stone. Missionary position can be awkward, too, especially if both parties are fat. So yes, some, a few, sexual pleasures are denied to fat girls. On the other hand, this is not only true for fat girls; for instance, a girl with very small breasts can't fold her lover's cock between them. Also, some pleasures are very definitely best with fat girls, as any man, or women, who enjoys being smothered in breast flesh or beneath a bottom will testify.

Perhaps the most outspoken of the *Belly* girls was Cleo, who appeared as one of the models in the *Bellenium* issue and also in her own photoshoot and the big girls from outer space feature. Cleo is tall at 5' 9" but, at twenty-one stone, fairly average in weight for a *Belly* girl. Speaking to her, my immediate impressions were of intelligence, strength of personality and above all, sheer fun.

Cleo appeared fully nude in *Belly*, by her own choice and has no problem at all with this decision. She likes her body, she is proud of her body, and if she has a problem with her size it is that many people will not accept that she knows her own mind and is happy the way she is. This is a common feature in our society, the assumption that nobody likes fat girls, least of all the fat girls themselves. Cleo illustrated this with an example of a phone-in on the Richard and Judy show. A woman rang, depressed because she was fourteen stone and her husband had had seven affairs in a few years. The advice she was given was to diet in an effort to win back her husband's love, advice that had Cleo grinding her teeth in rage. My reaction was the same. I mean, for God's sake, the guy's obviously a compulsive cheat! Get rid of the bastard, claim half his property in the settlement and get yourself another man, girl!

Another pet hate of Cleo's is the attitude of most pornography to big women. In common with anything else other than skinny, silicone-breasted blondes, the subject of being aroused by images of fat girls tends to be treated in a crude and misogynist way. Sexy big girls are 'fat slags' or 'hasty lard-ass

bitches', as if it is wrong for a big girl to be a sexual person, and that men who enjoy big girls are somehow 'weird'. The attitude of *Belly* is different, which is why Cleo chose to pose for Ricky.

Cleo is very pretty, which must help, but she has never been short of male attention. Even as a teenager, she was pursued by the local 'Mr Perfect'. On accepting a date, however, she found him so boring that she declined another, to the astonishment and envy of her friends. Since then, she has had no difficulty in finding eager partners, both men and women. Being confident helps as well, while her only complaint was that her size and obvious power tends to draw rather submissive men, while her true preference is to be sexually dominated.

On being a fat girl in the modern world, she has found that her size has occasionally led to her being discriminated against when applying for jobs. There is an assumption that fat girls are lazy, or that they will lack the energy to do a job properly. Cleo works as a nanny, and as anyone who has looked after four small children will testify, the job takes a good deal more energy than most. Now that she has established a reputation for herself, she is in high demand.

For big girls, fat is usually an important issue in relationships, be it positive or negative. The experience of another *Belly* girl, Alice, shows that this is not always the case. She met her current partner on a blind date, and he had no idea of her size – 5' 8" and twenty-two stone – before they met. He was a little taken aback at first, but quickly came to appreciate her and they have been together ever since.

What *Belly* is not is a militant magazine. There are the occasional jokes about force-feeding skinny models with cream buns, but this is tongue in cheek. Ricky and his team wish to promote the joys of big girls, not to politicise the issue or to be antagonistic towards those with other preferences. In fact his attitude towards the culture of thinness is best summed up by a quote – 'Skinny is boring, skinny is ugly, I'm just not interested.' In practice, the idea of antagonism between fat and thin people exists mostly in the media.

The one high profile incident involving the *Belly* girls was Creamy Claire's protest outside Stringfellows after Peter

Stringfellow supposedly said he didn't want fat people in his club. This allegation was false, but the *News of the World* reported it and pictures were duly published of Claire and others waving banners outside the doors of Stringfellows, protesting about his discrimination against fat people, and fat girls in particular. What actually happened was that the *News of the World* reported Peter Stringfellow's comments and then rang Claire to see if she wanted to protest. She didn't, but changed her mind when money was offered, got some friends together, turned up and was duly photographed, waving a placard made in the *News of the World*'s art department. Stringfellow, who Claire knew anyway, then invited her and her friends into the club's VIP lounge for champagne.

Jenny Blythe is the co-author of the Good Web Guide to Sex. *She lives in London, is active in the SM scene and was involved in Planet Big Girl. She has also modelled clothes for larger women in publications including* The Sun, Marie Claire *and* Eva.

Tight trouser times

A study by Professor Stephen Gray of Nottingham Trent University of more than 2,000 men in the UK found that 50% were squeezing into trousers that were a size too small. But only one in ten admit to always wearing their trousers too tight – and few are really aware of how their bodies really look.

Prof. Gray scanned 3D images of ten male volunteers to show them how they really looked. Only four correctly identified their own image, and only two women picked out their partner's scanned image.

He said, 'Men tend to stand in front of the mirror and pull in their stomachs, and then think they look OK. For the same reason, they will squeeze into trousers which are too small because they don't want to admit that they've put on weight. But wearing trousers too small often means they are worn under the gut, and that only exacerbates their stomachs.'

The survey of 2,100 men, conducted for the bread manufacturer Nimble, found that 45% of men thought they were slightly or very overweight. More than a third said they hated their stomach more than any other part of their body.

'Thin is in – and I don't want to change that.'
Alexandra Shulman, editor of *Vogue*

'Beauty is the simple thing, ugliness the extraordinary one, and all ardent imaginations probably always prefer the extraordinary thing in lust to the simple one. Beauty and freshness are never striking but in a simple sense; ugliness and degradation deliver a much more solid blow; the turmoil is more vigorous, hence the excitement more keen.'

Marquis de Sade

I spy

Abigail Lane

'Michael Jackson Sets his Sights on Einstein's Eyes' reads the headline from a newspaper clipping I took a couple of years back. It is commonly known that the brain of the famous father of relativity was removed during his post-mortem in 1955, carefully sliced and distributed among fellow scientists, presumably in the optimistic hope that the mysteries of genius might reveal themselves through its analysis. However, it was a well-kept secret that his eyes were prised from their sockets during this performance and quietly slipped into a small jar. These treasures were then stored in a bank vault by Dr Abrams, Einstein's personal ophthalmologist. "When you look into his eyes, you're looking into the beauties and mysteries of the world," he drools. What with Einstein being famous for his almost transcendent theories on light bending from the stars, I can't help but smile at the irony that, of all the eyes in the world, his lay fixed, lifeless and gazing into the darkness of a bank vault.

As if this story didn't already embody a delicious charisma beyond itself when, after forty years these strange relics were released from their prison and put up for auction, the perfect footnote has to be that it is Michael Jackson, pop's very own Frankensteinian superstar, who is waiting to acquire the gems for his collection of oddities. They say that eyes – the tangible organs through which the outside world is deciphered by way of light – are the windows to the soul, and certainly the word 'vision' may transcend its literal meaning in a spiritual sense. Both the jewels in the crown and the stars in the night, eyes drink from the outside world so that the imagination may be fuelled.

'Looking through Gary Gilmore's Eyes' was a song by the Adverts in the late seventies, which alluded to the possible metaphorical implications of seeing the world through a murderer's eyes. (Gilmore's eyes, and his other organs, were donated for transplant after his eventual execution.) Indeed, serious study has been conducted in the past as to the possibility that the retina might retain the ghost impression of its last sight. If this were true a murderer might be caught guilty, photographed and trapped in the glassy pupil of his victim. Wishful thinking, I guess. Yet, these romantic superstitions are as understandable as they are ridiculous and funny. To dwell on such shadows is ancient and is essential to the contemplation of body and soul, life and death.

Abigail Lane is an artist living in London. Having trained at Goldsmiths College, she helped to organise the 1988 'Freeze' exhibition that launched a generation of 'Young British Artists'. This excerpt (written as part of a 'Complete Arthole' project with Paul Fryer), refers to a sculpture made of glass eyes and brass wire which she exhibited at the Serpentine Gallery show, 'Some Went Mad, Some Ran Away'.

What to wear in a war zone

Battle dress
Janine di Giovanni

In the summer of 1993, my friend Ariane Quentier and I made several important discoveries. We were living together in the Holiday Inn in Sarajevo, sharing an office on the fifth floor, and it was damn hot. There was no water in the hotel in those days, so the important thing was to stay as cool as possible. One day, Ariane took an aid flight to Split on the Dalmatian coast for the weekend and came back not only tanned from the beach near the Hotel Split, but clutching a handful of little flowery dresses that she had bought at the market. These would become her – and my – staple wardrobe that summer. 'Twenty deutsche marks,' she said proudly, stripping off her Levi's and T-shirt and unlacing her boots. 'Winter's over. It's summer time and I'm tired of looking like a man.'

I knew what she meant. For the past five months I had lived in a too-short pair of jeans from Gap, Timberland boots, and layers of wool. I was no longer sure what my skin looked like: because, for two memorable months in the winter, I had slept and lived in the same clothes because it was too cold to take them off. When I finally did remove them to wash in a bucket of some icy water, the top layer of my dermis peeled off with my long underwear. Baths and showers were non-existent. We bathed when we got to Split or Zagreb, or Kisilijak in Central Bosnia – otherwise you might get lucky and scrounge a container of water from the kitchen.

Ariane was a French radio reporter and my best friend. We had been born one day and one year apart and had similar fiery, stubborn Latin temperaments, but physically, we were very different. She was small and voluptuous and everything

about her was done in extremes; she spoke in machine-gun rapido sentences and bantered non-stop. She drove a huge armoured car of which she was extremely proud and she sat in the driver seat with a cigarette glued to her lips. She did not suffer fools gladly, but if you were lucky enough to be tolerated by her, you had a true and loyal friend for life. She was a person who feared nothing and who could drink more whiskey than any man. She also sprayed herself liberally with Guerlain before pouring herself into her flak jacket. She was loved and feared by her fellow hacks, but whether they liked her or not, they respected her.

We were both mercenary, and we bonded because she had the office space in the Holiday Inn and I had the satellite phone. Before that I am sure she did not like me. But, that summer in Sarajevo, we were the only girls – as we thought of ourselves – and we knew we needed each other, to borrow soap and shampoo and things like that. We also discovered we had a lot in common. We both had long-time boyfriends with whom we lived, and of whom we had grown tired but dependent upon. We had both come from 'good' conservative families and got pearl necklaces on our sixteenth birthdays, but both of us were adventurers who wanted exciting and demanding lives. That summer in Sarajevo we got it. I will not write about the sad events of that besieged city. This is more personal.

'This dress really makes a difference,' Ariane said with wonder one day, coming back from the airport, where, for no reason at all, she had suddenly been let into the French soldiers' commissary – formerly off-limits to journalists – to buy cheap cigarettes and stock up on whiskey. I was having similar reactions with my one little dress. For months, Alma, the Bosnian girl who worked in the Reuters office, had been bugging me about my appearance. 'Why do you always look as if you are going for a hike in the mountains?' she said. 'Put on some make-up for God's sake. Don't you care what men think of you?'

She had a point. The female hacks, like me, tended to dress for warmth not glamour. Make-up was out of the question unless you were one of those blow-dried vapid American

TV reporters. I barely dragged a brush through my hair: in fact I did not *own* a brush. In contrast, the Bosnian girls made a huge effort, despite the lack of water, to look beautiful. They wore make-up. They artfully worked their dirty hair into elaborate coiffures. They wore their tightest and skimpiest clothes. Perhaps that is why male journalists fell in love with and married Bosnian girls while they did not fall in love with or marry Western female reporters.

I went to Split and came back with two dresses and a pair of flat sneakers to replace my Timberlands. The mortars were still falling and the snipers were still out on the hills, but it felt liberating to be out of my filthy jeans and heavy socks. The first day I wore my favourite dress from the market – very simple, high-necked, blue with little white flowers, to the knee – Alma looked at me and winked. 'Now you look OK,' she said, then turned back to her heavily sugared coffee and Game Boy. It wasn't provocative; it was just feminine – something I had not felt for a long time. It felt great.

Shortly after that Ariane and I went to the French base to interview some military brass. Waiting for our appointment, one French officer struck up a conversation with us, and casually told us that the French had *showers* on their base (in those days, all conversations eventually got around to showers). 'With water?' I said incredulously. Water and Sarajevo was an oxymoron. 'Yes,' the officer said, looking at me oddly. 'Why? Do you need one?'

Ariane and I exchanged sly glances. From that day on we had showers every other day. She would stand guard while I took mine; I would watch while she took hers. I do not think you can imagine how good it felt to run a bar of soap over skin that had not felt a blast of hot water for months.

With the new clean hair and the new dresses – which, by the way, were perfectly respectable, not even short – new opportunities unfolded. We were the last journalists to interview an elusive war lord before he got assassinated. A Bosnian commander who would never see us suddenly agreed to take us up to Zuc, a strategic front line hill that was preventing Sarajevo from being completely run over by Serbs. Even the

unpleasant guards at the airport checkpoint became more amenable. The nastiest soldier, the one who always sneered and turned us back to Sarajevo and had frightening hairy hands, came over and took my palm in his fuzzy one.

'Will you marry me and have seven Serb babies?' he said. He was serious. I didn't even have to answer him. He stamped our passports and let us through to get to the road to Pale. 'I don't believe it was that easy,' I said. 'It's the dress,' Ariane replied.

So, that was the summer of the Dress. It meant something to me and I learned a lesson. Women who do the work that Ariane and I do still, work in a man's world. There are some women, like my colleague Ann Leslie, who believe that being feminine can work to an advantage. 'It does no harm at a checkpoint to shake your bangles at them and pretend to be a bird brain,' she once told me. I admire Leslie tremendously, for her ability as a reporter, but also as a woman who wears a fur coat, full make-up and false eyelashes in a war zone and doesn't give a damn what other people think.

The other end of the stick, unfortunately, are my female colleagues who lack any humour or charm. Knowing full well that they work in a male environment they tend, unknowingly, to act and look like men. Therefore their resentment and distaste for the likes of Ariane and me, who celebrate being women (as well as being very good reporters and hard working) is vast.

I will never forget being in East Timor last year. One of my colleagues who had not seen a bath for some time asked me where I was going. 'To have a drink with the Brigadier,' I said. I had been invited, with several other reporters, to meet the most powerful British soldier in the area. 'Oh,' she said snidely. 'I haven't been asked. *But then again, I don't have long hair.*' 'Oh, give me a fucking break,' I said. 'I don't have long hair either.'

It wasn't that long in those days, but I knew what she was trying to say. I couldn't decide if I was hurt or if I found it ridiculous. It reminded me of the first time I met my other best friend, Connie, when I was four. Her mother brought her over

to meet me on the beach. 'This is Janine,' her mother said, pushing the little girl forward. 'You're going to kindergarten together in September.' Connie had stripey blonde hair razed à la Mia Farrow in *Rosemary's Baby*, which was all the rage then. She stared at me in my striped bathing suit, digging in the sand with a shovel. 'Oh,' she said. 'You have long hair.' Then she walked off.

A long time ago, when I was younger and less experienced, I cared what people thought. To a large extent it was Ariane who taught me not to. 'Why do you give a shit what these people say?' she asked when I told her the long hair story. 'You're controversial. You will always be controversial. You're a woman, you're not ugly, you do good work and you win awards. People are jealous. So what's the problem?'

I don't think of myself as controversial, but I don't think I will deliberately put a bag over my head when I go to work. Why should I? At the same time I don't look like a Russian hooker. Anyone who doesn't believe me should see photographs of me in Chechnya on top of a Russian tank swathed in so many layers of wool that I look like a Michelin man.

I will never forget the words of one of my snootier colleagues. 'I don't have to wear Chanel to prove I'm a good reporter,' she sniffed, as though it is a crime to wear perfume. I don't wear Chanel to prove that I'm a good reporter either, but if I did wear it, I would probably wear it simply because I liked it.

Janine di Giovanni is Special Correspondent for The Times. *She has worked as a war correspondent for ten years, covering the struggles in Bosnia, Rwanda, Zaire, East Timor, Sierra Leone, Israel and Kosovo. She has won the Foreign Reporter of the Year Award (from* What the Papers Say*), two Amnesty International Awards and the* National Magazine *Award for Excellence in Reporting. Her books include* Against the Stranger, *about the Palestinian conflict and* The Quick and the Dead: Under Siege in Sarajevo.

Bra News

Triumph International Japan has launched a new product. Constructed from silver fabric with a row of coloured lights across the bust line, the Armageddon Bra has a sensor and a 'control box' which will warn the wearer of dangerous objects falling from the sky. The lingerie company has announced that this garment marks the dawn of a 'generation of bras designed for a world where castastrophes can strike at any moment'.

Oh Rose, where art thou?

What becomes a legend most?
Jessica Berens

We in the fashion department are wondering why Mrs Rose West has not obtained the customary iconic status that befits an evil woman.

Her maniacal cruelty should have inspired a legion of profitable products yet she has failed dismally to capture the public imagination. She is one of the most demented serial-killers in criminal history, but she has not been honoured by global demonisation. We in the fashion department have been forced to conclude that the reason for this lies in one sad fact: Mrs Rose West is very badly dressed.

An amoral woman must be a gorgeous woman whether she is Eve or Catwoman or Bonnie Parker. The *femme fatale* who lurks in the shadows must show all the radiance of youth and loveliness when the headlights of the police car finally illuminate her features. She must be aware of the demands of fashion, for her cause can suffer no support without the benefit of a sense of style. To sum up, the female serial-killer must have design intelligence!

But Mrs West has never heard that essential phrase 'dress to kill'. She refuses to take loungewear seriously and she knows *rien* about age defence renewal serums or colour fusion eyeshadows. She is plain and stupid and frumpy and she is not wearing Gucci. So she is ignored.

If Rose had been blessed with a girlish figure and clothes that reflected the new directions from Paris, her story would be very different. If Rose's features had received advice from the Estée Lauder counter and her hair had been sleek with product, prestige would have been hers. If she had realised that

accessories can make or break a look, or if she had been able to carry off the new Chanel ra-ra skirt, everyone would have wanted to photograph her and visit her and attend her court. She would have ascended to the heights of glorification where all words of wisdom are hallowed by headlines and where relics go over the net for thousands of pounds.

It is not difficult to comply with design trends in order to enjoy broad appeal. It only requires an open mind and an open wallet. Practical flexibility and groomed finesse are both possible; it is simply a matter of finding a few key pieces and tailoring the silhouette to maintain the stylish refinement that is now expected of any woman living in the public eye.

Mrs West could easily have adopted the chic monochrome palette that did so much for Myra Hindley.

The fashion rules are simple. All the female serial-killer needs is a capsule wardrobe of ultra-modern classics. Dark colours are essential for those forced to work by cover of night, while methodical dismemberment requires comfort and mobility. Any season's leather collection fulfils these functions – leather provides streamlined ease of movement as well as the sensual glamour so well understood by the house of Versace who merit a mention because they have paid £15,000 to feature on the page opposite this one.

The secret is attention to detail. Le Sac parfait, for instance, would be a leather wrist bag from the Chanel boutique, available in a range of stunning colours and large enough to carry a concealed weapon. Jewellery should be under-stated, though it is worth noting that Chaumet's gold cocktail rings spice up any outfit as well as making an attractive knuckle-duster. A purposeful Max Mara cashmere coat (that eternal classic!) teamed with a structured trouser suit from the Burberry Prorsum collection forms an ideal ensemble for burials in the woods.

In a profession where underwear is as important as outerwear because of the possibility of a strip search, the murderess could do worse than opt for the reasonably-priced Dolce and Gabbana 'Intimo' range where balcony bras and stunning zebra prints guarantee an up-to-the-minute look. Hosiery

should be high quality, both soft and sheer, as it may have to be worn over the face as well as on the leg.

A silk scarf is an ideal trans-season accessory and doubles up beautifully as a gag, while a Dries van Noten belt will always be a stylish ligature.

And finally, for running away? There is nothing prettier than an Emma Hope kitten heel.

Jessica Berens is wearing a Laura Ashley cardie.

Dynamo hum

Bullets for broads

Happiness is a warm gun
Katharine Gates

I have a fetish for guns. Hunting rifles, sniper rifles, assault rifles, shotguns, revolvers, semi-automatic handguns – you name it, I own a weapon in almost every style and calibre. It's a rainbow family of perfect precision machines, each with their own distinct personality, their own unique flavour. The time I spend with them, cleaning them, oiling them, breaking them down and reassembling them, adjusting their accuracy, filing their triggers, customising them just so, makes me feel so fulfilled, so DAMNED happy.

My guns aren't just for looks. Shooting is my favorite sport. On occasion, I've hunted cute little furry animals such as groundhogs and rabbits. I've also killed cute big furry animals like deer. (Yes, girls, I murdered Thumper and Bambi. I cleaned, skinned, cooked and ate them, too.) Hunting wasn't a very pleasant experience, though . . . it's not something I'd do again soon. It's the gun itself – not the damage it does – that interests me. My preferred victims are made of paper. At gun shows, you can buy targets representing Mafiosi, 1950s G-Men, gang members, even Saddam Hussein. I once set myself up a complete training course in the woods behind my house. I painted myself up in jungle camouflage, played Wagner's *Song of the Valkyrie* at top volume on my boombox and ran among the trees screaming and shooting at televisions, road signs, beer bottles, and the occasional plush toy stuffed with blood-red Karo syrup. For special fun, I'll buy custom ammunition for my twelve-gauge shotgun. Some rounds turn your weapon into a flame-thrower and others are filled with tiny sharp flechettes that will flay the bark right off a tree. Sometimes I suspect that

I need to do this as an adult because I wasn't allowed to play cops and robbers when I was a little girl.

My husband knows that the fastest route to getting me sexually aroused is to suggest that my guns need cleaning. He doesn't love guns the way I do, but he knows that simply feeling the cold weight of a Beretta 9mm in my hand or smelling the aroma of Hoppes No. 9 gun-cleaning fluid will get me in the mood. My pupils dilate, I sweat and I flush all over. At the shooting range, what gets me going is the feeling of tension as I slowly squeeze the trigger, the build-up of intensity as I wait for the explosion that I know will come. I want it but it terrifies me. It scares the shit out of me, but I need to do it. If something is stressing me out, shooting will calm me down faster than any form of meditation. (Actually, it IS a form of meditation. You've got to breathe, focus, and relax. No incense or chanting necessary.) When it finally comes, the BANG gives me a sense of full-body release as good as any orgasm. Don't get me wrong, I love sex in many of its more conventional forms, but shooting guns is like sex taken to eleven.

It's hard enough to talk frankly about sex without freaking someone out, but talking about guns – without either condemning them as morally-loaded symbols of human evil or defending them as unassailable symbols of freedom – is sure to get me in trouble. When I tell most people I have a gun fetish, they recoil in horror. If they're liberals, they'll generally assume I'm either a sociopath or a wild-eyed right-winger, or both. (Not so. I'm a rather ordinary, stable, middle-class, married woman. Politically, I'm significantly left of centre.) Even pro-gun activists tend to squirm at my combination of sex and guns . . . most are conservative males who also rail against pornography, assertive female sexuality and feminism. By exploring the sexual symbolism of guns, I might just give them a bad reputation.

The weird thing is, I live in a culture with a serious gun fetish. Guns have ceased to be simply man-made machines, albeit some of our oldest and most deadly ones; they have attained a talismanic, almost sexual status. Popular films are filled with loving close-ups of weaponry, slo-mo 'cum shots' of

bullets blasting from barrels, ripping into flesh and making deep, wet wounds. We pay our nine-and-a-half bucks to be aroused and titillated by gunpowder explosions, the bigger the better. Advertising, the fashion industry, and mass media know that guns are sexy. They use the imagery of guns to grab our full and immediate attention and to sell products.

It's ironic that we Americans find it relatively easy to accept our love of violence in entertainment, but we deem overt sexuality – especially anything deviating from the 'norm' – to be too dangerous. Europeans find it bizarre that America places few limits on violence in television but unfailingly censors nudity and sex. Just as in the classic definition of fetishism, we've transposed genital sexuality onto non-sexual objects. Unfortunately, most people aren't conscious of this mechanism and end up victims of their own ignorance. The violence of our sexual repression has come to express itself in an eroticism of violence.

In the American gun fixation, guns are coded as strictly part of the male domain – they represent exclusively male sexuality, male aggression. Over the last ten years, guns have come to bear the burden of embodying two conflicting mythologies of manhood. The first is a romantic narrative of the rugged (male) individual feeding his family, competing against nature and defending himself from animals and the animalistic evils within mankind. Noble man against nature and animals. The second is an apocalyptic drama in which innocent women and children are victims of (male) brutality. The animal within man against women and children. To pro-gun folks like Charlton Heston, the gun is the embodiment of American manhood, a sacred tool that must never be severed from its owner. To the radically anti-gun folk, the gun is also a phallic symbol, though in this case it represents the evil phallus that penetrates and rapes – one that must be castrated at all costs. Am I the only person who finds this funny?

Of course, the most visible enemies of both guns and pornography have so far been women, the most fanatical of whom insist that guns and porn have only one purpose, only one result: violence against innocent women and children. In

this ethos, both guns and porn possess an almost supernatural capacity to unleash man's inner animal nature. To see guns themselves as evil – rather than the folks who misuse them – has become a religious catechism. Guns and porn are black magic that can bewitch men (never women), incite them to rape, lust, murder, and destruction of families. To possess a gun or porn is tantamount to worshipping the Devil, the priapic pre-Christian horned God. Eradicating porn (or guns, or penises) will stop the evil that men do. It's one of our oldest and most disturbing forms of magical thinking: we project our darkest desires onto objects or people outside of ourselves – and then destroy them. It's the 21st century version of the Crusades.

In this context, the concept of women with guns, women who call themselves gun fetishists, women who get off sexually by shooting guns, is one that pushes all of our collective buttons. It contradicts both mythologies of the gun. Women aren't supposed to use weapons, aren't supposed to be aggressively sexual, aren't supposed to possess that tooth-and-claw urge to life and death. They're also not supposed to be independent and intelligent manipulators of technology. Whereas some cultures worship a powerful, sexually ravenous woman (think of the Hindu goddess Kali), it just won't fit into our American psyche. If a woman acts like that, she must want to be a man; she must have penis envy.

It would be way too easy to dismiss my fascination for guns as evidence of penis envy. Frankly, I'd much rather have a gun than a cock. Guns are more reliable. (Actually, I have a delightfully masculine husband, so in many ways I get to have both!) Sure, guns are phallic symbols – that's part of the fun after all – but they're so much more than that. They're tools for summoning the invisible forces around us. When I handle them, I become a high priestess of speed, power and precision. Through my weapons I worship the forces of nature: through discipline and skill I master my animal urges, I respectfully tame my own tooth-and-claw animal self. I am an animal, but I'm an animal possessing technology. I love my weapons as finely-honed tools, beautiful magical machines. They're

designed to call up this ancient, prehistoric sense of awe, with their matte-black surfaces so reminiscent of stone flint tools and the charcoal of long-ago campfires. I believe it's this primal quality of guns, their brutal dark efficiency, their call to our wilder selves, that makes some people hate them so.

Given our national gun obsession, you might imagine that there would be much more gun erotica, but that simply isn't the case. There exists a long soft-core tradition of women with weapons, though it seems to be primarily a phenomenon of the 1960s, seventies and eighties. I've got a small collection of pin-ups from the 1950s showing nude cowgirls fondling six-shooters, and the occasional Bonnie Parker 'bad girl' with a machine gun. Russ Meyer's busty gun-toting vixens are a thing of the past. You used to be able to send away for hilariously camp videos of bikini-clad babes shooting full-auto weapons in the desert. (I always figured the guys who bought these videos had a serious gun fetish. But if they got a stiffie watching the video they could always claim it was because of the jiggling breasts and not the guns. No one wants to feel like a sexual deviant.) The ads usually showed up in magazines like *Soldier of Fortune*, but they're hard to find now.

Something seems to have changed in the last ten years. I've looked for fetish websites about women and guns. The handful that I did find – *chicksandguns.com*, *guns-and-babes.com*, and the like – were created by male pop culture fans to share stills and clips from movies. Some of their favourite images are the same as mine: the wiry and capable Linda Hamilton in *Terminator 2*, the ferocious warrior Sigourney Weaver in *Aliens*. But these sites never mention sex, desire, arousal, or fetishism. The intense level of obsession and focus would seem to indicate a certain amount of erotic energy, but it's either suppressed or denied. I've also found a few websites created by female gun owners who support a woman's right to bear arms and defend themselves against rape. Good, serious talk, but nothing sexual. I suspect those women might be offended by this essay, might feel that it trivialises the issue by bringing up sex. But the sexual undercurrent of gun worship/hatred in this country is far from trivial.

To many people, a woman with a gun is a deeply threatening notion . . . it just doesn't make sense, so they'll do anything to twist the image to fit into a more conventional scenario. Dian Hanson, editor and publisher of the commercial foot fetish magazine *Leg Show*, told me that she has to be very careful about using photographs of women with weapons in her magazine because readers might think that she's promoting violence *against* women. How could one possibly interpret a woman holding a weapon as an invitation to rape? Dian once featured a cover shot of a *Road Warrior*-type babe brandishing a shotgun. *Leg Show* received two letters from self-described 'pacifist' male readers critiquing her implied association between sex and violence. This in a magazine that regularly shows women in stiletto heels cruelly stomping on men's penises.

In May of 2000 – the same month as the Million Mom March – *Penthouse* magazine published a 12-page photo spread of 'Nikita', a tough-but-gorgeous model expertly wielding a selection of gigantic handguns. (This is a surprisingly rare occurrence in commercial porn. The Meese Commission on pornography made the combination of guns and penetration a bustable offence and most publishers and distributors have steered clear of it.) According to editor Peter Bloch, *Penthouse* magazine received several letters of complaint. Most came from lawyers for gun manufacturers 'outraged' that their clients' products would be used for such nefarious sexual purposes. Oddly, I've never heard of gun manufacturers writing letters to Hollywood complaining about how their products are used in scenes of graphic violence. In fact, I understand that gun manufacturers routinely give action stars' prop men free weapons in the hopes that they'll get good product placement on the big screen.

I used to think I was the only woman in the world with a gun fetish, but in the last few years I've met a handful of women who take their gun eroticism to places that never would have occurred to me . . . into the bedroom, for example. I've been pleased to find that these women are extraordinarily insightful about the nature of desire, conscious about the

difference between fantasy and reality, and knowledgeable about their own reasons for eroticising weapons. Rather than unconsciously repeating phallocentric myths, their sexual attraction to guns has everything to do with consciously – and conscientiously – manipulating popular imagery for their own pleasure. They're breaking the rules and, in the process, forging new ones.

Ilsa Strix is a professional So-Cal dominatrix who plays with weapons sexually in her private life. A lovely, feminine, bisexual woman, Ilsa has engaged in negotiated consensual sex play in which she fucked a woman with an unloaded gun. She's quite comfortable with the phallic imagery inherent in the weapon. 'It shoots, it's long, it's hard, it has something inside of it that's going to erupt. It's an archetype.' Chicks will play with dicks, and will also have a pile of fun doing so.

For Ilsa, one of the greatest pleasures of playing with weapons is her sense of accomplishment and mastery over the machine. She has become a serious shooter, regularly going to her local range for practice and training. Target shooting is hot in and of itself. 'It's an incredible full-body experience. I remember once taking this German girl to the range and she shot a few times and she said [imitating a German accent], "The sound it goes in my heart and it does not come out. I cannot do this." I said, "Oh, but that's the *cool* thing! – You get this sensation throughout your body, this vibration. And vibrations are what sex is all about anyway." '

Ilsa acknowledges that while guns can be horrible things in another context, when used non-consensually, 'At the same time, when used responsibly and when used as a fantasy material, guns are pretty amazing.' Situations that would be repulsive in reality can pack a huge sexual punch. 'The thing that is the hottest for most people is generally the thing that has the most energy attached to it, whether it's a German [Nazi] woman for a Jewish man or whether it's a gun. It titillates because it walks that line.'

Susie Bright, author of *Susie Bright's Sexwise* and *The Sexual State of the Union* explains one key to understanding gun eroticism. 'For me, the distinction between fantasy and reality is as

real as gunmetal. I've been held up and threatened for real with a gun and of course, I was in fear for my life, and it was not the least sexy or fun in ANY way, and it really shook me up long after it was over.' At the same time, she recognises that within the safety of fantasy and responsible consensual sex play, a tea-spoon of fear can be very hot. 'But I have also been very cre-ative about a lot of erotic scenarios that involve power and fear as an aphrodisiac, and I know how intoxicating that can be. I certainly don't feel traumatised by that!' Susie has never played with guns in a real-life scenario, but she could imagine doing so – as long as it's not loaded.

Carol Queen is a sex researcher, author of *Real Live Nude Girl*, and all-around sex goddess in San Francisco. To Carol, gunplay is a gender-fuck. When she was growing up, the only images of women with guns were those in which women used them for self-defence, rather than simply to assert their power. 'I appreciate the facility of weapons when a woman has to defend herself, but I also like the fact that that's not often the way they're coded when men are talking about them. It helps that women can take over some of that cultural power that is usually coded to men – either on the top or the bottom of erot-ic play.' For Carol, part of the charge comes from breaking the rules of the type of feminism she grew up with. 'It's this defiant erotic act in the context of feminism. I have no question that part of what informs my eroticism around weapons is fear of the weapons, fear of the people who are typically encoded as using the weapons and guilt around finding this erotic. I have no problem admitting to it!'

Although her personal preference is for playing with knives, Carol has given a lot of thought to gunplay. Her short story 'Silencer', part of the *Noirotica* erotic crime fiction series by Black Books, explores a sexual fantasy of submitting to a powerful man wielding a gun. Carol's fantasies often involve submission. 'I tend to want to be the bottom, and I tend to like the way the weapon adds to the overpowerment potential, and that's something I find erotic, at least in the right hands.' It's an SM toy that immediately ramps up the intensity of a scene. Outsiders tend to assume that being submissive is about

being wimpy and weak, but Carol explains that there's a lot of pride in being able to handle such a powerful emotional and physical situation. 'In order to be a submissive and face down something that is in fact a weapon in real life, is a powerful act . . . "I must be really rough and tough! I must be really able to take it and transmogrify that which is not supposed to be sexy, safe or anything else, into an agent that ups my sexual arousal."'

What kind of weapons does she like? Carol laughs, and describes an old Western six-shooter with beautiful tooled inlay and pearl handles. 'When I think about guns as fetish objects, I'm such a femme that when they do those loving close-ups on the History Channel's *Story of the Gun*, I find that I'm crazy about the old weapons – which in my experience are never the ones that people want to play with. Those exquisitely tooled and inlaid, frilly and yet undeniably macho weapons. It's probably part of my gender-bending thing. They're the drag queens of the gun world. Undeniably big and deadly, and yet dressed up!' Carol doesn't see herself playing with real weapons unless she met someone who was highly experienced with weapons and whom she could trust. 'And it's not the benefit of the doubt that I would give to just anybody, and in fact it's not the benefit of the doubt that I would give most people.'

Bonnie (a nickname I've given her to protect her identity) is a prominent bisexual West Coast SM player whose first exposure to weapons was in boot camp in the military. She never had a childhood gun fascination and she never played cops and robbers, but basic training coincided with a period in her life when she was breaking out of her family environment and pushing herself beyond what she had known as a little girl. For Bonnie, pushing her own limits on the shooting range came to interlock with her sense of erotic selfhood, claiming and possessing her own adult sexuality. 'The first summer where I was coming into my adulthood and making my own decisions I think are really tightly tied into my sexuality and the weapon – the pistol, the handgun – just becomes a highly symbolic object that that's focused on.'

Guns, like our earliest sexual experiences, are terrifying

things. We're afraid of letting go, of submitting to our desires, losing control in the explosive orgasm. Our 'fight or flight' reptile brain responds to the fear stimulus and gets our adrenaline going, our heart beating. It also sometimes sends blood flowing to interesting parts of the body. Scientists have discovered that many creatures experience a sexual reaction to frightening stimuli; and surviving a terrifying experience can awaken the libido. (Statistics show that there are often spikes in the birthrate nine months after a minor earthquake.) There's something liberating in pushing through that fear and anxiety and surviving, and that liberation hooks into our most primal erotic response . . . it's 'fight or flight' with a third option added . . . fuck.

For Bonnie, the smell of a weapon can trigger a flashback to that thrilling time: 'I have this memory of being in basic training . . . that hot, scorching earth . . . being at that edge of my physical psychological emotional limit, the satisfaction of pushing myself and doing well at it. And that very raw, animal state, and that olfactory memory of the smell of a freshly fired weapon. That kind of slightly acrid, slightly sulphur smell, that combined with that heat of the South and the smell of the soil.' I too respond strongly to the odour of Hoppes No. 9 gun-cleaning fluid. It instantaneously wakes me up, puts me on edge, gives me a little jolt of excitement. Odour is often a key element in fetishistic response. Bonnie points out that smells can pull us back to a pivotal moment in our lives and can unleash all sorts of psychological and emotional responses. 'There's nothing like an olfactory trigger that will give somebody a flashback. We must be wired that way. How's a baby going to identify momma, right?'

Bonnie fondly remembers her first gun porn. It was the premiere issue of a now-defunct magazine called *RAGE*. The photo shoot featured a fierce girl brandishing huge handguns. 'There's this beautiful olive-skinned, Italian/Mediterranean woman, tall, long legs, dark hair. Not at all the Hollywood type. The whole spread was evocative of the Bond girl. She's got impossibly short dresses, and great gun cases, and this huge weapon with a silencer and obviously this *Miami Vice*, 007 look

going on.' The hottest image was the woman in the shower, her make-up running, eyes glaring, teeth showing, pointing a hand cannon at the reader. There's a muzzle flash, as if she just fired the weapon. 'There isn't anything fluffy about her. She looked like this woman that would put up a good, sexy fight in bed, a woman you would roll around to get the upper hand, and then you wouldn't mind being pinned down, and you didn't mind pinning her. It didn't matter if you were on top or bottom. She looked feisty!' To Bonnie, the picture of woman being openly powerful, openly animal-ferocious, is a directly erotic image. It demands we respect the female libido.

Bonnie has used real guns in sex play with a female partner who owned a weapon for self-defence. 'When we were messing around and getting frisky, I would tell her to go get the belly belt. [A kind of waist holster.] It's not "Go get the strap-on, baby!" it's "Go get the belly belt." I'd look at her and say, "Pack it low." She'd shove the pistol in the belly belt nice and low and I'd hop on top and grind on the weapon laying flat on her belly. I found that very exciting.' Was it loaded??? 'I'm sure she never had it loaded, but I didn't know. My conscious mind knows that she didn't have it loaded. She would store things separately. But there was a part of me that didn't know, and didn't want to know.'

Bonnie had another hot gunsex experience at a 'play party' in San Francisco, a private sex party organised and run according to standard dungeon safety rules (guns are a serious no-no.) Bonnie and a bunch of hot dykes sneaked into a dressing room at the back of the party, posted sentries, and proceeded to act out one of Bonnie's hottest fantasies. As a small crowd of appreciative women looked on, two beautiful lesbians holding unloaded weapons undressed and fondled Bonnie. They wrapped the tips of the muzzles in foam to protect her from the rough edges of the sights, then used the weapons to fuck her orally and vaginally. 'It wasn't a fear scene, it wasn't a violation fantasy, it was *naughty*. Here we were, doing things that we knew the rest of the party wouldn't approve of because they were very much by-the-book "safe, sane consensual" and this is not by-the-book safe sane consensual play . . . One of the

trips was that I was a powerful sexy beautiful woman too. It was three powerful women going at each other. I had a sense that the two of them were servicing me.'

For Bonnie, guns are part of her lifelong erotic interest in power, domination and submission. Guns ramp up the intensity of the scene. As long as both people trust each other and communicate with each other about what they want, they can play with their fear in a safe way. One of her most compelling experiences involved a loaded weapon and a long-term girlfriend: 'I'm fisting her. I have my left hand in her cunt and she's wrapped around my hand, and I reach for her weapon. It's loaded. Rounds in the clip, one in the chamber, safety on. I'm already deep inside of her. I'm deep inside of her physically, and I'm deep inside of her heart . . . I put the muzzle in her mouth. And she's looking into my eyes. Not wavering, not blinking, and neither defiant nor fearful. And without blinking, she reaches up and undoes the safety . . . There was no fear. There was no anger. There was no confrontation . . . I had her life in my hands and I had this vision of the white wall behind splattered in red and brain and at the same time this understanding that I could not destroy her because destroying her would be destroying me. This amazing universal love overcame that godly power of destruction . . . That was a moment of *satori*. I will hold on to that whiteness of my mind – it's like the muzzle flash moment.'

One of the reasons Bonnie prefers to remain anonymous for this interview is that the BDSM community has become increasingly rigid in its adherence to the credo 'safe, sane and consensual'. Gunplay falls squarely into what many would consider unsafe 'edge play' – failing to publicly condemn these kinds of activities might provide fodder to enemies of alternative sexuality. The mainstream fears sexual non-conformity, suspects that exploring unusual sexuality is inherently dangerous, and that anyone who participates in unusual sex must be crazy or criminal. Promoting or appearing to condone edge play with guns could feed into those fears. But breaking the rules is what some folks' eroticism is all about . . . pushing the edges, testing one's limits may simply be hard-wired into some

people's psyches, just as some people need to take risks with extreme sports or skydiving.

Gunplay is clearly risky, and downright insane if explored by inexperienced people. Guns are incredibly dangerous in the hands of novices, and people who know weapons know that it's absolutely essential to believe that all weapons are loaded. Realistic caution and respect for the deadly power of the machine are essential. But truly experienced shooters can be safe, just as truly experienced bungee jumpers can do things that ordinary folk would best avoid. Accidents do happen, but the key is to keep a close eye on reality.

Ilsa Strix has found that she gets little call for guns in her professional life – it appears to be a relatively uncommon fetish. She's noticed that plenty of men show up at fetish events wearing swords, but none show up with guns, fake or otherwise. 'You go to these straight functions and you see all of these guys with swords, so why not guns? It's just the next logical step. I don't think it gets eroticised as much except by more artisan types, who can understand its vast implications. A sword is one thing, a knife is one thing, but a gun is in an entirely other category. It's a machine that gets used inappropriately a lot and so it comes with a lot of baggage. It's a machine that 10,000 mothers went to Washington to protest on Mothers' Day.'

Ilsa adds, 'I understand that guns are used to do some heinous, awful things, but then so are penises for that matter. And we don't want to take all of the penises away from the planet, do we?'

Katharine Gates is the author of Deviant Desires: Incredibly Strange Sex.

Filth, fumes, freeway!

The invincible motor woman
Michelle Handelman

If only Rapunzel had a fast car.

Damn, that girl would be flying. She would jump from her tower into a 1965 turbo-charged Lotus Elan. Silver-plated. Black leather. Interior. She'd be poppin' it full throttle. Dust that old witch with exhaust as she tore through the woods looking for her man.

Just imagine the hair. Flying in the wind like a serpent on Ecstasy. I can see her pulling around a corner now, hair stretched back for miles, a giant whip on wheels wrapping around signs, trees, pulling pedestrians to the pavement, taking everything out with the sheer velocity of liquid nitro. Move over Medusa, this bitch is high-tailing it! And even though her foxy prince may have been blinded by the witch, he'd find her. He'd smell her exhaust, hear her rev, feel her rpm, jump in for a ride. Sparks would fly out her ass as she straddled the highway. Fuckin' her prince in the back seat with one hand on her gearshift his tongue up her pussy (the muffled screams of her old bat of a godmother stuffed into the trunk). Rapunzel would be free.

Isn't that all any woman wants, freedom.
No, some of us want speed.

1. History

When I was a little girl all I wanted to be was Emma Peel. An assassin, a spy, a killer in a tight jumpsuit and a fast car. I would drive across borders. Tell my Mom I was going to the

library then after dinner get in the car and drive straight up Hwy 94 till I crossed the Illinois/Wisconsin border then turn around and go back home. I wouldn't do anything. Just cross the border, get off at the next exit, then turn around and go back home. I could do it in less than two hours. Still get in some time at the library. Fuck imperialism, fuck my parents, fuck the outer limits. I'd do it once or twice a week. Wisconsin, Indiana, it made me feel powerful. Like I was invincible. Crossing borders with abandon was my secret rebellion against inertia. An inexhaustible drive for forward motion. And it was on the outer edges of each state, the vagrant's playground, where I could feel extreme determination. It was my secret rebellion against bourgeois predestiny.

(All she wanted was a car. Something hard and fast . . . something to make an entrance in, an exit in a puff of smoke. It was the escape that predetermined all her actions.)

The invincible motor women of my past: Modesty Blaise and her '61 Triumph Speed-Twin, Monica Vitti and her '64 Moto Guzzi. Catwoman, Tura Satana, Penelope Pitstop, She Devils on Wheels. Honey West in a gold convertible.

Fuck James Dean, think Kathy Acker,
'In a society defined by phallic centricism, how is it possible to be happy?'

Some of us need danger.

2. The Dream

I always knew that to defy gravity was to be a hero.
To propel oneself into the great asphalt void would impel adventure.
It's a world of freeze. Where frames fly by like blurs on the window leaving marks on my body like tattoos of tread. That's all I ever wanted. Rocket-fuelled charisma.
A pedal to the metal means you never have to lie.
And if you never have to lie, you'll never cry.
That's all I ever wanted.

No responsibility. Pure sensation.

It's selfish, and it's hard, but I like it that way. Makes me feel safe. Makes me feel cool.

Makes me feel better than you. Because I can get away from the crowd.

Because leather jumpsuits look fuckin' hot on me.

The crash is always hovering

Everything, my life my dreams my sex my shit my failure is thrown into the pedal.

3. The Crash

Move to California. Buy a motorcycle. Bought a '64 Barracuda with a push-button transmission. The car rocked me. The motorcycle defied me. It had a mind of its own. They all do. Like a hard cock against my legs but harder. Excitable. And the shiny chrome made you want to drop down and lick it. But riding was pure Zen. So close to death at any moment. Just one false move and it's me and the pavement. Meat pummelled into the asphalt. I never rode drunk. Well, maybe once. Like that time I fell over three times outside the bar in SF and I was still parked (hadn't even taken off from the curb). We made it home OK. Remember (can't remember) but we made it home.

I answered an ad in the *San Francisco Chronicle*: 'Brand new Honda Rebel-150 mi. – hardly used.' I was a rebel. It was a small bike. I had short legs. My first bike. A baby bike. I drove over the bridge to the bitch's house in Sausalito. Bitch was the owner, not the bike. A tight-assed, pointy-nailed attorney with teased hair and leather trousers – a divorce lawyer in the process of divorcing her own husband – selling the bike was part of her plan to 'thin out my assets'. It was obvious she had never ridden the bike. Neither had I. But I couldn't very well buy without a drive. That would be stupid. So I told her I wanted to take it for a test drive. She got nervous. Asked me if I knew how to ride. I lied, told her yes. She said she wanted to wait until her friend came over, a man who was going to help

her sell the bike because she really didn't know that much about it. I said, 'Forget about it, we don't need him. Let me just take it for a small spin.'

OK, now how can I explain the following . . . picture this: she lived on the backside of a hill at the end of a cul-de-sac. The bike was parked at the far end of the cul-de-sac, facing downhill. To the left, her fancy jeep van was parked at the edge of her driveway, partially sticking out into the street. She showed me the clutch, gas, brake . . . of course I acted like I knew it all. I got on the bike and started it up as she went back into the house. Let's see . . . gas, clutch, brake . . . gas, clutch, brake. I gave it some gas/let off on the clutch, and SMASH!!! I drove straight into her van, front wheel of the bike wedged into the rear wheel well of the van, my face smashed flat against the side of the car. One second, two seconds, she came running out of the house right at the same time her friend pulled into the driveway. I was lifting myself off the ground trying to ascertain the damage. She whisked me into the house, gave me an icepack, called a doctor. Guess she was covering her bases in case of a lawsuit. Shit, now there was even a witness. But it didn't matter. I was hooked. Blood was streaming from my nose. I was seeing red. That bike had challenged me. That metal rat bastard. I had no choice now but to buy it. Make it bend and fold to my desire. I had to conquer. Whip it into shape. Show it who's the daddy. But after a few months I knew it was time to move on. Something bigger, more weight, more power, more SPEED!

Acker always told me, 'No man ever looks as cool on a motorcycle as a woman does. It's time for a total revolution, We've got cocks, too.' One day Kathy took me for a ride on her 750cc locus of power. She showed me the vertiginous madness from the top of Point Lobos. She told me never to stop. I never stop.

My next bike was a vintage '74 Honda Super Sport. Another ad, another suburb. This time it was a surfer dude from Santa Cruz. The headlights worked without a fuse and the fuse for the blinkers would control the brake lights. Ghost in the

machine. No one could ever fix that bike. Because ultimately the vehicle is more powerful than human. It will run you over, house your suicide, feed off concrete. And while a human's innate desire may be to control wild horses, we all secretly hope to lose ourselves to the spin of the machine. At least that's what I wanted. A mechanically-induced orgasm. But my Super Sport failed me. It never rode for more than a couple of days without a breakdown. Most of the time, wherever it stopped, it dropped. I'd leave it parked all around the city. Could be days before I got a truck to move it. Sometimes I'd have to bring the mechanics to it. She was like a beautiful sexbomb, too ill to fuck. No one could help her. Everyone tried. I kept pushing her from one neighbourhood to the next. She sure looked cool, but damn, that bike was useless. One day while some surfer boys were fixin' her from their garage the police came by and scooped her up in an unregistered sweep. That was it for us. She had become a high maintenance babe – too many parking tickets. I couldn't afford the bitch.

4. Chrome Spit Polish

Ballard may have fetishised the crash, but what about the fill up? Like a fast hump with a hooker all lead-free and public. The first time I got gas on my motorcycle was an unexpected forbidden experience. Legs spread, the attendant takes their nozzle in hand, then dips it into your hole. They squeeze the handle. Fluids enter. Oh my fuckin' god! No one ever, ever told me about this. That I would come all over the tank to the smell of $co2$, carbon and gas, that gas smelled better than semen, that fuelling was just so fuckin' intimate. I thought I'd fall off the bike right there. I couldn't look the attendant in the eye because I knew if I did I'd have to let 'em in a little deeper. And after all, wasn't part of my desire for speed a veil for my fear of intimacy? Fill 'er up and get the fuck outta there.

I got three speeding tickets the first week I had my BMW. Do you think the police will let me off if I tell them I was just having an endless orgasm?

5. Epilogue

Kathy Acker worshipped the machine. It was the only thing she trusted. 'It's all glory and heaven and huge sky on a bike,' she said. 'What really gets me off is the idea that you can just travel, and travelling is just like having an endless orgasm. You just go and go and go.' She abandoned the language of time for the language of violence. Where one must be where one is. Because being in constant motion is the opposite of paralysis, and paralysis is death.

All I ever wanted was rocket-fuelled charisma. No responsibility. No home. Just pure sensation and the wide open road spread before me. Makes me feel safe. Makes me feel cool. Makes me feel better than you 'cause I can get away from the crowd. I can run from my fears and look fearless. In fact fear is the fuel. Shiny leather, the machine.

Michelle Handelman is a filmmaker, writer, and media artist dealing with the extreme consequences of female sexuality. Her work ranges from the video performance series 'Cannibal Garden' to her radical documentary on the San Francisco leatherdyke scene, BloodSisters. *Her writing's been published in* Apocalypse Culture *and* Herotica 3 *along with several websites and publications including* Filmmaker Magazine *and* Art Forum. *Handelman is an adjunct professor in the Media Studies department of The New School University and is currently developing a serious desire to race cars.*

'It is the female cyclist who does the rash and venturesome thing . . . riding about with an indifference to death that is positively Dervish-like.'
Manchester Evening News, *8 September,* 1898

Wheels on fire

Sex in a wheelchair
Casey Porter

I have known I was different my entire life – how could I not know when carrying fifteen pounds of steel on my legs, along with the clanking and clashing of crutches? My right leg is completely paralysed, and my left only works at about 30%. But despite being paralysed to that extent, I have complete feeling in both legs, which also makes me different from others.

Our school system kept us gimp kids strictly segregated from the 'normal' kids. We had our own classrooms, our own playground and our own small room for lunch – no going to the cafeteria for us. Talk about sending us a message – we knew, bone deep, that we were different, and definitely not as good.

The day I started my first period was terrifying. I didn't have a clue what was happening: I thought I was dying, and that it probably was all my fault, because I had touched myself, 'down there'. A lot. I knew if my mother ever found out, she would hate me for being a nasty, dirty girl. I stuffed a wad of toilet paper in my panties and waited for death for three long, torturous days. One of my sisters must have finally squealed to my mother, because on the third day she came into my room and threw a pad, a belt and a booklet at me, snarling, 'Read this and take care of yourself!'

That was the extent of my sexual education. But not only did I continue to bleed every month – other things started happening. I learned to give myself an orgasm, which must be about the happiest day of anyone's life. I liked it so much that I once did it all night, leading to the second happiest day in my

life – when I realised that it gets easier to have an orgasm if you've just had one.

Puberty hit me like a ton of bricks. My breasts inflated faster than a fighter's cauliflower ear; in sixth grade I sported very large breasts. I was already the class freak, having been mainstreamed in the middle of the school year. The other kids had known each other since kindergarten. When a gimp kid suddenly showed up, they weren't ready to open their ranks. My braces, crutches and breasts made me the target of a lot of teasing. The boys especially loved to embarrass me, calling me 'Chesty', which did not endear me to the girls. Today, I look at pictures of myself in high school and marvel at how ignorant I was of my own appeal. I was a cute girl, with sparkling blue eyes, a sexy full mouth, and dark brown hair. My figure was great: big tits, a tiny waist, and a lovely bottom. I was a knock-out, and I didn't have a clue.

Unless you have a disability you cannot imagine what it does to your self-esteem. When I was young you saw no 'real' people with disabilities on the television except on Jerry Lewis telethons. Any film on the subject would have a happy ending only if the disabled character was healed, ending their terrible torment of life as a gimp. Teens feel awkward, ugly and out of it in general, and it was even harder being a teen wearing all that steel, and orthopaedic saddle shoes. Then there was one more blow. When I was in the middle of tenth grade we moved to a new town, with a new school.

I was the only disabled kid and I did not stand a chance of being popular. But, once again, because of my breasts, I was asked out a lot. Not literally, 'out', mind you: I was more of the backstreet type of date. A guy would not want to actually be seen with me, knowing his buddies would tease him unmercifully. Eventually I did have steadier boyfriends. Still, most of our dating was confined to my front porch or the boy's car. We would wrestle and debate over access to my tits. Once in a while I'd grant it, and it did feel good. In fact, some things boys did felt *really* good.

I thought I should go 'all the way'. It would get me some love – something that was in very short supply in my life. I

wasn't quite sure what going 'all the way' really meant. When I daydreamed about it, I got all misty after the kissing and pet-ting. I knew boys had penises. I knew we probably fit together down there, but couldn't envision how. But it wasn't as if I could gracefully disrobe, coyly allowing my alabaster skin to come into view. With all that steel wrapped around my legs, any sort of seductive gracefulness was an impossible dream. And the skin on my legs? Years of surgery had left them criss-crossed with scars, like a demented road map. Who would want to see them? I went over the idea time and again but I could never figure out how to get from fully clothed to screwed with-out making a freak show of myself. Then my best disabled friend, Barb, got laid. I was so excited when she told me, 'I let Stan go all the way with me last night! Want to hear about it?'

'Oh, my God, yes!' My heart was pounding like a trip-hammer. 'What did you do with your leg brace?' Not, 'How did it feel?' Or even, 'Are you all right?' I wanted to know the mechanics so I could get laid too. I don't even remember what she told me exactly – it was more that she gave me the encour-agement I needed to go through with taking the thing off in front of someone.

My mother had been telling me for years that I would end up pregnant and 'have' to get married. She turned out to be right. I got pregnant, got married, and it was disastrous. My husband was abusive and called me a 'cripple'. After ten years and three children, I left. I wish I could say that leaving him healed my injured ego, but that is only partly true. I went to college and did very well. I became my own lover again, and my body rejoiced in remembering how to orgasm. Then I fell in love. He was talented, outgoing and personable. Things were wonderful between us – except when it came to sex. The scars on my legs disturbed him. I kept the lights out for our entire relationship. But he knew the scars were there, and he blamed them for his inability to maintain an erection. I would give him a blowjob, for hours, but he would lose it when we tried to have intercourse. It took me a long time to realise the extent of his personal problems, which went far beyond issues of my body and his performance.

I wanted to learn how to heal my self-esteem so that I could stop falling into the trap of accepting so little. My first step was to swear off men forever. To my way of thinking, I was better off alone, getting myself off, than frustrated and boiling in silent resentment with another lousy lover. I started exercising and taking care of myself, knowing that my low self-image was partly hinged on loathing my own body. And I started something else – something that came very hard at first. Every night, after my shower, I would apply lotion to my entire body. As I reached each body part, I would thank that part for doing its job. I would praise my hands for being so agile. I would thank my arms for being strong enough to push my wheel-chair, to which I eventually had to move from braces and crutches. I would thank my belly for cradling my babies. And my legs . . .

The first night I started this routine, I got to my legs and really looked at them. I saw the scars. I saw where they didn't work, but I also saw where they *did*. My 'functioning' leg had laboured so hard, doing the lifting and walking for two. Even my paralysed leg had given a lifetime of work, filling my brace and making it possible to walk for as long as I did. Once I saw my body in this light, I saw the rest of myself differently. Not overnight, but after a few months, I found that I was a woman I could be proud of. I was smart, compassionate, resourceful and sexy. Sexy? Yes, that too. I began to regret that I had sworn off men.

One night I pulled up AOL's Member Directory, clicked in a request for a list of local members, and started reading profiles. A lot were badly written and predictable, but this one guy, Rick, showed some real intelligence and humour. A librarian? Yes! That pleased the addicted reader in me. He was a musician as well. This seemed too good to be true. I composed a message, but was sure that I would be disappointed when it came to conversation. Rick and I chatted online for forty-five minutes the first time. We went on chatting the next day, the next week, and then the next month. On the phone, he had the sexiest voice imaginable. We wrote and talked for hours each day. By the end of the first week, I had written him the story of

my life. I did not want to build a relationship with someone who might be bothered that I was disabled.

Finally he wanted to meet me. I got so anxious. Online, this man wanted me. On the phone he wanted me. But what about in real life? I dithered for a while, all my insecurities washing back to haunt me. I would meet him, I decided, but I wouldn't make love with him that first weekend. And when we did make love, it would have to be with lights out. Unknown to me at the time, that last idea almost killed my chance of a sexual relationship with him. Most men are very visual lovers. When I wrote to him about 'no lights', it made his heart sink. He was more than willing to put off love-making until I felt ready, but he was not willing to do it in the dark. I drove to my online lover's town. He was even more handsome and young-looking than his pictures had led me to expect.

We sat at the kitchen table, talking. It was as if there were a thin layer of plastic between us, keeping us from meeting as intimately as we had on the computer and on the phone. In desperation, I suggested we move to the couch, figuring I'd get out of my wheelchair. I still don't know why that made the difference, but we connected much better there. Within an hour, we moved to the bedroom. He made it feel so safe that I didn't fret, even though it was broad daylight and the curtains were wide open.

We ebbed and flowed into one another so naturally that I wasn't even surprised to feel my first orgasm with another person. I just started laughing in delight. Thank goodness he read me correctly, or I could have really given him a complex. But he laughed with me, kissing my face as I beamed at him, tears in my eyes. For months after, I would laugh every time I had an orgasm.

We grew together in stages. At one point after we met, he wanted to try sexual spanking. I was a beginner and very nervous, but I realised this was a huge turn-on for my lover. I was curious and eager to experience it, but I panicked, knowing my legs were going to be completely on display. He showed the perfect understanding that we shared as lovers from the

beginning, and did the one thing that erased all my doubts and worries. He started kissing my feet and worked his way up.

'I love your feet and legs. Your skin is like silk, so smooth and creamy.' His words rang with sincerity, and I have never doubted his love for my feet and legs since. How can I, when he is always nibbling and kissing them? By the time we got to the spanking, that was amazing too. It turns out that I am one of those rare birds – a dyed-in-the-wool spanking fanatic who didn't know until it happened. But that's really another story . . .

Casey Porter is a professional freelance writer living in Michigan with her husband, Rick, the man described in this story. She has four children and two grandchildren. She can be reached through SilkDreamr@aol.com.

Any old iron

Medieval mayhem in the midlands
Katrina S.

29 May
Finally arrived at Manchester Airport, where Richard of
Tollyboy met me with one of his friends who had kindly offered
to drive me from the airport to save me having to struggle with
the British public transport system in my jet-lagged state. Very
nice to fall into a car and enjoy the scenery all the way down
to Sheffield. It was a lovely sunny day and the British country-
side was at its best. On arrival at Richard's flat, where I will be
staying, he confiscated my suitcase with all my clothes in it
until he could go through them to see if they were 'suitable'.
He offered me a cup of coffee and then told me to strip. After
taking detailed measurements of my nipples and clitoris he
explained to me that my waist was bigger than my hips and
therefore a chastity belt would not stay on. He said that from
tomorrow, I was to consider myself chaste and that I would
never again be permitted to touch my genitals. He did not tell
me how he intended to enforce that with me being the wrong
shape for a belt but I have a feeling he means it. I was sent to
bed at 22.00 and tethered to the bed so there was no chance of
getting up for a midnight snack or, in fact, doing anything
more than standing by the bed. Richard gave me a vibrator and
said, 'Enjoy yourself. It will be the last time.'

31 May
Still suffering from the effects of jet-lag. Dead all day.

2 June
I went to look at Richard's workshop. Scary.

3 June
Thunderstorm. I did not like it one little bit as I was tethered in bed and could do nothing to escape it. I hate thunder and lightning and would normally have found somewhere to hide.

4 June
Richard measured me for an old-fashioned corset. I am getting used to being tethered in bed all night and have lost the fear that I am going to strangle myself with the chain. I am also tethered when I am in the flat on my own, but I like being in control of my body, and this restraint is frustrating.

5 June
I have been testing a device which has a piece of metal pipe and a dildo. It is attached to the ankles and when the knees are flexed, the dildo goes up and down. Most interesting. Richard and I are discussing improvements to all kinds of devices that he has invented. It is fun most of the time, though some of the products look as if they could be quite painful.

6 June
Still tethered.

7 June
I am getting in deeper! I was measured for a stainless steel waistband for a chastity belt today. Also two pairs of very nice handcuffs arrived in the mail. They fit well. Oh Boy, am I in trouble now! Tethered and handcuffed. It is no wonder that it is difficult for me to write this.

8 June
I helped Richard take assorted ironmongery to his workshop. I nearly died. The energy levels have plummeted to zero. I was taken to the doctor for an appointment but the surgery was closed. Will go back tomorrow.

9 June
Spent a very quiet day in the flat.

10 June
Some lovely person tried to burn the high-rise down. Richard came home and found an ambulance, two fire engines, police and assorted onlookers outside and smoke billowing from a stair-well. I could smell smoke but I did not know where it was coming from, nor could I have done anything about it if I had since I was tethered in the flat. Oh well. No barbecued Kat this time! I was unleashed and we went for a walk to get rid of the fumes. Richard said he would have liked to have seen the look on the fireman's face if he had had to help me escape.

11 June
I am now wearing the metal waistband. It is a little irritating but that is to be expected as the skin and the waist are not used to anything tight around them. It feels very hot and seems to burn. I went for an outing to Dale Head, Ashford-on-Water and Bakewell. Bakewell was very busy. I hope no one noticed the extra bumps on my waist. I am overweight and the belt makes extra dents in my clothing.

13 June
The postman arrived with some very nicely made silver filigree nipple covers. These are designed to stop me playing with my tits and to make my nipples look continually aroused. They came with special tools to fit them and to enlarge the holes in the nipples where I wear rings. The enlarger makes the nipples extremely sensitive and itchy. They are also a bit tender. But scratching them is out of the question. It is driving me to distraction. I went to the doctor but, fortunately, she did not ask me to undress.

14 June
I went dancing. No one noticed the waistband. It does not restrict movement.

16 June
I had to remove the hole enlarging tool as my nipples are

extremely sore to the touch and are throbbing. I do not want an infection to take hold.

17 June
Richard made the belt one inch smaller today. Ouch!

19 June
Quiet day. I went for a walk to the farm and then to the pub. Drank Guinness. Now I am hardly noticing that I am wearing the belt.

20 June
Joined library.

21 June
I rambled around the farm and met some calves. They tried to lick me to death. I had forgotten how rough their tongues are. Most interesting. Went dancing but I found it difficult to relax because I was worried that the belt would be detected.

23 June
A friend came to test a remote-controlled dildo. It has a motion sensor that can detect if it is moving, upright, or lying down. It also has a timer that delivers a shock if it is being used without 'permission'.

25 June
I went to a steam rally and drove a steamroller.

26 June
Richard woke me up with a new whip he has just finished making. I have also been testing various sized dildos to wear with the belt. He wants to build one with a circuit so that it is like a cattle prod. Ouch! The waistband has been made another inch smaller.

1 July
The corset arrived today and I tried it on. I have lost weight

and it is very comfortable. I have even found my waist after twenty odd years. My waist has gone from forty-four inches to thirty-six inches but I cannot bend down!

21 July
Corset on. Walked to car boot sale. Rained. Walked home. Played computer games until a.m.

Katrina S. lives in Tasmania. She is a fifty-year-old grandmother. Married for twenty years, she now lives happily alone. She thinks that her experiments with physical restriction are an effort to regain familiarity with the emotions that she submerged in order to survive her marriage. Tollyboy (original security belts) can be contacted through enquiries@tollyboy.com.

Nookie with a wookie

The culture of slash-lit
Kitty Fisher

I learned about the existence of slash-lit in the eighties, when *Star Trek* fandom was something the British public could laugh at over their cornflakes. Newspaper articles described conventions where a sub-culture ranged from fans who wore Spock ears to fans who wrote their own 'Trekkie' stories in which the lead characters had sex with each other. The reader was supposed to look down on all this and laugh at the sad anoraks. Only I didn't, because my favourite episodes of *Star Trek* were the ones where Spock and Kirk were together, especially when they touched, or showed their love, or their love was recognised by an outsider. All of which happened quite often. As even the least observant alien knew, the best way to get Kirk to do something was to threaten Spock. Not, I think, that the writers were encoding homosexual sub-text into such scenes, but more that the text was readily open to a deviant reading. And that is something slash fans are very good at.

Knowing that slash existed – or that I wanted to read some – wasn't enough. None of the press coverage told me where slash could be found – after all, why would any of their (male) readership want to find that kind of (female/gay) rubbish. The article was there so the subject could be ridiculed, not sought out. This was in the days before the internet. Slash was an underground movement, and the only way to find it was either through knowing the right people or by reading the 'zines' in which it was published – these, with titles like 'Dyad' and 'Uncharted Waters', were sold under counters at conventions and through mail order companies whose addresses were difficult to track down.

I grew up. I worked as a topless waitress in Amsterdam. I sold vintage clothes in Camden. Finally, I settled on the book trade. I enjoyed myself. I never felt I was lacking anything, but I was still occasionally titillated by the idea of slash – after all, I was still reading gay fiction, looking out for gay porn, and loved nothing better than to discover TV shows where men bonded. In my view, any male bonding, be it hugging or animosity, had to find some sort of sexual outlet, and I would imagine what those characters would do when the camera was turned off.

Then, one day in 1990, I came across a copy of the *Star Trek Fan's Handbook*. Curious, not really expecting there to be anything other than episode listings and how to make a command crew uniform from old curtains, I leafed through and found a section on slash, which included publishers' addresses. I can remember standing there, absolutely breathless, aroused even by the idea that I might actually get to read some of the stuff I had wanted for so long.

Well, reader, I bought the book. The next day I posted letters, money, statements that yes, I was over eighteen and that yes, I knew what I was buying, thank you very much. Two weeks later I received a few 'zines and an invitation to a convention. A slash con. Sixty women meeting for a weekend focussing on men having sex. I signed up at once.

But the con was weeks away, and the *Star Trek Fan's Handbook* had more in it than just slash. It had addresses of bookshops. So I went travelling. Not too far, just down to South London. There I found a friendly shop with a small back room which stocked 'zines. Not slash, but fan-produced A4 bound books of stories written by fans. Wonderful! I bought a stack and went home to read them.

Those stories were a revelation. I had always known I was turned on by the idea of two men in bed, but these stories weren't sex, they were just well-written, gripping fiction. One story was about Spock and Kirk stranded on an uninhabited planet. It made me laugh, it made me cry, and it made me want more. The next week I was back, chequebook at the ready. At the cash desk I was enthusing (drooling) and trying to get

around to the subject of (blush) slash, and in walked a customer – tall, blonde and utterly gorgeous. She turned out to have written the story I had loved so much.

That was the beginning. An introduction was made. We talked and I was invited around to her house. So there I was sipping tea and eating biscuits, and discussing a subject with someone who understood. I looked up at one of her bookshelves and spotted the complete set of *The Professionals* novelisations. 'Oh, I've got all those,' I said. 'Really?' 'Bodie and Doyle, they were great. There's not um, er . . . is there?' 'Mmm,' said my host, and smiled.

That's how I found out there was more to slash than *Star Trek*. My host crooked a finger at me, beckoned me into her study and, in the manner of a devil offering the riches of the world, showed me a bookcase full of slash. *Professionals* slash. Bodie and Doyle having sex and angst in almost equal measure.

I carted off two carrier bags of 'zines and stories, and spent two weeks in an erotic bliss as intense as the first weeks of a love affair. In fact, that's what it was. I was the supreme voyeur – in love with two men – in lust with their lust for each other. Delicious. Of course there were good stories and bad ones – or I should rephrase that to say well-written stories and not-so-well-written ones.

Some of the scenarios were more to my taste than others. I never have liked saccharin sweet or domesticity, preferring angst and suffering, pain and redemption, along with hot sex, please. But back then I was so new, so overwhelmed, that I read everything, and found love, rape, elves, lust, violence, DIY, baking, romance, drama, history, tragedy, comedy and any combination of the above.

Then came the convention, and I found myself being welcomed into a large, varied and utterly wacky community of women. Women from all over the world, women from vastly different backgrounds, women who were open about what they liked and who were unashamed of it. Nobody blushed at admitting to liking rape stories. No one laughed at or mocked any idea – except in the friendliest of ways. I met housewives, teachers, librarians, academics, technicians, booksellers, lawyers, stu-

dents and till-operators. A couple of mothers brought their daughters, who shared the interest. No one brought their husbands. Not all the women were straight. Not all of them lived with just one partner. I took a deep breath and made friends. I talked and listened and read and, at the end of the weekend, went home transformed. I had found another world.

In the slash community you are just you. It doesn't matter what you look like, what you wear, what you read, what you do for a living or for fun. This, in itself, is unusual. I can think of very few places where all sexualities mix without judgement. So you live with your husband *and* your girlfriend? Great, but did you see the way Methos looked at Macleod in that episode? Oh, you have a slave? Fantastic. Serious SM with your girlfriend? Great, can you describe the mark left by a cat-o-nine-tails?

Factions do arise, and flame wars sizzle away on the net. If you want strong opinions, slash is the place to find them. But there is amazing support too. And a network of women that winds its way right around the world. Some of my closest friends live thousands of miles away – women I would trust with my money, my hopes and the first draft of my new novel.

I had been reading slash avidly for a few weeks when I began to think. I want to write this, too. Out loud I doubted that I was capable. The woman I was with just looked at me and said, 'Of course you can!' Not 'try it and see', or 'have a go and see how good you are'. Just straight out, confident fact. You can do it if you want to. So I did. And eight years on I am still writing mainly, but not exclusively, gay fiction, some of it as Kit – a nice non-gendered name so as not to frighten anyone off. I can confidently say I would never have written anything if it wasn't for fandom and the support that the slash community offered in the way of editing, publishing and confidence.

Many other fan writers have the same experience – not all, for the path from professional writer to fan writer links both ways. I can think without effort of a handful of slash writers who are now pro. I can also name a handful of pro writers who indulge in slash for fun, for the freedom it gives, for the irreverence of it all.

Part of the appeal was certainly the underground nature of slash. 'Zines were passed around like contraband, and acted better than any drug I have ever found. The simple act of subverting popular culture and transforming it into something utterly different was heady stuff. Still is. Though, with the internet, the underground aspect is slipping away. When you can do a search for 'Mulder slash' and come up with 7,000 hits, then you're no longer hiding in the shadows.

I still love 'zines, mainly for their production values and the quality of the editing. But on the internet you can try before you buy. And you often need to. Stories can go straight from keyboard to web page without even a cursory wipe over with a spell check. Some stories are so poorly written that I click away from them, embarrassed to be associated with such juvenilia. But then a gem appears. Or a writer so stunning that you want to kiss their feet, weep for joy and follow them to any fandom they might care to write in.

The internet also provides ease of access to an almost limitless variety of slash fiction. OK, so you like the *X-Files* and you like slash. A few searches and you can select from Mulder/Skinner, Mulder/Krycek, Skinner/Krycek, Mulder/Langley, Langley/Byers/Frohike, Krycek/everyone, Mulder/everyone. Or any of the above combinations, but adding Scully. And I know I've missed some out as the idea of Cancerman and anyone makes me feel slightly queasy, but if you fancy it, just search. Like the truth, it's out there somewhere.

One of the characters is dead? No problem, there'll be an alternate universe version somewhere. How else would there be the thousands and thousands of Obi-Wan/Qui Gon stories, when the Jedi master was well and truly dead at the end of the movie. You like Bodie and Doyle but the guns and C15 stuff bore you? Then read about Doyle as an elf, or relocate to an historical/futuristic setting. Everything and anything is possible. And sometimes the least likely-sounding summaries can turn out to be the most wonderful stories. A good writer can convince the reader of anything. Though I have personally yet to be convinced by elves.

Almost every TV series ever made that has two male pro-
tagonists has been slashed. Yes, mum's favourite *Inspector Morse*
can have an interesting time with his Sergeant Lewis; Obi-Wan
Kenobi can indulge in far more than meditation with his
Master and for the truly interested, Sunhill is a den of sexual
vice and depravity. Soaps, drama, crime, thrillers, sci-fi, no
genre remains unslashed.

At the time of writing the most popular slash fandoms –
those with the highest count of new stories – are probably
Stargate SG1 and *The Phantom Menace*, with *The Sentinel* and
the *X-Files* still holding strong. Fandoms go in waves of fash-
ion and interest, partially dictated by TV scheduling and
whether a show survives from one season to the next; partially
by some inexplicable global zeitgeist. Some fandoms are always
popular. The classic ones are *Trek* (of all varieties), *The
Professionals*, *The Man From UNCLE*, *Blake's 7*. Others have a
surge of popularity then die back to comparatively nothing, an
example being *Highlander*.

Copyright is a contentious issue. Most fans try not to annoy
the big companies. Stories tend to start with disclaimers and
writers make it clear that their activities are non-profit making.
Cease-and-desist notices are all too frequent, and no one
argues with a multi-million dollar company.

The Japanese understand slash. They have their own vari-
ety, called *yaoi*. *Doujinshi* (fan-produced material) can be
bought in shops and isn't considered shameful at all. The com-
panies who produce the original shows don't see the fan work
as anything other than added publicity or simple flattery. They
don't sue. How enlightened. *Yaoi* began at roughly the same
time that slash was becoming widespread among Western fans.
There are many similarities in the way the two phenomena
have grown, though where slash is almost entirely based on TV
shows, *yaoi* is based on manga (comics), anime (cartoons) and
computer games. The fan work is almost entirely manga and
the art-work is stunning. The other difference is that the
Japanese manga publishers have begun to slash themselves.
Seeing a good thing, they publish books of M/M manga, using
original characters, aimed at women. Even here in London you

can pop into a Japanese bookshop and buy one of these monthly collections.

It is said that the very first slash was written around Sherlock Holmes and Dr Watson, though this may be apocryphal – simply based on the fact that Conan Doyle provided a perfect set-up with two gentlemen living together, one of them tormented, and both of them clearly devoted to the other. I love the idea of demure Edwardian women sitting down to pen stories where the two heroes find more than friendship once the doors are closed and the housekeeper is safely tucked up in bed. But why start in this century? Why not a Jacobean lady sighing over Hamlet and Horatio (dying in someone's arms is always a good slashy moment, as thousands of *The Phantom Menace* stories have proved). Or one of Dickens' readers imagining a tryst between, say, Eugene Wrayburn and Mortimer Lightwood – there's enough anguish and love there to fuel a few fantasies.

In thirty years slash has changed beyond recognition. From the early days when the distribution of stories was a simple sharing of photocopied sheets between friends, to the staggeringly high quality of fan-published 'zines, to the global immensity of the internet, slash has evolved and grown. It is still a community, though. We all watch TV, wanting the slashy moment – the scene, the confrontation, the dialogue, or whatever it might be that makes us put pen to paper. We still want to read what other writers have made of the same. And talk about it with friends. Then, suddenly, a fandom has begun and the conventions are organised, and two Americans and an Australian are coming to stay, and very little sleep will be had.

So, think about it, would Fox Mulder have better sex with Skinner or with Krycek? Which one of these men could make him happy, build a relationship with him and shag his socks off? Is Bodie a top or a bottom? In *Buffy*, what exactly did happen when Spike shared Giles' apartment? Are two men who only have male/male sex with each other gay or straight? Does Spock have a libido when he's not in Pon Farr, and exactly how

alien is he? Talking of alien, can you really slash a Wookie?
And would you want to?

Kitty Fisher, also known as Kit, resides in London and lives for her lovers (one of each sex), friends, and porn, in roughly that order. Her new novel, Paper Flowers, *is available from* www.waywardbooks.com.

She can be contacted at kittykitty@btinternet.com. *A variety of slash-lit can be found at* www.slashcity.com.

Seeing stars

Why I hate Gwyneth Paltrow

A look back at anger
Mikita Brottman

On 16 July 1917, an unsigned letter was sent out from the Universal Film Manufacturing Company, Pacific Coast Studios, Universal City, California. The letter was addressed 'To All Directors', and it contained 'a list of things not wanted . . . in our productions'. Some examples of these are as follows:

Maudlin displays of patriotism
Fake wallops in fight scenes
Excessive smoking
Situations likely to instill 'fear' especially in the minds of young people
Scenes showing hauling about of dead bodies
Insanity
Hunchbacks, dwarfs and extreme cases of deformity
Snakes
Milk bottles to indicate poverty
Pie slinging contests
Excessive expectorating
Kittens
Close-ups of repulsive looking characters
Mugging in close-ups to indicate grief
Heavy dames
Distressing situations
Sissies

This quaint litany of demands now seems amusing and slightly puzzling (I wonder what the problem was with kittens?), but serves most of all to highlight the rigid imperatives

of the studio system as an organised mode of production. Documents like this perhaps explain the formulaic output of the major Hollywood studios in the early days of cinema, when issues of cultural power and authority were handed down by autocratic *diktat*, when movie directors were the paid lackeys of that race of legendary Titans, the studio heads.

This document, remember, is almost a hundred years old. It seems pretty surprising, then, that things have changed so little. Look at the pitiful selection of pap masquerading as 'cinema' on offer this weekend at your local googleplex. What's *that* all about? With the occasional rare exception, most films coming out of Hollywood today are vacuous, unwatchable charades – minor variations on narratives as formulaic and predictable as those produced under the studio system. Nasty situation is righted by sturdy action hero. Boy meets girl, falls in love and buys her jewellery. Self-righteous capitalists are upstaged by indignant, blue-eyed altruist. Ailing weakling is cured by the forces of good.

INSIPIDITY RISING

The only interests Hollywood cinema represents today are the interests of big business. The cinema is nothing more than a venue for commercial organisations to indulge in increasingly obvious kinds of product placement, soft-drink sales and tie-in marketing. Films have become mere feature-length advertisements for syrupy confections, plastic mugs and trademarked frippery interspersed with pointless and deafening computer-generated 'special effects' on a tediously monumental scale. The cinema today is nothing more than a place for groups of slack-jawed morlocks to worship at the shrine of interchangeable airbrushed 'celebrities'.

And just look at them – these bland nobodies who pass for 'movie stars'. Could the casts of these blank tales be any *less* inspiring? Male leads are either chummy, vacant hunks like Mel Gibson or Kevin Costner; twinkly-eyed septugenarians like Sean Connery or Clint Eastwood, or glistering meatheads

like Bruce Willis or Arnold Schwarzenegger. Female 'stars', when they're not simpering anorexics like Gwyneth Paltrow or Cameron Diaz, are those insufferably 'edgy' types like Susan Sarandon or Helen Hunt. Add an ethnic role-model and you've got a blockbuster hit. Throw in a mincing queen and you've got a risqué melodrama. Toss in a smarmy brat and you've got a 'heartwarming classic'. Add that hysterical sociopath Robin Williams, and you've got a 'laugh-a-minute comedy'. Bring back those sissies, I say.

Perhaps the one virtue of contemporary mainstream cinema is its honesty. Most films don't really pretend to be something they're not. Even more offensive than these fatuous pantomimes are those films touted as 'alternative', 'independent' or 'European' that bear the familiar commercial trademark of 'arthouse fare', are marketed by major distributors, and shown on the screen at the multiplex alongside Paltrow's latest tearjerker. This includes almost anything that plays at Cannes, and absolutely everything by Neal Jordan, Atom Egoyan, Lars Van Trier, Pedro Almodovar, Mike Leigh and Kryztof Kieslowski. I recently had the unfortunate experience of sitting through the latest piece of Danish dogshit from Lars Von Trier, *Dancer in the Dark*, the only bearable moment of which was when that wailing pixie Bjork had her vocal chords snapped by the hangman's noose. The only difference between these self-styled 'arthouse' films and the regular blend of Hollywood pap is the lack of plastic toys in the cinema lobby. This is *art*, darling.

Like that of the traditional studio system, the ideology of contemporary cinema is totally restrictive. The difference between what Universal wanted to see less of in 1917 and what today's political fashions dictate is one of kind, not degree. Ideological imperatives of the cinema today include the following. Grandparents must always be good and wise. Fat girls must always hide an 'inner beauty'. The lessons of life may be hard, but learning them must make us stronger. Artists must struggle. Children must be innocent. Single mothers must smoke. Everything must happen for a reason.

The following people must always be good: deaf mutes,

hookers, musicians, animal lovers, small shopkeepers, black women, artists, orphans, homosexuals and Chinese families. The following people must always be bad: people with big offices, people with their own parking spaces, power-dressing women, rodent terminators, evangelical ministers, judges and corporate lawyers.

Personally, here's what I'd like to see less of on today's cinema screen:

Show people who are 'lonely in a crowd'
Lifelong friends
Funnymen who are 'sad inside'
Holocaust survivors
Bizarre twists of fate
Libidinous old people
Gay priests
Witty transvestites
Cripples who 'triumph over adversity'

It's a sad truth that no film ever picked up for mainstream distribution has ever genuinely exploited the full possibilities of the motion picture photograph. This criticism is particularly true of 'arthouse' cinema, whose directors often really do have the ability and opportunity to do something *important* with the power of the moving image, but elect instead to give us yet another lesson in race relations, or rehearse some tedious credo about spontaneous improvisation or other 'radical' acting techniques. The financial and ideological imperatives of contemporary film rarely allow it to explore any of its spectacular potential. Today's cinema is completely anachronistic.

WHEN I HEAR THE WORD 'CULTURE' . . .

Let's try for a moment to remember how things got to be this way in the first place. The invention of the motion picture photograph meant, in fact, that there was no longer any need for much of what we've learned to call 'culture' today. After all,

let's face it, anything done on stage can be done far more effectively on film, which obviously eliminates the need for any kind of live performance. And this is what's so important about film, and why we should use it for a much higher purpose than we do. To use film to sell plastic junk is like taking a piss against the Wailing Wall: it's a sacrilege. Film has all kinds of magnificent, wonderful powers. For a start, it can incorporate all kinds of additional developments – various kinds of editing, dubbing and cutting techniques as well as the addition of subtitles or soundtrack effects. Fluffed lines can be reshot, angles of perception varied, dialogue added or removed, location shots intercut, and all kinds of other illusions provided by the judicious use of special effects. Shakespeare, by way of the most obvious example, is perfect for the screen. Has any theatrical production ever surpassed the power of Max Reinhardt and William Dieterle's *A Midsummer Night's Dream*, Akira Kurasawa's *Throne of Blood*, or Peter Brook's *King Lear*?

Whenever I volunteer this opinion among people who are fond of 'culture', however, they always tell me that there's something just unaccountably *special* about sitting beside the stage, about being in the presence of real live actors, about witnessing the drama unfolding right before one's very eyes, rah rah rah. But they're wrong. It's simply that film, because of the way it's been abused by the interests of big business, has lost its grandeur. The truth is that nothing can happen in the theatre that can't happen more effectively on the screen. There's nothing 'cathartic' about live theatre, despite everything they tell you in English class. The theatre is just the overpriced folly of chattering fools who screech with hilarity at the same joke in a production of Shakespeare they'd find totally offensive in an episode of Benny Hill.

Live events have an added dimension only when experiencing them involves being a 'part of the crowd' in a manner impossible when the event is mediated – though anybody who's ever sat through an all-night horror show or full house screening of a great comedy knows that being part of a movie audience can be a phenomenally festive, communal, and interactive experience. Of course, there are a number of activities,

like football matches and rock concerts, whose success depends on the kind of audience relationship that's impossible to reproduce away from the arena. But is the same true of a classical concert? At all the classical concerts I've been to, the rubes sit there in reverential silence, petrified to even unwrap their gourmet mints. I do enjoy classical concerts, but I enjoy them most on my television screen, in the privacy of my own home. And if you really like dressing up and going somewhere special, you can go to see a film premiere. You might be disappointed by the acting or the plot, but you can be sure the leading lady won't be at home with a throat infection, and you're pretty much guaranteed a good seat.

The same, of course, is abundantly true of painting. Who's not been disappointed on seeing pictures in a gallery that seem pallid and washed out compared to their wonderful reproductions in art books or photographs? Many people tell me that standing in a drafty art gallery with a crowd of French schoolkids is a more 'authentic' way of viewing art than looking at full-colour reproductions in an art book. Since pretty much everybody has seen a reproduction of Van Gogh's *Sunflowers*, how much more important it must be to see the original, right? Wrong. The truth is, the original has become entirely worthless – except, of course, in the inflated world of the art market, the origin of that insidious lie that is the *fetishising of authenticity* in the age of mass-production. The world of 'culture' is fatuously obsessed with 'originals', whether it be art, antiques, first editions, celebrity souvenirs, serial-killers' silverware, couture shoes or continental cheeses.

And along with this fetishising of authenticity comes something perhaps even more insidious, because even more mendacious, and that's the fetishising of 'nature'. Nobody really likes to admit it, but the truth is that the artificial is almost always better than the 'natural', and in almost every way. This goes for light, highs, textures, fabrics, colours, and almost every other item, attitude and experience. 'Natural' food never tastes as good, to me as food that comes in a tin. Anyway, the Ryvita-ad version of 'nature' has virtually nothing at all to do with 'real' nature, which is all about infection,

disease, incest and cannibalism, not silken ears of grain waving in the summer breeze.

Towards the end of his life, the artist Piet Mondrian grew to have such a pathological hatred of 'the natural' that he worked in a studio painted completely white, offset only by a vase of artificial flowers. He even rearranged the furniture in his house to avoid the chance of glimpsing any actual trees out of his windows. I think his instincts were right. The truth is, inside is better than out. Just as the artificial is better than the real. And this is also the case with cinema. Film, when allowed to reach its full magical potential, is always more fascinatingly powerful than any version of the kind of familiar experience we've come to understand and describe as 'reality', or its mediated counterpart, realist cinema.

But what are the alternatives? Certainly nothing that you'd ever find showing at your local multiplex, or anything that would ever involve the divine Gwyneth Paltrow. There *are* alternatives, however – in fact, there's a whole tradition of abstract, non-realist, non-narrative filmmakers who understand the sacred potential of this fascinating, spellbinding medium. This tradition originates with the work of that great magus of the cinema, Kenneth Anger.

'EVERY MAN AND WOMAN IS A STAR'

The work of Kenneth Anger provides a subversive alternative to mainstream cinema that also references this world, and quotes from it. Anger was fascinated by Hollywood history and the escapist glamour of Hollywood movies – especially silent cinema – and mainstream Hollywood functions both as his matrix and his adversary. In the *Hollywood Babylon* books, images of Hollywood stars are taken out of their usual structures of representation and put into a new, perverse context intended to disturb customary modes of perception. These books, like Anger's films, serve to highlight the very ambivalent dynamic between the cinema audience, and the stars they worship and destroy.

For Anger, cinematic projection is an actual ceremony (rather than a re-enactment of something previously staged). It can therefore also function in the form of a prophecy – and, from time to time, a hex. As his films demonstrate, Anger believes strongly in what he describes as the 'cinema of correspondences'. He regards film as having the potential, when properly used, to invoke primal forces, perhaps even demons. Once released, these demons can affect not only those involved in the film's production, but also, through a series of occult circuits connecting physical with spiritual dimensions of existence, the film's audience. Anger claims that he's always considered movies to be evil; the point of cinematic images, he believes, is to 'control' lives and occurrences. 'My reason for filming has nothing to do with "cinema" at all,' he claims. 'It's a transparent excuse for capturing people . . . I consider myself as working Evil in an evil medium.' He regards film as a kind of terrorist aesthetic, a form of alchemy which works to bring both image and spectacle to life. Anger's *Hollywood Babylon* books, in fact, are chronicles of the ways in which lives have been cursed and destroyed by the demons of film.

Anger was perhaps the first filmmaker to understand the full potential of cinema, and the first to explore the full extent of the relationship between light, projection and image. And though his superstitious belief in the supernatural power of film may sound eccentric, it's actually a very common attitude, expressed all the time in the contemporary media. Christian organisations, censorship advocates, feminist crusaders, V-chip pioneers and other assorted campaigners for 'family values' regularly express a profoundly superstitious terror of the power of film to wreak havoc in our lives, to turn us all into perverts, child abusers and serial-killers. This attitude closely resembles Anger's version of cinema as the gateway to a demonic otherworld. After a screening of *The Exorcist*, for example, Evangelist Billy Graham declared that there's an evil embodied in the very celluloid of the film itself. In fact, the assumption that spools of magnetic tape encased in plastic contain 'evil' is very rarely called into question.

Similarly, it's an ideological commonplace that 'on-screen

violence' can lead to rape and murder. Many women, and perhaps even more men, seem especially terrified by the power of pornography to sexually arouse the viewer, thereby forming a potent threat to all those lies that are perpetuated in the name of 'the family'. On a long drive recently, I was listening to the Dr Laura Show when a young woman on the verge of hysteria called in to report that she'd discovered that her husband had been looking at a pornographic movie on video. Dr Laura's mindful advice? Grab the kids, get out of the house as soon as possible, and get the deranged pervert into counselling before it's 'too late' – a lot more draconian than the measures she suggested to a wife who'd learned that her elderly husband had been spending his lunch hours in Hooter's. A little bit of lunchtime lechery is innocuous compared to the terrifying lures of the magnetic videotape.

In the same way, Anger's belief in the talismanic capacity of film to evoke anxiety and trauma in its audience is not so unusual as it may first appear. In 1975, psychiatrist James C. Bozzuto described a clinical condition known as 'cinematic neurosis' – a condition that can apparently be precipitated by the viewing of a particularly disturbing film by previously unidentified psychiatric patients. Films that Bozzuto mentions as having caused this condition include *Psycho* and *The Exorcist* (though no mention of *Patch Adams*, the film that did it for me).

We often sneer at primitive people who believe the camera has the power to capture a piece of their soul, but the truth is, many people in the West have an equally superstitious horror of spools of magnetic tape. It's a popular truism that the moving image has the power to cause people to lose all their control and dignity, to turn gentle husbands into drooling onanists. And perhaps there's a certain amount of truth in this – perhaps the moving image *does* have a kind of supernatural power. But if it *does*, then surely the *real* sacrilege isn't the ubiquity of images of sex and violence, but that this wonderful, sacred medium is exploited as a tool to further the ends of a commercial economy. The *real* scandal is that cinema has become a function of capitalism, and the sublime magic of trapped light is used to make films like *You've Got Mail*.

THE DEMON CINEMATOGRAPH

'Lucifer,' writes Kenneth Anger, 'is the patron saint of the visual arts. Colour, form, all these are the work of Lucifer.' It was Anger who first understood that film, properly used and respected, is a spiritual form, a magical ceremony involving the display of trapped light. We often forget that the word 'media' is the plural of the word 'medium', the most common word for a channeller of spirits. The filmmaker is an artist working in light, his camera a ceremonial instrument of invocation, the cinematograph his magical sceptre. And the lord of light, of course, is Lucifer.

When Anger first began making his films in the 1940s, he designed his work to cast a spell over its audience by means of a creative synthesis of all aspects of the filmmaking process – cinematography, lighting, set design, wardrobe, acting, editing, lab printing, and projection. The intention behind films like *Puce Moment* (1949) and *Inauguration of the Pleasure Dome* (1954–6) was to open up the cinematic experience to new levels of consciousness not ordinarily attained during 'normal' daily life. The esoteric nature of these films is designed to help the audience attain an altered state of mind. Indeed, Anger once said that he wished he could bypass film completely and project images directly into the viewer's mind.

In later films like *Scorpio Rising* (1963), *Lucifer Rising* (1966) and *Invocation of My Demon Brother* (1969), Anger experimented with montage editing, projected, superimposed images and other forms of cineplastics in an attempt to realise more fully the esoteric magic of the cinematic process. For Anger, a screening of one of his films was a serious, potentially dangerous alchemical ritual, a kind of technical, hypnotic form of astral projection. The sinister, hermetic symbolism of *Lucifer Rising*, like the arcane optical effects of *Invocation of My Demon Brother*, are brilliant shadows cast by the perverse imagination of a master magician. To Anger, himself a high-level practitioner of occult magic (and disciple of Aleister Crowley), making movies was a way of casting spells in the form of 'shadow prints'. By combining the regular and the structured with

images of chaos (such as having the whole screen shimmer with glitter), Anger attempts to induce a state of hypnosis in the viewer, which will then leave them more receptive to occult signs and symbols. He also experiments with techniques like multiple exposures, subliminal cuts, celluloid that is scratched to create a glittering spray, abrasive editing, documentary elements and the use of strobes, split screens and hypnotic waves of sound.

Lucifer Rising, to touch on just one example of Anger's cinematic style, is intended to function like a spell, invoking feelings of anxiety and trauma in the film's audience through a free-form exercise in dream imagery involving taboo realms, mainly homoeroticism. Imaginative, hypnotic presentations of violence and perversion use the rich texture of myth to explore psychological conditions, focussing mainly on sexual neurosis. The montage of hermetic symbols becomes first dreamlike, then menacing; centuries of mystical thought are distilled into a series of voyeuristic fantasies, a kinky psychodrama backed by the carnival strains of a psychotic calliope. Anger intended *Lucifer Rising* to stand as a form of ritual marking the death of old religions like Judaism and Christianity, and the ascension of the more nihilistic Age of Lucifer. The old era burns itself out as the new one is born. To symbolise this process, occult images are mapped onto motifs taken from contemporary popular and youth cultures to create a series of ironic montages. The film thus represents the performance of a perverse Eucharist reversing the alchemical transformation of substance into essence through the invocation of cinematic demons. *This* is cinema.

PROCESSED FLESH

To point out that cinema has a transcendent potential isn't to stray too far from most people's realm of experience. Who hasn't been mesmerised, horrified, sexually aroused or moved to tears by the power of film? It seems to be a fairly widely held assumption that film has the power to provoke lust, inspire

crimes and cause madness, as well as to bless, and perhaps even to heal. Like all forms of art, cinema is a spiritual medium full of sublime metaphysical possibilities, with the capacity to provoke all kinds of intense and profound emotions, perceptions, insights and prophecies: the truths of trapped light.

Sadly, however, few filmmakers other than Anger have been brave enough to acknowledge the rapturous, elemental possibilities of cinema for taking us beyond what is 'real' and 'natural' to the sacred, hermetic realm of mechanism and artifice. In an essay called 'Modesty and the Art of Film' published in *Cahiers du Cinèma* in 1951, Anger describes the neglected art of this kind of abstract, non-realist cinema as the 'reflection of the divine fire of inspiration'.

> [T]his transient fire, this flash of light which appears out of the night and has to be given expression and yet which sometimes has the incandescent force of a newly-born volcano – is a fragile thing: a witch's light, St Elmo's fire. What Einstein called 'the first vision'. What a strange paradox, then, is the film medium, that magnificent and terrible instrument born of our time to tempt and torture our creative imagination . . .

How shameful it is that this 'magnificent and terrible instrument' has been appropriated by the commercial forces of capitalism and used as a crude advertisement hoarding for the sale of soft drinks and celebrity tie-ins, for the promotion of Gwyneth Paltrow and everything she represents. This 'incandescent force' has become no more than a simple club used to knock people broadly over the head and stun them for a while with a procession of stars while they guzzle down their piles of processed flesh. *This* is why I hate Gwyneth Paltrow and the whole Hollywood system she stands for – not because of what it *is*, but because of what it *could be*.

Anger's 1951 essay is actually a very eloquently voiced complaint about Hollywood's obsession with 'the grandiose, the epic, the big' – that is, the commercially profitable, rather than

the smaller scale, the more lyrical, poetic and personal. Anger argues that large-scale films necessitate a rigid commercial control that sacrifices freedom and spontaneity for the sake of a highly refined style and formulaic narrative. And if this were the case in 1951, how much more the case it is today, when it's virtually impossible to find a venue for films that are any less than feature length, or anything other than realist narratives, or not available on video, or in any way experimental in their formal and technical properties. 'The widespread neutralising of the essential point of cinema – its power to simulate real experience – enshrines its more offputting tendency. So we are now in the cul-de-sac of stylisation,' wrote Kenneth Anger almost fifty years ago. I bet he didn't see *Titanic*.

But if it seems tragic that this sublime medium is now used almost solely for commercial purposes, how much more pathetic is what goes on in the so-called *avant-garde*. So many of the kinds of films shown at arthouse cinemas and specialist screenings – films that are promoted as 'conceptual *tours de force*' that 'expand the frontiers of cinematic possibility' – are hung up on representing the world 'as it is', on photographing a mediated version of 'reality'. Filmmakers like Michael Mideke and Michael Snow might 'experiment' with different cinematic lengths, styles and textures, but they're still showing us things that exist 'outside the camera'. If you're going to be experimental, why not experiment with content, as well as with style? Why not show us some of those things that we could never see outside the cinema? Surely here, if anywhere, is a venue where cinema can be made to realise its full, rapturous, incandescent, magical potential?

Recently, a film critic in New York, perhaps sensing my need for further education in these matters, invited me to attend a special screening of *avant-garde* films being screened as part of this year's New York Film Festival. The first film, *Time and Tide* by Peter Hutton, consisted of thirty-five minutes of footage taken from tugboats moving slowly up and down a river. The second, *Arbor Vitae* by Nathanial Dorsky, seemed to be a series of extended close-up shots of butterflies, trees, shadows and people standing at a bus stop. The points of these films, or so I

gathered from the monosyllabic mumblings of their startlingly unattractive directors during an interminable question-and-answer session after the screening, was something to do with looking at ordinary things in a new way. The whole experience was a rather less entertaining reminder of sitting through my grandparents' out-of-focus slide shows of their barge holidays on the Norfolk Broads, except that the audience for the most part was so silently reverential that I felt embarrassed getting up to go to the loo.

My question is, why should we have to look at ordinary things in any way at all? Surely this, if anywhere, would be the venue for showing what is *extraordinary* – and, in particular, what is extraordinary about the transformative powers of the demon cinematograph.

TRASH CAN PROPHETS

Anger concludes his article in *Cahiers du Cinèma* with a call to those prophets of 'personal lyricism' who have the courage to 'restore faith in a pure cinema of sensual revelation', to 're-establish the primacy of the image', to 'teach us the principles of their faith: that we participate before evaluating'. With the help of such prophets, claims Anger, '[w]e will give back to the dream its first state of veneration' and 'recall primitive mysteries'.

> The future of film is in the hands of the poet and his camera. Hidden away are the followers of a faith in 'pure cinema', even in this unlikely age. They make their modest 'fireworks' in secret, showing them from time to time; they pass unnoticed in the glare of the 'silver rain' of the commercial cinema. Maybe one of these sparks will liberate the cinema . . .

If such prophets do exist, then it's pretty clear they're not going to be making films that star Gwyneth Paltrow. Nor are they likely to be found among *avant-garde* 'intellectuals' like

Hutton and Dorsky. And it also seems unlikely that their work would ever be screened at the New York Film Festival. In fact, to find this kind of cinematic poetry Anger is describing – the kind of cinema best represented by his own early work, perhaps – we need to look outside the realm of 'official' cinema to the kinds of venues where films like *Lucifer Rising* were first screened, and rummage through that obscure pile of cinematic detritus known as 'the underground'.

Having said this, it's important to point out that the phrase 'underground film' covers a lot of territory, and a great deal of underground film is 'underground' only because the director hasn't been able to secure a distribution deal, or because its subject matter is too disturbing, obscure or distasteful to attract a mainstream audience. The worst underground film is film that aspires to be *avant-garde*, only lacks the intelligence and historical perspective to do so. Luckily, however, such films are rare. The best underground cinema is genuinely spellbinding, and, in its perversely fascinating style, comes close to attaining the kind of cinematic metaphysics that Anger was calling for fifty years ago in 'Modesty and the Art of Film'. It's these seldom-screened, no-budget productions, many of which are created from footage literally rescued from dumpsters or stolen from trash cans, that most closely approach the aesthetics of pure cinema.

Mark Hejnar, a Chicago-based filmmaker, is best-known for his 1996 production *Affliction*, a forty-five minute documentary chronicling the life and work of several performance artists. Far more interesting, however, are Hejnar's shorter films like *Bible of Skin, Christian Hole* and *Dreams of Amputation*, in which found footage and home movie loops are mixed with images of Holocaust victims and other displays of human carnage. The resulting films are retouched and distorted until they take on the patina of a sexual, familial or psychic trauma, to be endlessly repeated but never overcome.

Hejnar's latest piece, a six-minute short entitled *Slow Death of a Large Animal*, is a haunting, elegiac montage of found footage put to an apocalyptic soundtrack by orchestral noise band Larval. And this is 'found' footage in the most literal

sense. Every single image is taken from someone's discarded waste. All the film stock used was found in a trash can, abandoned warehouse or burned-out store front in Detroit. Black-and-white images from a small-town carnival dance beside gaunt visions of Holocaust victims; semi-disintegrated film stock weaves abstract shadows on the screen. Strange, sad-eyed clowns and scantily-clad tightrope walkers go through their lonely routines, somehow rendered frightening and pitiful by the bleakness of the print. In the film's last sequence, Edison's famous elephant suffers the pangs of execution, and falls heavily to its terrible, heartbreaking death. Two figures are shot out of a circus cannon. A horse stands eating grass in a post-apocalyptic setting with the film stock decaying all around it, before the screen suddenly fades to a corrupt and dirty black.

Equally, powerful, however is *Sincerely, Joe P. Bear*, a four-minute, sixteen mm. movie made by Oregon-based filmmaker Matt McCormick. In this very short film, McCormick has appropriated a strange news clip from the 1960s of a pair of actors cavorting on a huge piece of ice in the middle of a New York street. One is a glamorous, bikini-clad starlet, the other a man dressed as a rather pathetic-looking polar bear. Intercut with abstract clips of hand-painted film, the footage is overlaid with a squeaky, halting voiceover in the form of a letter from the bear to his ice-queen lover, Francine, who's now gone on to greater things, leaving him behind, alone. This heartbreaking letter is read to the accompaniment of loose chords played on a harmonica, as the images from the news clip recur over and over again, in different colours and sequences, and inter-cut with abstract images and symbols. The finished piece is a genuinely haunting evocation of childhood traumas and adult pathologies. *This* is where the power of film is used to its full potential. Here, in this brief clip of footage from the trash cans of Hollywood, lies more insight and meaning than can be found in any number of Spielberg epics or Lucas blockbusters. The power of film lies not in the way it reproduces 'reality' but what it does with artifice.

In *The Picture of Dorian Gray*, there's a passage in which Oscar Wilde describes those kinds of terrible nightmares that

come during 'dreamless nights that make us almost enam-
oured of death', when 'through the chambers of the brain
sweep phantoms more terrible than reality itself', full of 'that
vivid life that lurks in all grotesques'. Then the dreamer wakes,
and real life returns, along with memory and consciousness –
and, with it, a mundane sense of our daily routine that is more
horrifying in its ordinariness than the most terrifying of night-
mares. 'We have to resume it where we had left off,' writes
Wilde, 'and there steals over us a terrible sense of the necessi-
ty for the continuance of energy in the same wearisome round
of stereotyped habits.'

Why do we expect the mundane banality of narrative real-
ism that forms the entire content of contemporary Hollywood
cinema to give us the transformative experience of art? Why do
we insist on digging 'below the surface' of the 'real world' for
intimations of the sublime, rather than transfiguring that reali-
ty itself? As Wilde says earlier in the same novel, '[t]he true
mystery of the world is the visible, not the invisible'. In the
refusal to accept what 'reality' offers us, in the spiritualising of
the senses – here lies the highest form of realism.

And *that's* why I hate Gwyneth Paltrow.

Mikita Brottman is the author of Offensive Films, Meat is
Murder, *and* Hollywood Hex, *and the editor of* Car Crash
Culture. *She also writes for a number of alternative and under-
ground publications. She has a PhD from Oxford University and is
Professor of Liberal Arts at the Maryland Institute College of Art in
Baltimore.*

RECOMMENDED VIEWING

1. *Teenage Gang Debs* (1966)
2. *Caged Heat* (1974)
3. *The Belles of St Trinians* (1954)
4. *Scrubbers* (1983)
5. *Chopper Chicks in Zombie Town* (1996)
6. *Mädchen in Uniform* (1931)
7. *Faster, Pussycat! Kill! Kill!* (1965)
8. *She-Devils on Wheels* (1968)
9. *The Female Bunch* (1969)
10. *Switchblade Sisters* (1975)

Hairy hands make light work

The beast and the machinations of female desire
Kerri Sharp

Walerian Borowczyk's *La Bête* was, until recently, a very difficult film to track down. Until summer 2001, it had been screened in the UK only about twenty times in as many years. I'd seen his five-section film, *Immoral Tales*, in 1997 and had been impressed at the time by the inclusion of an uncompromising scene of female masturbation in *Thérèse the Philosopher*. I first saw *La Bête* at the National Film Theatre on London's South Bank in 1998 – and there it was again. How many times does one see female masturbation featured in a movie that isn't straight porno? It's rare by anyone's estimation. Aside from Borowczyk's, *Immoral Tales*, it's in *Being There* (Shirley McClaine's spiritual scratchings), Ken Russell's *The Devils* and, er . . . that's about it. Female orgasm is portrayed on screen either as something that happens during penetration in a darkened room, or it's a joke on the lead man 'cos the chick has faked it (*When Harry Met Sally*). You get the picture? Mainstream cinema has always shied away from showing female onanism. Not only does it wipe out the need for the hero and his dick, any realistic portrayal is going to challenge long-held notions that nice girls are sexually fulfilled only through romantic love.

There's a lot of fucking in the movies but I would argue that very few sex scenes achieve anything like the creative realisation of the erotic in Borowczyk's films. Both mainstream *and* arthouse cinema are very fond of cathartic and steamy lovemaking scenes . . . and these always seem so crushingly dull. The jewels of the human sexual imagination are left unexplored while the camera prefers to linger on heaving body parts

in anonymous apartments. Moreover, the more intense and explicit the sexual relationships, the more downbeat and po-faced their actualisation seems to be. Think *Damage, Romance, Intimacy* etc. Why is today's cinematic passion such a grim affair, and so seemingly devoid of the *jouissance* we can find in older, more fantastical films such as *La Bête*?

Images of female rapture proliferate advertising. Used to sell ice cream, soap, moisturising cream, cars, toilet roll and fabric conditioner, the message seems to be that women are more likely to reach a climax from rubbing Oil of Olay in their shoulders than doing the nasty. The metaphorical representation of orgasm has become primary – to the detriment of representations of the real thing.

What you get in *La Bête are* glimpses of the real thing: hands going into pants and objects rubbed between legs in the broad daylight, in the afternoon. Given the director's fascination with the accretions of *mise en scène*, and his tendency to go off on tangents of fancy, it's not a bad effort in getting right in there and exploring the playfulness which is absent from more recent works that have attempted to explore female sexuality.

For those of you who haven't seen it, here's a rundown of the narrative: the film begins with graphic footage of rutting horses in the stable courtyard of a château. The stallion snorts and bites his mate; the filly's calm complicity is touching in its acceptance of her priapic aggressor. But she wants it as much as he does, given the shot of her oozing horsey hole. She does very little except flaunt it for him; he's hard and gagging for it and making a right tool of himself. This allegory will be repeated throughout the film.

Watching the beasts mate is Mathurin, educationally-challenged son of the Marquis de l'Esperance. The Marquis' estate will crumble lest he can marry off his backward progeny to foxy and wealthy American girl, Lucy Broadhurst. Lucy arrives, accompanied by her aunt, in a state of youthful enthusiasm for the beauty of her surroundings. She's photographing everything on her journey to the château, including the mating horses.

There are complications to the Marquis' plan to marry off

Mathurin to Lucy. Family law dictates that only the Marquis' uncle, a cardinal, can marry Mathurin and his betrothed but the uncle won't comply as Mathurin is a pagan (idiot other) and has to be baptised. And whom does the Marquis bring in to the house to perform the baptism? None other than the ageing roué that is the local pederast priest – who is always accompanied by his achingly beautiful choirboy helpers, desperately gorgeous in their androgyny. This is better than Buñuel. Not only does the director poke fun at the clergy; he effortlessly disempowers the sanctity of the church, making them out to be nothing more than confidantes of the French aristocracy. The irrational and ungodly has encroached onto the proceedings at the same time as the 'destructive' distraction of desirable female flesh. Everyone is thrown into a spin by this collision of elements of disorder.

Borowczyk is in tune here with the narcissistic side of female fantasy: the one that lets you be gorgeous to the point of causing chaos and allows your sexual attraction to exact a power of such magnitude that men will be confused by its efficiency while you reap the benefits. Lucy – having just arrived at the house – finds dusty reminders of her forebears. A corset preserved under a belljar exacts a powerful draw on our voluptuous subject. (There are echoes here of Max Ernst's *Une Semaine de Bonté*: pretty girls thrown into erotic rapture by the sight of seemingly innocuous objects.) Lucy then discovers a family album belonging to the eighteenth-century Marquise Romilda de l'Esperance. In the album is a drawing of a hairy creature – The Beast – and the inscription 'I fought and defeated him'. This beast is due to reappear every 200 years. Lucy's sub-conscious mind seizes upon the bestial theme that permeates the house and it isn't too long before she's in her room, using her Polaroid snaps of the rutting horses as erotic stimulation. She's interrupted once when a servant arrives, bearing a rose – supposedly a gift from Mathurin but actually sent by the Marquis. The servant has been called away at an inopportune moment: the Marquis' daughter has been seducing him in her room but now, left alone, pursues completion through the vigorous use of the bedpost. (All the women are at it in *La*

Bête.) The rose fails to impress Lucy – for the time being, at least. She is far too immersed in her imagination, fuelled by the more potent erotic souvenirs she inexorably stumbles upon. Isn't it every young girl's dream – to stumble upon the treasures of a bygone age: dressing-up clothes, baubles and 'things' secreted in dusty attics? Add a grown-up woman and take it all one inevitable step further and we're into territory that possibly only Angela Carter or Leonora Carrington explored with any real imagination.

Lucy, lying on her sumptuous bed, clad in a soaking-wet diaphanous gown, begins to dream about the eighteenth-century Marquise and her coupling with the beast that caused the famous, now-preserved corset to be ripped from her body. This fairytale dream sequence is accompanied by harpsichord music by Scarlatti and manages to be uplifting, sexy, liberating, scatty and beautiful all at the same time. It is this scene which is the most memorable in the film. This sequence was filmed originally as an eighteen-minute short, *La véritable histoire de la bête du Gévaudan*, which was devoid of any framing story featuring other characters. Borowczyk makes no concession to subtlety in this short sequence: a man in an ungainly but unclassifiable 'beast' costume cavorts, captures and ravishes the Marquise in the seclusion of the woods. During the pursuit she loses her powdered wig and, by this, seems to transform into a contemporary woman, sporting cropped hair and a very slender, almost boyish, frame. After her initial reluctance, she gives in to the power of the beast – his complete necessity to possess her – and applies enthusiastic oral and manual stimulation to his hairy pizzle.

The beast oozes copious amounts of ejaculate (it's rumoured the film crew used potato soup for these shots) lovingly captured in close-up, before he dies, spent. We get to see prolonged display of the huge spurting beast-cock – a treat for any female filth-hound despite (and maybe because of) its ridiculous size.

Lucy wakes up and begins once more to masturbate, this time using the rose to good effect. By this, Borowczyk cleverly ameliorates any need for subtle metaphor as cunt and rosebud

collide in glorious close-up. The camera stays focussed on Lucy's holiest of holies long enough to earn the film the 'slur' of pornography. This scene caused outrage when the film was originally released and was still powerful enough to make a significant number of the 1998 audience walk out of the screening at the NFT. Here, the character of Lucy is Everywoman in an hotel room with time on her hands and lust on her mind. She isn't immersed in the need to find anything so bothersome as a lover; she's happily self-contained in her reverie and is quite content using the *idea* of untamed lust as her trigger.

Lucy dreams again and wakes with the sound of the expiring beast ringing in her ears. She gets out of bed and goes to the idiot Mathurin's room, where she finds he is dead. His corpse is laid out later on, and he is found to possess a hairy paw and tail. Lucy and her aunt flee the house and the closure of the film shows the Marquise Romilda covering the poor dead beast with leaves and walking away slowly from the place of her carnal coupling.

La Bête works as a fine execution of the difficult-to-represent machinations of female desire. It would be far too glib to say the film was a metaphor for the power of female sexuality; it *shows* the power of female sexuality. The entire focus is on Lucy's newly-discovered carnality, prompted by close contact with the beast of the imagination. Like Angela Carter's *The Company of Wolves*, *La Bête* rejoices in the profane and the pagan and returns nature to sexual culture. Puritans and anti-porn feminists would have a problem with the bestial scene. The Marquise is effectively 'raped' by the beast and enjoys it. And so what? He's not Everyman; he's a mythical creature thrown up by the erotic sub-conscious. He's going to know what you want without you having to ask. You're going to get the fuck of your life without having to listen to chat about football. As Colin Davis notes in his article *True To His Own Obsessions – the Films of Walerian Borowczyk*, 'Makers of such movies are customarily accused of having a profound fear of the sexual woman but Borowczyk, though he often deals

with the power of aroused femininity, doesn't seem to be afraid of it.'

I'd agree with this and add that he doesn't see a need to punish his characters, either. None of them wind up dead, punished for their carnality in some paternalistic Judeo-Christian, 'told-you-so' nasty ending. The underlying message of the film seems to be that the sexual imagination is chaotic and bestial, and the sexual female is devouring and unwittingly dangerous. The women go on to revel anew, unscathed, while Mathurin and the best die and the Marquis is left to his financial problems.

In a culture where sexuality is sanitised and commercialised to the nth, it's refreshing to revisit work like *La Bête*. Liberating, provocative, aesthetically original and arousing, we have a duty to corrupt ourselves with such delightfully transgressive material. As this book goes to press, *La Bête* isn't yet available on video or DVD in the UK although, if anyone is going to release it, *www.salvation-films.com* are likely candidates. *La Bête* is available in the US from: *www.videoholocaust.com*

BIBLIOGRAPHY

Colin Davis, *True To His Own Obsessions: The Films of Walerian Borowczyk:* article in *Shock Express 2*.

Pete Tombs and Cathill Tohill, *A Private Collection – The Films of Walerian Borowczyk*. Article in *Immoral Tales*

A version of this essay was originally published in the UK *in* Headpress #19 *in 1999.*

Tura Satana hangs tough

Claws for thought
Jessica Berens

Black and white autographed photographs signed by Tura Satana go for twenty bucks a throw. The famous image is of her, as Varla, in Russ Meyer's 1965 film *Faster Pussycat! Kill! Kill!* where she is portrayed karate chopping a man to death in the desert. She is a demented Amazon; he is sprawled and helpless.

She wore a black T-shirt and black gloves and drove a very fast car – a superbitch with fists of steel. Tura. Varla. Varla. Tura. Beautiful murderess. Big and strong with amazing bosoms. She wasn't embarrassed. She was bisexual. She had it all.

The poster came with the tag-line, 'Russ Meyer's ode to the violence in women'. The movie arrived with a voiceover that described women as 'A dangerously evil creation'. This was something of a motif for Russ – the post-lapsarian animalism of the female spirit. His second wife was called Eve and the production company was named after her. In the Benny Hill Genesis of Russ movies the woman is always the diabolic temptress and very rarely the victim. And this, I am sure you will agree, is a very good thing.

Some lovely freaks are doomed to exist only on obscure websites or in the minds of esoteric theorists who can tell you the true meaning of Herschell Gordon Lewis. And do, given half a lager and half a chance. Varla, though, Varla lives. Car. Flick-knife. Tits. She was the best gang-girl of all. Like Louise Brooks, she lives because she was seen as dark and wayward and sexy, and, like Louise Brooks, her exalted position in the pantheon of Hallowe'en *madchens* far outweighs either her ability or input.

Tura Satana was aided by an extraordinary appearance – no

chemist-blonde she – at twenty-six she was dark, Oriental and decorated with black lipstick and false eyelashes that needed serious muscle to flick them. Femme men wanted to be dominated by her and butch femmes wanted to be her. She had pansexual appeal. Simple enough.

There have been bands dedicated to her. A glam rock outfit from Los Angeles once called themselves Faster Pussycat and asked Meyer to film their video. Later on another group named themselves Tura Satana and released a couple of albums. There is a magazine, *Varla*, devoted to music and women and a kind of goth-trash ethic. And, here and there, Manhattan nightclubs still hold theme evenings in her honour. Dangerous burlesque is camp and glam and always good for dressing up. So now she is up there with Frank N Furter and Cruella de Ville and Morticia. If you get the point of the *Bride of Chucky* you'll get the point of Tura Satana.

I met her at her niece's house in Burbank: the street was leafy and sunny and the house was full of children – fifteen to be exact – because the niece, Joy, had started having them when she was sixteen. 'Will I have another baby?' she says. 'I expect so. That's what I do.' You wouldn't believe the energy of this woman. She is forty-two. She is just laughing and making cups of tea as if nothing had happened. She is going to the hospital later because her sixteen-year-old adopted daughter has just had a baby. 'I've told her *she's* got to look after it!'

There are children everywhere. Teenagers lope about and one 'special' little boy hugs everybody. Children wherever you look and pictures of them covering the wall: a lot of bridesmaids and those terrifying school photographs with the centre-parting that everyone has to buy. Joy runs a catering company and she also runs Tura's fan club. Tura gets fan mail from all over the world. On a shelf there is a loving display made into a shrine of her memorabilia – old black and white photographs of her as burlesque queen; a video of Astro Zombies in which she featured as a detective amongst a lot of low budget extra-terrestrials.

'The older I get the more popular I get,' she says.

She is sixty-one now and she has six grandchildren, three of

whom live with her in Reno. Long black hair hangs witchy down the back: she is wearing a Tura Satana T-shirt and black jeans. Not tall, but big. Like an old rocker chick or Hells Angel mama.

Quite a lot of things have happened to her, as you might imagine. Both in the present and in the past. She is a widow, having just lost her husband, Eddie, who used to be a police-man and then started an engine rebuilding business in Long Beach. Tura knows a lot about cars and a bit about men. 'I like guys with character,' she says. 'I don't go for pretty faces. I don't want to be in competition with them as to who gets the most attention. I like them to open doors for me, to cater to me, but to let me be independent. I like a guy who lets me be me.'

Eddie taught her how to use a gun and gave her a .38 spe-cial for her birthday. 'I have a licence to carry a concealed weapon,' she says. 'I have a pair of boots with a holster and a .35 Sig Sauer.'

She is not frightening exactly, but she looks tough in a blue collar Roseanne way; you wouldn't go up against her, put it like that, though you might wonder what she looks like naked. She works as a security officer at the Hilton hotel in Reno, wears a badge and everything, and you can see her with the belt and handcuffs, as you often see those kind of women in America, in uniforms, wide and manly, standing at the doors of banks.

She looks as if she has the potential to be very aggressive indeed. Lori Williams, who played Billie in *Faster, Pussycat*, told me that she was 'terrified' of Tura when she first met her, but this, as Tura herself says, is largely a defence mechanism. 'It was the same when I was dancing,' she says. 'I was terribly stand-offish. Once people got to know me they realised it was a different story. I am a very happy go lucky person. I love peo-ple. I love to talk to them. I love to learn about them; you can learn something new from somebody every day.'

She had to learn to protect herself pretty quickly because she was raped in an alley when she was ten years old. She was on the way back from the bakery, in their neighbourhood in Chicago, and five Italians jumped her. It should be mentioned

that Tura, at the age of ten, had a pair of 34c breasts and they had made her famous locally. The kids at school had always had their hands all over her. So did the teacher. There was a sexuality around her which was enhanced by the fact that they were the only Oriental family in the neighbourhood. The breasts and the exotic looks stirred up devilry – so five grown men between the ages of seventeen and twenty-one jumped a little girl and fucked her in the back of their car.

'They all had a go.'

She crawled home bleeding and her father went mad. Tura knew who the men were, as rape victims so often do, and they were arrested. They were arrested but, according to her, they bought the judge off. 'You could in Illinois at that time,' and, as a result, it was Tura who went down. 'They said it was my fault. That I had enticed them . . . I still resent that . . .' She went to a juvenile detention centre for three years where, again, she had to look after herself. 'I made friends after I beat up the bully.'

She was thirteen when she came out and she was different. She probably would have been different anyway, her mother was in the circus, her father was Filipino, but now she was really different. She had had sex for a start. And her breasts were huge. They ended up double FF. She was thirteen going on thirty-three. But she did not hate men and this was thanks to her father, who not only taught her Aikido and Karate, but listened to her pour out the trauma of the rape.

Despite the kindness of her father, she could not forget it and she could not let it go. She felt that she could not move forward if she did not avenge herself.

She came across the first on a street in Chicago. She walked up to him and asked him if he remembered her. He did not and proceeded to make a pass at her. She lured him behind a building and (thanks to the Karate) kicked the life out of him.

The second was with his girlfriend in a Chicago nightclub. She flirted with him until he left his girlfriend and followed her out of the club. 'He's talking a lot higher these days,' she says.

She ran into the third while she was working in a joint in Detroit. He claimed to be with the syndicate. 'I knew bigger

people,' she says. 'And I gave them a call. They took care of him while I watched. He will never hurt another female again.'

She came across the fourth while she was on a plane to California. She seduced him, beat him up and proceeded to tell his wife everything.

The last member of this unlucky group turned up at a party in Chicago. Again, Tura faced him in front of his wife and informed her that her husband had raped her when she was ten. Then she and her policeman boyfriend took the man upstairs.

'It took me fourteen years to get them all,' she says. 'But I did.'

The family decided that she should marry the son of her father's best friend, John Ellinger – who was sixteen – and who did not love her in a marital way, but had known her for ever, so they got married in Mississippi, which was the only state that allowed them to, and went to live on a military base. But John did not know much about sex. Things dissolved and Tura started stripping in nightclubs, where the breasts, at last, became an asset. But again, they stirred up trouble. Once she was shot at by a jealous boyfriend. Once she found a man in her cupboard, just like that, hiding after a show.

Her shows were burlesque, with a giant Buddha, glittering head-dress and tassle-twirling. She did not tend to actually take her clothes off, except once, for Harold Lloyd. She posed for him nude. He told her she should be in films.

She was married to a jockey, Lester Balaski-Satana, for a short time. He adored her but that marriage too dissolved. She bore her first daughter, Kalani, by a lover in 1958.

In 1963 Billy Wilder cast her as Suzette Wong in *Irma La Douce* and then she met Russ Meyer who was looking for someone to play a turbulent lesbian. It was 1965 and she was stripping in the Pink Pussycat club in West Hollywood. He was forty-four and one of the most controversial film directors in America. Even in the sixties he was controversial, thanks to movies like *The Immoral Mr Teas*, his 'comedy for unashamed adults', which had enjoyed record-breaking box-office success and opened the way for a genre of saucy nudie flicks that were

the precursors of porn as we know it. *Mr Teas* featured a man
on a bicycle secretly enjoying the sight of various naked ladies.
It owed a lot to *Monsieur Hulot* and it established Meyer's per-
sonal pantomime of pop-eyed men and wiggling women.

The son of a policeman and a registered nurse, Meyer start-
ed out as a photographer, taking cheesecake shots in the fifties
before progressing to his singular brand of erotic filmmaking.
He is set apart from mundane sleaze by a comic vision and a
worldly insouciance that remained unrepentant in the face of
years of feminist complaint and censorship pressure, both of
which he saw as useful promotion tools.

The question of his misogyny is destined to remain in the
eye of the beholder and will doubtless crop up eternally in
post-fem discourse. Certainly he was fearless, driven, and
occasionally very brilliant, particularly at first, when the satire
was sophisticated rather than vaudeville. But none of the icons
that he created were rewarded with either dazzling careers or
useful residuals and some of them came to regret working with
him. Edy Williams (to whom he was married) claimed that her
appearance in 'sexploitation' had killed her chances of ever
being considered for a dramatic role.

Edy had begun happily enough as the star of a nude water-
skiing sequence, but the relationship ended acrimoniously with
battles about money. She told the *Hollywood Reporter* that it
was not going to be easy to move 134 bikinis out of their
Beverly Hills mansion. He, meanwhile, told the *Toronto Sun*
that she was a 'thoroughly unpleasant person' who had mar-
ried him to 'further her own career'. The exploiter, had, appar-
ently, been exploited. Tit for tat, in every meaning of the words.

Anyway, he had this script and needed a curvaceous Kali
willing to work for $350 a week. They all went off to the
Mojave desert for a month – Tura and Haji and Lori Williams
and a couple of lunkheads who were destined to become road
kill. *Faster, Pussycat! Kill!Kill!* was released as a drive-in movie
in 1965 and it wasn't acclaimed as a work of great genius. The
LA Times decribed it as 'ludicrously erotic' and the *San
Fransisco Chronicle* said it was 'the worst script ever written'.

Tura and Haji went back to dancing. They were both single

mothers with daughters to support. Tura had a second daughter, Jade, in 1969. Lori Williams started to get parts in *Charlie's Angels*, then she too had a daughter. Everyone dropped out of sight.

In the eighties some important things happened. Meyer, who owned the rights to most of his films, successfully cashed in on video with the result that he became richer and his weird opus entered the common culture. This meant that his sixties psycho trash-queens could be seen by anybody and now they remain in circulation, unlike, for instance, the similar sisters who had starred in the *Mini-Skirt Mob* ('hog straggling female animals on the prowl'), *The Hellcats* or *Sisters in Leather*.

The lads loved him. In England sexism was (and still is) fashionable, acceptable and amusing, thanks to the success of *Loaded* and similar men's magazines that have had about the same effect on the progress of gender thinking as the publication of the *Malleus Maleficarum*.

At around the same time John Waters wrote in his book *Shock Value* that *Faster, Pussycat* was the best movie that had ever been made and not only did he write it but he also said it on various American chat shows. Waters was amongst the first to articulate and celebrate the white trash aesthetic – he knew that huge-bosomed, huge-haired women in crochet-knit flared jump-suits were cool, cool, cool.

Russ became legit. Once dismissed as a 'Neanderthal hack', his fiestas of 'gravity defying giganzos' started to receive honourable accolades. He was awarded various prestigious retrospectives and a *Guardian* lecture. Theorists started to refer to his 'Steinbeck' period. He was called a 'radical structuralist' and compared to Jean-Luc Godard.

Tura, meanwhile, had a car accident that nearly killed her. She spent two years in and out of hospital; she had to have surgery to bring the feeling back to her left leg and hands and she had to go to Canada in order to receive injections in her lower spine that would allow her to walk again.

But the film students were waking up to the quality of Meyer's work, the fans were starting to write and culty 'zines wanted interviews. Get a website, they all said. So she did.

Now she owns her name and has copyrighted it. She is her own merchandise. Russ Meyer, always the *auteur*, owns the *Faster, Pussycat* images, so she can't sell those, not unless she buys them from his company. The attorneys write letters telling her this. It is all attorneys now because Meyer has senile dementia and is out of the picture. King Leer, in his seventies, is in his final act. He is up there in the Hollywood mansion with a cardboard table and a disappearing memory and everyone wondering how the kingdom will be carved up. But his creations are still out there, alive and loved and selling themselves. So Tura buys the videos from the company – Russ Meyer Films International Inc – and sells them on. Now Varla is Tura Satana: the character is as significant as the actress. You think of Varla you think of Tura. Varla Tura, Tura Varla. And this is right, she thinks, as she brought a lot of herself to the character – her personal anger, as well as the martial arts which her father had taught her after she was raped. 'Russ would always listen to my suggestion,' she says.

Now it's all email and personal appearances and cult movie conventions where Count Yorga has promised a personal appearance and the Troma mob have got racks full of *Toxic Avenger* and things about singing cannibals. There are a lot of geeks selling vintage posters and sometimes the other Ultravixens turn up. Haji. Lori Williams. Cynthia Myers. All with their photos and posters. Kitten Natividad sits quietly in a corner doing her knitting. Kitten was an Ultravixen too. One of the breastatic legends. It was ironic actually because Russ paid for her implants so that she could be Lola Langusta in *Beyond the Valley of the Ultravixens*, then, twenty-five years later when she got breast cancer, he helped to pay for the double mastectomy.

But the longest queue is the queue for Tura. She who was never really an actress, never even that ambitious, has achieved immortality. Varla is a snarling icon of the collective unconscious, enervated by the unfathomable causes that mean some characters survive and become totems while others disappear into the B-movie sludge of vampire mermaids and go-go zombie trash.

Why, I wonder, did she never work with Meyer again?

'His other films were just basically tits and ass. I felt that I had too much talent for that.'

Jessica Berens is co-editor of Inappropriate Behaviour.

Old news

Online lover had corpse in freezer

A twenty-eight-year-old man has given up surfing the internet after discovering his new-found love was a pensioner with a corpse in the freezer. Trevor Tasker flew to America to meet Wynema Faye Shumate who posed as a sexy thirty-something on the web. She was really sixty-five and kept a dead body in her freezer. Shumate was jailed for one year while Mr Tasker is now back home in Selby, North Yorkshire. He now refuses to use the internet. Mr Tasker flew to South Carolina after Shumate hooked him with sexy chat and sent him a semi-naked photo taken thirty years ago. His shock at the airport turned to horror when he discovered Shumate had put her dead housemate Jim O'Neil in the freezer. She kept him there for a year while she lived in his house and used his money. He had died of natural causes. She had also lopped off one leg with an axe because the body was too big for the freezer. Shumate pleaded guilty to fraud and unlawful removal of a dead body and was given a year in prison.

Sheikh your booty

Belly dancing for older women
Zaida

ATTITUDE

**'Don't wait for the light at the end of the tunnel.
Stride down there and light the thing yourself.'**
The most difficult lesson for older women to learn is how
to overcome their upbringing, the rules which were drilled into
their minds from infancy: 'Do not wiggle your hips'; 'Do not
flaunt your bosom'; Don't show off'; 'Don't draw attention to
yourself'; 'Sit with your knees closed'; and the most often
repeated instruction –
'If you act like a lady, you will be treated like a lady.'
To **ENJOY** belly dancing, you must unlearn all these Do
Nots/instructions – except the last one. That one still holds
true in any situation. Always act like a lady.

You will find that, as you progress into the intricacies of the
dance, you will understand that you are NOT flaunting your
body – you are expressing your inner self, the self you have
always been instructed to suppress. You will find a newborn
sense of 'me'. You will be thrilled to experience your femininity.
You will learn to 'FLY' and release your soul. You will learn to
be **WOMAN**.

Many older women, when first experiencing belly dancing,
find that they cannot make LARGE movements with their
arms. Their torsos are rigid and unyielding and they cannot
raise their eyes to look at anyone else in the class. Try to allow
yourself six months' trial, before deciding that belly dancing
is not for you. You will never look back. Your friends will
see a new person. Your husband will discover he has a new and
exciting wife. You will feel much more calm and 'laid back'.

Once you are more relaxed with yourself and can accept that your body movements are an expression of the music you will find a whole new world, which you did not know existed. Think of yourself as the music. Think of yourself as a musical note dancing to the tune. Think of yourself as anything other than an 'older woman'. You could have at least thirty years of dancing ahead of you. Enjoy yourself.

Discarding your inhibitions will improve the intimate areas of your life. Older women, having matured prior to the release of the contraceptive pill, grew up knowing that the only reliable form of contraception was the word 'NO'. When you mature with a specific mind-set, that will remain with you all your life, unless you deliberately work at changing your attitude. Belly dancing will free your mind as well as your body.

Do not try to get into other people's heads (especially your adult children) and worry about what they are thinking. They have to live their own lives. You have to live yours. You have no need to worry, or care, about what people think about your dancing. The nice people will be happy for you, when they see how much you are enjoying yourself. The others don't exist.

This is your playtime. You have earned this time for yourself.

DANCING & MUSIC

'Achievement is largely the product of steadily raising one's level of aspiration and expectation.'
You will become so enthusiastic over your new-found passion that you will be unable to stop yourself telling anyone who'll listen all about belly dancing. This will lead to invitations to dance at parties and at gatherings of your peers – especially women's groups.

These groups are very appreciative of any entertainment and will support you wholeheartedly when they see how much you are enjoying yourself. At each party or gathering you will receive a number of enquiries about how to learn. Remember, if nobody was prepared to entertain his or her peers, life would

be very dull. You will have a 'party piece' which will really make them sit up and take notice.

Choose the places where you will perform very carefully, and you will never receive any unpleasant responses from your audiences. Old people's homes and hostels, care facilities, club functions for older people, private family celebrations are all fun places to dance.

You may like to select an exotic name as your dancing persona. It certainly adds to your performance to be introduced as Sheherezade rather than Jane. If you are looking for an Arabic name, type Arabic Names in your Search box and you will be 'smothered' in sites containing names – and sometimes, their meanings.

Enjoy your dancing and your audience will enjoy watching. Belly dancing is not a chorus-line dance such as Riverdance. Its charm lies in the self-expression of each dancer. Each dancer moves differently and there is none of the rigidity found in classical dance such as ballet, where a certain move HAS to be done in a certain way. Each dancer interprets the music and the various moves in her own way.

A classic example of this is the interpretation of 'The Camel'. This is a very simple, basic move, where you imagine you have a hinge just below your ribs. You do a figure eight on this hinge; imagine someone has given you a sharp poke in the small of your back causing you to move your spine forward, and then a sharp poke in your belly button causing you to shrink your belly upwards and backwards. With practice you will develop an undulation.

If you do an opposite figure eight, this is 'The Fish' or reverse 'Camel'. You can layer this basic move in any way you wish, with arms, legs, head, feet, shimmies, walking, travelling, anything at all, but the basic 'Camel' remains the same.

MUSIC

Westerners, with their passion for order, have devolved a musical scale which has equal intervals between notes. This is the

sound to which our ears have become tuned, since birth. Eastern music uses a microtonic scale which incorporates intervals smaller than a semitone. This can sound quite discordant to the Western ear, until that ear is trained to accept the new tonic scale. Thus, many dancers prefer Westernised music. Some even dance to modern pop music. This is within the nature of the dance. After all, the dance was originally the dance of the ordinary people, and they danced to their ordinary music – 'pop music' – before the term was invented. You dance to whatever music works for you. My personal preference is for the Arabic sound which has been Westernised enough not to be discordant to my ear but which has not lost the Arabic 'feel', the complicated rhythms without the high-pitched wailing sounds. I also tend to avoid vocals, because I have no idea what is being said . . .

SWORDS

Some dancers enjoy dancing with a sword. This can look very spectacular, but is not for every dancer . . . it is a personality thing. If you like the sword, you can obtain finely-crafted, perfectly balanced, lightweight, blunt swords, designed purely for dancing and made from stainless steel or bronze, from a true swordsmith, who has studied the history and the art of manufacture then had his swords 'road tested' by a professional dancer who loves to dance with swords.

COSTUME

There is no 'uniform' costume for belly dancing. Follow your own inclination. You understand your figure perfections and imperfections better than anyone. Many older women have beautiful legs and delicate ankles – design your costume to display this perfection in you. You may, in the beginning, have a thickened torso. Don't worry: this will soon diminish, much to your joy. In the meantime, design your costume to minimise

the torso. This can be achieved in many ways with soft draping or decorative beads and fringes. You know best.

Costumes need not be expensive. You can raid thrift shops, buy old ball gowns and chop them up to your heart's content. You may even combine two or more gowns to achieve the effect you wish. You may find beading or fringing in these shops. If not, Christmas decorations are usually very pretty and some are strong enough to withstand the demands of dancing.

Plan your first costume just for the classes. This way you will learn what adjustments you need to make in order to have a serviceable but comfortable outfit. Also, your dancing in class will be enhanced when you are dressed in context. You will slip easily into your dancing persona. Leave your everyday self at the door. Enjoy yourself. I like to wear a yashmak – and people have said to me '**I didn't know it was YOU!**'

SALUBRITY

Salubrity – 'conducive or favourable to health or wellbeing'.

To become a belly dancer, there is no limit on body weight, height, age or eye colour. Dancers progress at their own speed and ability and are not pressurised into performing at a level of activity beyond their comfort zone. All the movements used in belly dancing are designed to strengthen the muscles and improve flexibility. In doing these movements, the muscles work on the internal organs of the body and improve their performance.

Balance is improved as the leg muscles strengthen and knee, hip and ankle flexibility improves. Shoulders are stretched and flexed until the shoulders are completely free and can move independently through a wide arc of movement. The rib cage is moved sideways, forwards, backwards and in diamond and circle configurations whilst keeping the remainder of the body completely stationary. Then the hips are moved through the same movements whilst keeping the rib cage stationary.

Abdominal muscles are flexed in circular movements upwards, sideways and obliquely, creating abdominal rolls, flutters and waves. All these movements are performed whilst moving the arms, feet, neck, shoulders, even eyes and eyelids.

When muscles stretch and contract they stimulate the many vital organs within the torso as well the lymph system. Elimination of toxic substances within the body will be markedly enhanced by the stimulation of the lymph system. Exercise decreases blood volumes in venous reservoirs such as the spleen. The shifts in reservoirs makes more blood available to the heart, arteries and exercising muscle and makes respiration more efficient. The body learns to mobilise sources of nutrients rapidly for energy production.

Doctors are now recommending belly dancing as a pain management system for women suffering from endometriosis. Blood pressure is stabilised; the heart muscle is strengthened and lung capacity increased, and the whole body is left with a feeling of well-being. Dancers find that heel or spinal vertebrae spurs cease to be troublesome, and arthritis symptoms are noticeably improved.

Fertility is enhanced and a dancer can expect a trouble-free pregnancy and birthing. One lady, a midwife, suffering from agoraphobia after the birth of her son, found that belly dancing helped her to regain her self-confidence, as her ability improved. Dancers find that they feel more confident and worthwhile. They also become much more sensual women. Dancers' spouses are the most enthusiastic supporters of this form of dance. After a belly dance session, dancers are on a 'high' and ready to 'party'. A dancer will probably take about six months to reach a good standard of flexibility, muscle power and balance; but even the first lesson will be fun, with much laughter and happy feelings. Western dancers have to overcome their rigid upbringing, but once they learn that there is no embarrassment in moving the body, and come to love the driving music, they will become enthusiasts.

Zaida, 64, lives in Queensland, Australia. She discovered belly dancing four years ago and now performs at old people's homes and

care facilities as well as at fund raisers and local social groups. She is keen to promote the health benefits that arise from Middle Eastern dancing, and her philosophy can be found on her website: http://welcome.to/Zaida

Helping the aged

Fashion leader redefines style for seniors

Pauline Trigère, the ninety-two-year-old design icon who has dominated fashion circles for decades, is turning her tailoring talents to America's senior set – long ignored by traditional retailers. In fact, while most of Seventh Avenue is still trying to figure out its internet strategy, Trigère has just inked a deal with retailer Gold Violin for a collection of luxury goods targeted to older consumers. The Pauline Trigère Collection for Gold Violin will be available exclusively at the company's online store (*www.goldviolin.com*) and in its popular catalogue. Gold Violin is the first retailer dedicated to upscale products, unique gifts and services designed for older adults. 'At my age, for me to start something new, it must be very special,' says Miss Trigère. 'Designing products for people like myself, people who need a little assistance, but who haven't lost their sense of style, really intrigued and moved me. I noticed, especially at the theatre, how many people walk with canes and how unstylish they are. Just because we are getting older, doesn't mean that we have to look it.'

Bringing originality to the design world for more than sixty years, Trigère first arrived in the United States after leaving her native Paris in 1937. She settled in New York City where she quickly found success as a fashion designer. Known for a unique combination of old-world French elegance and American practicality, she has created designs for many celebrities and dignitaries, including the Duchess of Windsor, Josephine Baker, Angela Lansbury, Anne

Bancroft and Lena Horne. The Pauline Trigère Collection for Gold Violin includes her new signature handcrafted walking sticks, a custom walker bag and matching pill case, an eyeglasses case made of sumptuous red leather, and more. Gold Violin is the first and only online store and catalogue dedicated to upscale products and services designed exclusively for seniors. In a category that has traditionally been defined by bland, depressing products, Gold Violin infuses the market with a sense of optimism, elegance and style.

Press release from New York public relations company LaForce & Stevens

Raging Grannies starter kit

(It's never too late to protest)

1. BRING TOGETHER A GROUP OF FIVE OR MORE WOMEN.
• You do not have to be a grandmother and you do not have to be a good singer. You do have to have a lot of spunk and believe in progressive politics.
• Strive to start with a multi-ethnic group. It's very difficult to change the racial composition of an established group.
• It helps to have one person who is the song leader.
• Make a 'Grannies' sign and take it to all performances.

2. DRESS FOR THE PART:
• Go to your closet or the thrift store and get crazy hats and a 'granny costume'. The more colourful the better.

3. FIND SONGS TO SING, THEN PRACTISE, PRACTISE, PRACTISE:
• Order *The Raging Grannies Songbook*.
• Being able to carry a tune helps, but clear enunciation of the words is more important than being in the right key.
• The Seattle Grannies practise twice a month and perform about two gigs per month. We find this keeps us plenty busy.
• If everybody knows five or six songs by heart, you can usually wing it with the rest.

4. KEEP IN TOUCH:
• Have a telephone tree to keep in touch with everyone in your group.
• Please let us know of your existence so we can post you on the web.

The Raging Grannies are an American direct action group who use song to raise awareness about peace, the environment, and social justice. Dressed in wild hats and 'granny' costumes, they have demonstrated at rallies against nuclear power, militarism, racism and at other places where they are neither expected or wanted. They can be contacted at openhand@jps.net.

Godhead

Satan gets a manicure

Changing perceptions of pagan practice
Kerri Sharp

'*I will not be other than I am. I find too much content in
my condition.*'
 Young French witch, early sixteenth century.

My attraction to things 'pagan' began at a young age. I
was always happier playing in the woods than watching TV
(unless *Catweazle* was on) and narratives of sorcery, transfor-
mation and animal wisdom held an uncommon attraction for
me. As an eight-year-old I practised my own religious rituals;
these included a mockery of the holy communion I learned at
convent school, and a re-enactment of the immaculate concep-
tion involving an inflatable skunk and a giant plastic fish – who
played the parts of Joseph and the Virgin Mary respectively.

By the time I was twelve I was carving 'Satanic' symbols
into the floor of the school games room, scaring the prefects,
and farting about with a Ouija board. I devoured trashy novels
by Dennis Wheatley and wanted to be Caroline Munro in
Dracula AD 1972. Puberty was a good time for me as it coin-
cided with the sexualisation of British culture and a cinema
that was the sleazy pagan horror movie's golden age.
Everything suddenly seemed marvellously rude and danger-
ous. Horror, the supernatural, paganism and witchcraft
seemed to be bound up with erotic experimentation. In the
early 1970s one couldn't pass a cinema without luscious
pornographies and vampiric lovelies molesting the sexual psy-
che. From horror movies to comics, an 'adults only' warning
was plastered on everything I was attracted to – which, of
course, made it all seem far more exciting than it probably was.

I would scan the back section of the London *Evening News* and get the cheap thrill of looking at the tiny newsprint ads for 'X films' showing in the West End: *I am Curious, Yellow; Lust for a Vampire; Cool it, Carol; The Flesh and Blood Show; The Devils*. And those small words: Danish. Blue. Adult. Flesh. Deep. *Devil*. They made me throb with excitement. A lascivious attraction to the heathen got into my bloodstream around that time and has remained there ever since. Two films particularly stand out as being quintessentially British and pagan – *The Wicker Man* and *Blood on Satan's Claw*. Neither film features the overblown gothic motifs of the Wheatley-esque 'witchcraft' movie – inverted pentagrams and the like – and the locations are rural, outdoorsy, rather than Hammer Horror high Victorian.

The dominant theme in both films is the conspiracy of rustics; ripe and sexually confident young women are the wayward protagonists who undermine the (male) figures of authority through lust, earthy humour and feral behaviour: the pious clergyman in *Blood on Satan's Claw*; the uptight Calvinist policeman in *The Wicker Man*. In the early 1970s – when these films were made – paganism was represented as anarchic and unpredictable, flaunting its ripened sex in the faces of the squares. Look how silly the law was when it tried to arrest the fool and his bladder, the teaser and the 'Obby Oss, the horned dancing men.

These days, paganism is a sanitised and politically correct affair. Its assimilation by the whiter than white mind, body and spirit industry has meant that there's barely a trace left of a heathen thrill. Across Britain and the US, well-heeled desperately seeking somethings are happy to pay handsomely to get the authentic 'sacred' experience of their ancestors – as if we can ever know what that was. One can now easily access a spectrum of innocuous weekend lifestyle choices, ranging from sword and sorcery vision quests to goddess-centred workshops to find the crone within. And I don't want to ponder too long on the 'men's movement': I know that beards and nakedness are involved, in a gentle way, at the same time, and that's enough for me.

The problem with these workshops is that they're never what you want or envisage them to be; they're never as magical, as strange or as life-changing as the stuff you can make up by yourself. And that's really the point. When the New Age industry starts dealing in pre-history and magic it makes an ass out of you and me. At some point in your quest for the ultimate sacred experience I guarantee you'll find yourself standing in a circle of dull white-collar workers from the Home Counties, making polite conversation. You may get to share some wine and look fondly at a few trees, but you'll probably have to listen to some embarrassingly bad prose and go home feeling faintly embarrassed with yourself. If you want thundercracks and orgiastic feasting, or the chance to feel immense power and awesome transformation, you'll need to look elsewhere.

Silently holding hands – or worse, bashing bongos – around the stones at Avebury does not inspire. What happened to the earthy, anarchic, *celebratory* experience? If you look at eighteenth-century prints depicting the Beltane festivals, for instance, there's more of the Bacchanalian tableau and less wishy-washy reverential smugness, especially around issues of sexuality. Not 'grounding breathwork for sacred honouring of women's land' but unholy revelry, snorting with the bulls and rutting in the mud, preferably drunk. And that's how we like it.

While the politically correct and the profiteers dominate the new paganism (paganism without horns, if you like), traditional folkloric practices of the British Isles die out by the year. How many rural schools even erect a maypole these days? Since the mid 1970s, the indigenous and curious 'calendar customs' of Britain have been dropping away – and this, to me, is something of a tragedy. Books like *A Year of Festivals* (1972) document hundreds of fascinating, unique observances, whose origins are rooted in the ordinary people's right to have a bit of a laugh or a day off work, rather than in striving to be something 'sacred'. In actuality, many customs evolved to mark rights gained against landowners and overseers. The four-hundred-year-old Birdlip cheese-roll, for instance, held in Gloucestershire on Whit Monday, harks back to when the

villagers won the right to graze their sheep on the local hill, which has a one in three gradient. A huge cheese is tied with ribbons and set off down the fearsome slope by a fancy-dressed master of ceremonies. It is pursued by those who dare, some of whom end up with broken limbs and squashed noses. Risky, but a hoot nonetheless. The starting point of the chase is marked by a ceremonial staff – a reminder of the villagers' rein-stated right to dance around the maypole – a 'pagan' practice outlawed by the Puritans and revived after the Restoration.

This all seems a lot more fun than the risk-free reverence and stoned-crusty aesthetic that dominates much of today's pagan practice – the solstice rituals, for instance. Personally, I'd like to see more intensity in these rituals, and a more radical application of them. It amuses me to envisage a new 'calendar ritual' of initiating young men into adulthood, psychically and sexually. I'm convinced it would prevent them becoming such appalling little shits later on. Dose them with a hundred magic mushrooms apiece and take them to some desolate landscape in the darkness of Walpurgisnacht. Set up initiation camps, complete with fire-walking, scary masks and ritualised howl-ing. Make one of those 'endurance TV' shows out of it, if you like, but put the fear of the Devil in them. Would they be so keen to embark on a lifestyle of street robbery with violence if they'd been forced to kiss the smoking hoof of Beelzebub? Can't see this being put on the Home Secretary's agenda for tackling youth crime, but it's surely no worse than bunging them in detention centres and brutalising them even further. Oh well, I can always use it as a storyline for a new British pagan horror movie, throwing a couple of horned beasties in for dramatic effect. While we're on the subject . . . what about that old Devil? What's happened to him? Many neo-pagans believe he's just a demonised version of the original Great God Pan, himself Greek.

This isn't intended to undermine the genuine experiences of those trying out goddess-worship, druidry, shamanism, the Northern tradition, the Native American way or even the old favourite of seventies exploitation cinema, Wicca or witchcraft. I want to focus on the changing *perception* of pagan practice. As

the New Age industry assimilates and conflates a variety of traditions – and makes up a few new ones along the way – our understanding of the history of pre-Christian religions becomes blurred. This confusion seems to have its roots in Margaret Murray's *The Witch Cult in Western Europe*, published in 1921. Since its publication we have readily mixed witchcraft and paganism together, believing them to be the same thing under different names. Murray postulated that those who were branded 'witches' were really the benevolent pagans of pre-Christian Europe. She advocated that the mass burnings and torture were the church's response to paganism, so fearful were they of being toppled by a rival religion. This is an accessible theory – and one I had believed myself until I looked further into it – but it is generally incorrect and couched in romanticism. Richard Cavendish states in *The Black Arts* that not enough is known about the pagan religions of Western Europe to tie them to what became the 'witch cult', and there is no evidence to suggest paganism as such survived much beyond the reign of King Canute in 1035. It took about a thousand years for Christianity to suppress the old practices, assimilating feast days and places of worship into a Christian framework, but by the mid eleventh century there was nothing going on to suggest anything like a 'pagan cult' in existence; nothing of the proportions that would be seen as a major threat to the Christian order.

Witches were regarded by their Christian botherers as an entirely new group of heathens from the simple country folk we think of as 'pagans'. Satan was very much the Devil of Christianity rather than the friendly 'horned one' of an older religion. It is interesting that almost all witch trials are devoid of reference to pagan gods and goddesses. The main dude in the fray is always the Christian Devil. In fact, the vast majority of people accused of being witches were Christian. Also, the height of the burning times coincided with the Reformation and the rise of Lutheranism in the sixteenth and seventeenth centuries when any old reactionary could set himself up as a witchfinder general. This is some five hundred years after the suppression of the Anglo-Saxon and earlier Germanic heathen

traditions. And it was the local secular courts that were responsible for 90% of deaths during the burning times in the UK and USA. Not robed priests but puritan councillors and their henchmen – righteous zealots with suspect agendas – using the Bible as an excuse to torture.

Apart from Murray, it is feminist spirituality that seems to have had the most influence on the way neo-pagans think and behave. Their thoughts on institutionalised Christianity during the period of the fourteenth to seventeenth centuries – full of brutal misogynists who would torture women given half the chance – are along the right lines, but their reinterpretation of pre-history as the one-stop time-slip to caring, sharing matriarchal societies is absurd. While I'm no fan of patriarchal religious systems, one cannot just gloss over the nasty, brutish and short reality of life in ancient times and pretend it was great, simply to bolster your contemporary rituals. It's all too easy to evoke a Neolithic golden age where the mother goddess was honoured and we happily danced our moon rites before proto Indo-European warrior tribes came to bludgeon the sewing circle. In fact, there has never been any concrete evidence to support the claim that matriarchies existed on the scale the feminist spirituality movement has professed. We need something other than a few stone figures of fecund women to convince me that females were revered as anything other than fanciable. The Willendorf Venus may be nothing more 'sacred' than Neolithic porn.

I also find their embracing of fertility as the pinnacle of the female condition particularly irksome. One look at the awful poetry and art of the 'We Moon' daughters and their wombyn/cunt mothering obsession has me clamouring for Marinetti. Give me speed, dynamism and the future! Camille Paglia said something along the lines of, 'if civilisation had been left to women, we'd still be squatting in mud huts'. Having gone under deep cover at various healy-feely neo-pagan events and seen what goes on, I've come to the conclusion that she's right. Too much embracing of the goddess just leads to wearing bad trousers and morphing into happy-clappy brood humans. And the old Horned one seems to have

been booted out of the celebrations altogether. It's enough to make you shout for that old time religion.

When it comes to writing the story of pre-Christian practice, a good many – like the goddess-centric feminists – seem to make it up as they go along. There's nothing wrong with that in principle – but we have to keep a perspective on things. We can apply our imaginations to personal rituals and to fictional narratives, but we have to be careful when we start accepting as historical fact what is pure speculation.

However, I don't want to delve too far into pre-history here, as it's the self-confessed Satanists who interest me the most; those 'daughters of darkness', whose imaginations were fired by such intensity, whose confessions were so wildly vitriolic and pornographic, and whose behaviour was so very inappropriate. Accounts of their gothic/Satanic high revel span the thirteenth to the eighteenth centuries. There are some real shockers in there – girls whose antics will never be appropriated into today's anodyne goddess workshops. These girls were not nature-loving Timotei maidens who had acquired a bad press.

The earliest accounts of the witches' Sabbat appear in the first half of the fifteenth century, although witch hunts as such began in France in the early thirteenth, just after the crusade against the Cathars in 1209. The 'success' of Simon de Montfort's grisly suppression of the Cathars, or of anyone speaking of a dualist religion, sparked off a fashion for scaremongering. 'Devil worshippers' could be lurking everywhere. The irony was that the Cathars and Gnostics were more ascetic and pious than the Crusaders and the Catholic bishops of the time, renouncing the ways of the flesh and living in isolated communities, doing no one any harm. All they dared to suggest was that there may be two powerful beings: one good, one evil. The Crusaders received a Papal decree to kill them all, and to seize their fertile land into the bargain. Western Christianity became a religion of struggle and terror; a battle against pestilence, famine and unimaginable poverty. The ordinary folk could never be sure that good would triumph, and many became obsessively superstitious.

At the same time, others became consumed by their own fertile imaginations. From the earliest accounts, cannibalism featured prominently in witches' 'confessions'. Catherine Delort and Anne Marie de Georgel were two elderly witches from Toulouse, who were tried in 1335. Georgel willingly proffered information of her and Anne Marie's twenty-year relationship with the Dark One, telling of how she regularly 'submitted to his pleasure'. Her lover was a he-goat that taught her spells, invocations and how to offend God by constructing sacrilegious communions. Delort also spoke of adoring the he-goat, serving his pleasure and that of the others present. She said they drank disgusting potions and feasted on the corpses of newborn children.

An anonymous publication, *Errores Gazariorum*, written about 1450, gives an imaginative account of a witch's initiation. Oaths are taken, including ones to kill children aged three years or under, and to do one's best to impede marriages through sorcery. (One appealing facet of the witch cult seems to be the intense horror of marriage and procreation.) After kissing the Devil on the rump the initiate is given a staff and a box of magic ointments and powders. Then everyone takes part in a feast, chewing on . . . yes, grilled children, as a special treat. The lights are put out and there is an orgy 'without regard to gender or family relationships'. After a couple more rounds of this behaviour, everyone urinates and defecates in a cask, 'done in contempt of the sacrament'.[1]

When it comes to the Black Mass, it's hard to know which came first: the accusation or the practice. I reckon there was a bit of the Ned Kelly syndrome going on; if you were going to be put to death anyway, why not go completely over the top? You'd heard all the elements: the Devil, goats, flying to the Sabbat, cannibalistic infanticide . . . weave them into a story of your own making, add a few original touches, and voilà! Between 1673 and 1680 at least fifty members of the clergy were put to death in France for partaking in the Black Mass. By that time, diabolical possession among nuns had become something of a tourist attraction. The confession of Normandy nun Madelaine Bavent (1647) is one of the most lurid of all,

and includes details of regular Satanic get-togethers among nuns and priests, and a few special guests. Animal costumes were worn, and always the most filthy of acts were performed. They would feast – sometimes on roasted human flesh, apparently – after partaking in frenzied orgies. According to her testimony they were particularly fond of nailing blood-red consecrated hosts to the figure of the crucified Christ. On one occasion a woman brought her own newborn child to the proceedings and had it crucified alive on a wooden cross. We will never know if these acts really occurred or if the uncompromising details were the works of a fevered, sexually repressed imagination either on the part of Madelaine or the men who transcribed her 'confession'.

This was undoubtedly a hellishly risky time to follow a left-hand path. The excruciating tortures inflicted upon those found guilty were carried out with such relish that one imagines something of a siege mentality must have taken hold of large areas of rural Europe. When talking to a cat could get you disembowelled and see your entrails being burned in front of you and the eyes of your whole village, one had to keep one's nocturnal experiments under wraps. The inquisition against heretics threw up holocaust-sized numbers of victims and details of their deaths make grisly reading indeed. This was the time of splitting live bodies asunder, the putting out of eyes with hot needles; stretching, drawing, quartering and burning; squassation, sawing in half and impaling. All done, of course, in the name of God the father. When you may as well have been hung for a sheep as a lamb (or for nothing at all) it seems that many of our ancestors really did go for it in their unGodliness.

Fornication with the Devil was a particular favourite. So much power was attributed to him that he must have seemed sexually potent and terrifying and attractive in equal measure beyond the wildest reaches of our modern imagination. His cock is often described as being unnaturally large (unsurprisingly) and his semen cold. However, what he lacked in warmth he seemed to have made up for in stamina. 'He is abler for us that way than any man can be,' spake Isobel Gowdie in

Scotland, 1662. When he was pissed off, though, 'he would be beating and scourging us all up and down with cords and other sharp scourges'.[2] No worse than the Lord of the Manor, then. Curious is the way so many witches stuck to their stories. Jeanne Dibasson spoke of the Sabbat being 'the true paradise'. Another apparently beautiful twenty-eight-year-old spoke of the masterful grip the Devil had on the hearts and wills of his women. So many hundreds of witches were given the opportunity to renounce their behaviour and repent. So many hundreds stuck to their stories and died laughing. Mary Phillips and Elinor Shaw were asked to pray at their execution but they chose to laugh uproariously, 'calling for the Devil to come and help them in such a blasphemous manner as it is not fit to mention'.[3] Mind you, if you'd gone to all that trouble to secure a place in Hell as Satan's right-hand woman, you were not going to renounce and repent at the last minute and scupper your chances.

In the Middle Ages – even through to the seventeenth century – the rural populations of Europe knew little of what went on outside their own barnyards. The means of communication were scant and there was not much in the way of recreation other than fucking and drinking. Incest would have been rife, rape too. And there would have been gossip aplenty. The vindictive tittle-tattle of illiterates and sadists was responsible for all manner of barbarity. It only took the fibs of some nasty little brat saying, 'old Greta suckles her cat with a third nipple' to see some poor old dear being hauled off for unimaginable torture. People haven't changed that much. The notion of bands of sacrilegious Satanists roaming Europe, indulging in cannibalistic infanticide and goat-fucking orgies is an entertaining one but is doubtlessly untrue. However, a reversal of fortune through making a pact with the Devil must have seemed an attractive option after a winter of bashing manglewurzels with frozen arthritic hands, and a significant number of people probably gave it a go. Let's not forget, either, the anarchic spirit of rebellion. There has always been an insurrectionist minority under any regime – those happy to experiment with the extremes of human experience and collective transgressive

practice – making it up as they went along, drunk on heady intoxicants and lust. One can imagine possible conversations: 'I hear old Alf's got a goat with three bollocks. Let's get 'im up 'ere, girls. Have a go at one o' them black masses.' 'Aye, and I hear tell Aelfric's brewed up some good cider this year . . . which is nice.'

Addle-pated early Christians believed that witches and magicians could perform their acts and invocations only through the assistance of supernatural beings. This twaddle came from our old friend St Augustine who condemned anyone practising astrology or sorcery as being in league with demons, using Isiah 28.15 as his inspiration: 'We have signed a treaty with death and with hell we have made a pact.' Over two thousand years later, fundamentalist America is still belting out the same explanation. An Oklahoma high school suspended a fifteen-year-old student in October 2000 after accusing her of casting a magic spell that caused a teacher to become sick. Brandi Blackbear was fond of writing horror stories and seems to have had a mild interest in things of a gothic nature, although name-calling had made the girl's life at school unbearable. A lawsuit alleged that the girl was summoned to the office of the school's assistant principal after a teacher fell ill, and was questioned about her interest in Wicca. According to the lawsuit, Blackbear had read a library book about Wiccan beliefs and, under systematic interrogation by the assistant principal, said she might be a Wiccan. In fact, Blackbear is a Roman Catholic. The interview ended with the assistant principal accusing the girl of practising witchcraft. The lawsuit stated that because of the 'unknown cause' of the teacher's illness, the assistant principal told the girl that she was an immediate threat to the school and suspended her without delay for what he determined to be a 'disruption of the education process'. This teaches us we should never, ever, assume those in positions of authority are rational, or that they will not dredge up the skewed reasoning of their own imaginations to justify 'punishments' – especially where young women are concerned. This brings to mind Marina Warner's call that, 'It seems vital . . . to own up to irrationality within the Western tradition.'[4]

I would argue that the history of paganism, witchcraft *and* satanism is part of the overall irrationality that dominates religion generally. One can't look at the history of religious belief without considering the history of the imagination (the 'oculus imaginationis' or 'inner eye'). Ultimately, all we can be sure of is that there are animals and humans, consciousness and ideas. The variables thrown up by such a mélange are enough to be getting on with, without bringing vengeful deities into the equation. The history of human experience is comprised of the marvellous to the abysmal and everything in between. We are capable of creating grand narratives – dark and florid – and given to stunning displays of artistic licence in all forms. We also have to remind ourselves that if we can imagine it, someone has probably done it; history, crime archives and the world's art galleries prove this point. We are hungry for transcendental experience, but seem curiously content to latch on to half-baked belief systems to give our lives meaning. And it is when belief systems become dogma that existentialists like myself run into trouble. This said, the religions that give an equal amount of respect to the tricksters and demons as they do to the 'good' guys seem to be on a more even keel than those following monotheistic beliefs. If we're intent on following a religion, we might as well trawl all the archetypes of the imagination. As Joseph Campbell said, 'all the gods and goddesses live within us'.

The fact that the greater percentage of the world's population believes in a singular God is not to my mind a cause for celebration. I would suggest that this is an atrophied awareness of human potential as it surrenders ultimate responsibility to one (presumably mythical) entity. The great gardener and philosopher Pascal noted that man never does evil with such relish as when he does it out of religious conviction. History is still proving him right. The seemingly indefatigable human impulse to play the game of 'my god is better than your god' will continue to throw up a fistful of catalysts for war, persecution and greed. The more fanatical the religion, the less it seems to make sense. And if you don't believe it, check out the environmental policy of America's Christian fundamentalists –

hand in hand with multinational oil companies and burning children's books; or the Taliban, blowing up ancient sculptures and bakeries: what's their policy on deforestation and population control?

If losing your religion is too scary a concept, remember that being an atheist is not necessarily synonymous with living in a state of numbness, inhumanity and misanthropy. Rather, it is an unsullied condition that leaves you open to the experience of discovering new things each day – becoming a growing, thinking being, unencumbered by dogma. Don'tcha wanna be one of those? As we discover more about the human brain – the biggest uncharted region left to us – the more we will hopefully come to appreciate the potential and the vastness of that interior landscape and say, 'Enough with the fairy stories!'.

Given the runaway upsurge in consumerism and commercialism over recent years, and its decidedly unspiritual agenda, it is no surprise that neo-paganism has seen a huge rise in popularity. But it doesn't always have to be as lame and wishy-washy as the stuff that's proselytised by the mind, body and spirit industry and their prohibitively expensive and often ludicrous 'healing' workshops. The forgotten or dubious religious practices of our ancestors make for interesting anthropology. Resurrecting them – or making them up as you go along – can also be a great way to have fun and meet people. However, we might also care to look at what's happening to our environment in the here and now and question why we still think of good and evil as autonomous forces, separate from the complexities of human behaviour. What 'evil' can be proven other than that which comes from religious fanaticism, a dysfunctional personality or – more commonly – excessive profit at the expense of human rights and the Earth? On that note, it's taken us less than two hundred years to royally fuck the ecosystem of a planet that's several billion years old. This may not be our movie-narrative concept of evil, but it's the biggest threat currently facing us as a species. That, and over-population. I'd like to see all the demons of the underworld unleashed if that would put an end to the gross exploitation of the world's resources.

To my mind the new paganism's presence is most beneficial

when it lends itself to movements such as Earth First!, the anti road-building lobby, and the sabotage of GM crops, where passion for the defence of nature takes on the multinationals and goes some way towards encouraging people to stop and think before hacking down another irreplaceable ancient woodland. Even if there isn't a 'great mother goddess', it is still in our own interests to respect the planet.

We need to shake off the pompous bigotry we've inherited from the patriarchal, monotheistic religions and wake up to responsibility. The ethos of man's right to dominion over the natural world has morphed us into a stupefied, celeb-obsessed, non-stop-breeding mass of uglies. We're stumbling like zombies, seemingly unaware of the damage being caused by our excessive consumption and endless spewing out of more and more babies. The United Nations Population Division recently estimated there will be a growth of over three billion more people within the next fifty years. If the acceleration of births continues at its current pace, there will be nine billion more of us by the year 2150, threatening our already imperiled ecosystem and obviously limited resources. Forget nuclear attack; we're going to breed ourselves out of existence.

It seems that something heart-stoppingly awesome needs to happen to stem the tide of dumbed-down greed, ignorance and non-stop human reproduction that appears to be encouraged on a global scale. Maybe collective demonic conjuring could be the answer. We should get the Devil back from those Iron John workshops. Make him angry again. I'm willing to give it a try . . . on the condition that I get to parade about in a diaphanous frock and look ravishing, like on those 1970s movie posters.

NOTES

1. Richard Cavendish, *The Black Arts*, p.308
2. Ibid, pp. 317-318
3. Margaret Murray, *The Witch Cult in Western Europe*, pp. 25, 26
4. Marina Warner, *The Inner Eye – Art Beyond the Visible*, p. 13

BIBLIOGRAPHY

Richard Cavendish, *The Black Arts*
Margaret Murray, *The Witch Cult in Western Europe*
Geoffrey Palmer and Noel Lloyd, *A Year of Festivals*
Marina Warner, *The Inner Eye – Art Beyond the Visible*
Cletus Nelson on Pentti Linkola, *Extinguish Humans, Save the World*
www.eyemag.com/archive.eco.

Kerri Sharp is the co-editor of Inappropriate Behaviour.

Win a date with Jesus

Male seeks female. Relationship: short-term, long-term
Body type: athletic. Height: 6ft 2″ Age: 27 Weight:
185 lbs. Hair colour: blond
Ethnicity: European-American Employment: full-time.
Education: college degree. Marital status: single. Has
children? No. Wants children? Yes. Smokes? No.
Drinks? Socially.

Description: golden-haired, blue-eyed Jesus seeks
loving young woman (18–29), preferably of recent Norse-
Germanic heritage, who wishes to live in the spirit of the
eternal. Innocence, or rebirth into innocence, and a desire
to transcend the material mendacity of this world are
essential! I offer a pure and spiritual existence of life's
essence, free of fear, free of despair.

I will reveal the bliss, power, and endless rewards of
faith and belief. The right woman who is ready for my love,
blessings, and unforgettable spiritual exploration will be
given the world, but will also want to give me her world in
the mutual quest to share the infinite. I offer you the abili-
ty to experience the fulfilment of your dreams and all you
seek. Prospective respondents should read 1 John 4:18.
True to artistic depictions, I have a lean swimmer's body
and a six-pack, and if you have sought your best in life you
will also be in good shape.

Please note: this is a legitimate ad. I am highly spiritual,

though not religious, and have often been called Jesus because of my appearance and powerful spirituality that I attempt to share with others. If you live in the DC metro area and are seeking a loving, trusting relationship founded on the mutual search for meaning in life as well as the desire to share deep romance and limitless passion, please reply with a description of yourself and a photo. This journey spans not only spirituality but also uncovers our place in the context of the peak moments expressed in culture, art, philosophy, and historical events. Dynamic, eclectic, curious, confident, intelligent, attractive, faithful and brave women are desired. Musicians and artists especially favoured. Characteristics: emotionally secure, energetic, positive. Things I enjoy: long romantic walks, lying on a grassy field at night gazing into the stars, the music of Beethoven, Bach, Burzum, Schumann, and Grieg, nineteenth-century German philosophy (especially Nietzsche and Schopenhauer), cooking dinner for a special woman, exercise of all types, composing and recording music, Northern European culture and values, deep and honest conversation that gets beyond ego, seeking out the best that life has to offer, and sharing tender cuddling that transcends time. Location Northern Virginia suburbs. Contact personal ad@jesus.com

Nun's the word

Once a Catholic, always a pervert
Julia Collings

When I was little, I was surrounded by Catholics. Not surprising, since I was at a convent school. What is surprising is that years later, I have unintentionally surrounded myself with them again. The fetish scene is full of lapsed Catholics, most of them submissive, to an extent that defies explanation by mere coincidence. The truth is that Catholicism is perfect training for a lifetime of indulgent pervery.

The Catholics I meet on the scene are the most unfucked-up Catholics about. Elsewhere are Catholics who, even after virginal marriages followed by umpteen kids, remain racked with guilt. For Catholics there's no truer catharsis than pervery; they're the best masochists around. And the more I see of masochists in general, the more I realise what good Catholics they would make. Far from crossing themselves in horror, I'm sure that the nuns of my old school would be delighted to see what London's submissives are up to. Faith, self-denial, worship, genuflection – all good Catholic concepts adopted by the modern-day masochist.

From the depths of its core, Catholicism is masochistic in nature. Only pervery can equal its juxtaposition of pain and sorrow with pomp, ceremony, gold and candle wax. And only pervs and Catholics can make a huge ritual out of something where the ultimate point is to cause discomfort. Take going to Mass every Sunday. For me, as a young girl, this consisted of the ritualistic getting ready, having my hair viciously brushed and pulled back, and being dragged along by a mother who wanted to go even less than I did. My mother's reluctance served only to make me more guilty at not being enthusiastic –

which has led to an immense gratitude to anyone who goes out of their way to cause me pain! Upon leaving the house, there was the essential arriving early, 'to get a seat at the back'. For years I thought the back was a more holy place to be, until it dawned on me that it was to make a quick exit before the priest came round and shook hands with everybody.

On Monday morning there would be the grilling by Mother Superior to find out who had missed Mass on Sunday. Any names would be duly noted, and the miscreants' mothers snubbed for a week at the school gates. I see all these mothers as the original dominants and their daughters as submissives, desperately trying to bear amounts of pain and boredom so as not to let their doms lose face.

If you admitted to missing Mass, you would get the sad shake of the head from the nun with the words, 'It's a shame, because Father Burns said something very valuable this week. In years to come, when you're married with children, you'll wish you'd heard it.' I'm sure that the resulting inane fear of missing something is the main reason why, even now, I can hardly bear to miss a fetish night out. In fact I'm sure that most of London's fetish clubs are populated by not-so-lapsed Catholics terrified of missing something if they don't turn up.

Of course, cause and effect wasn't generally a large concept in a world where punishment was rarely connected to any crime. A portly nun would stand at the doorway at break, randomly dishing out strokes of the cane she held so expertly in her hand. So the idea of punishment was taken totally out of context, and became something to be embraced at any time or place. Far from dreading random pain, you felt unlucky if she missed you out. Another idea which I'm sure has stuck with me: anything that hurt was 'good for you'. The dishwater-esque soup that was meted out every lunchtime was inevitably sloshed around the bowl until a black and white figure plonked you on her knee and proceeded to choke you with a soup-filled spoon. The whole room became a chant-filled hall. 'But I don't like it!' would come the cry. 'Then it must be good for you!' would be the echoed response.

The whole basis of Catholic thought provides a perfect

framework for the current masochistic spirit. Firstly, the idea of Original Sin. We are all born with the curse of Adam and Eve's first sin: the biting of that shameful apple from the tree of knowledge. Therefore we all need to be punished, whether we have done something bad recently or not. So we should always feel guilty. The only way to alleviate some guilt is to bear some punishment, to do our penance. Then we can be forgiven, however temporarily.

It stands to reason that the more punishment you accept, the more you can be forgiven and the less guilty you are. Of course, the more naughty you are, the more you will be punished and the greater will be your forgiveness. It's a never ending cycle of needing to sin, to feel greater guilt, to get a bigger punishment and earn more and more forgiveness. The whole system is designed to produce more sinners than saints.

Of course, now I am a reasonably sane adult, I know I don't have to sin to be punished, I just have to ask very nicely. And as well as being good for me, the pain is actually quite pleasurable. It's never quite enough, though, to be punished to the point where it feels nice. I need to go beyond those boundaries. It is a spiritual interaction and, the further I go, the deeper and darker and better for me the experience will be. And when the endorphins kick in, I like to imagine myself as Joan of Arc with a serene expression on my face, oblivious to what is happening to me, on a different plane in communion with some higher force.

Like the burdens of Job, I need each masochistic experience to be harder and not easier than the one before. The serene joy of the martyr comes from being able to go that little bit further than before. Deviancy is attached to the sexuality of both the masochist and the martyr – they are both outcast by their peers, ostracised and, eventually, burnt, stoned or imprisoned for their beliefs.

It's not so much the pain, as the act of submission that really does it for me. A Catholic upbringing instils in you the idea that you are just a small part of the greater scheme of things. Denial is holy and Martyrdom is to be aimed for. Offering oneself up to a higher truth is the purest thing that one can do.

Whenever I enter into a sub-dom relationship, it is as an attempt to emulate the offering up of the self to God. Over and over as a Catholic schoolgirl, I heard the words of Mary quoted and recited: 'I am the handmaid of the Lord.' It instilled in us the command to go out and be submissive to another's will. If I didn't have an SM context to do it in, I'd either be living monastically in a shed in Shetland, or spending my whole day cooking and cleaning for some dodgy boyfriend in the North of England.

Being a masochist isn't a mere catharsis for Catholicism. In fact, I doubt I could be a better Catholic in any other way than as a perv. The act of masochistic submission is symbolic of the greater, religious submission. And the master or mistress is symbolic of the greater power. Through Catholic teachings, we are asked to put our faith completely in the higher force. Masochism requires the same sort of unconditional trust, of putting your life and safety in someone's hands and, further, consenting to allow that person to do what they like with you. As in Catholicism, so in SM, in that without consent, the act of submission is meaningless. The experience of emotional/physical pain is nothing unless given into gracefully.

Even on a practical level, SM is much more in keeping with the rules of the Catholic church than any other manifestation of sexuality. There is no need for contraception (a big no-no) and technically one could be a raging SM-er and still be a virgin. The fetish scene even offers the opportunity to ensure that virginity remains intact: chastity belts, the stitching up of the labia and vaginal piercings locked together all offer protection to the mighty Hymen. SM-ers can lead a full sexual life fully clothed and without any genital contact whatsoever.

Tight rubber clothing shields the body from view and direct touch. Of course, the hiding away of something makes it even more sexually appealing, which is the key to fetish clothing, serving to allude to rather than to reveal. Nothing else comes closer to the habit of a nun than a full rubber catsuit. Of course, if fetish clothing is about hiding what's there, covering up and only hinting at the flesh underneath, then nuns have it down to a fine art. Nowadays, sadly, the urban convents are a

bit downmarket. If you pass a nun in Tesco's, she could almost pass for a businesswoman: plain, no-nonsense white blouse, A-line skirt, opaque tights and sensible shoes and cardigan. But the veil always gives it away, shrouding the face like a halo. Or like a hood and collar.

The nuns of my childhood were much less scantily dressed. They are the breed that rubber nun fantasies feed on. Shrouded in reams of black heavy material, they didn't walk so much as glide towards you, with a fierce look in their eye. Constraining was a big thing with nuns, particularly where the hands were concerned. The traditional and compulsory sleeping position in Catholic girls' boarding schools was on the back, with arms lying exposed on top of the blanket – an aid in resisting the temptation of touching one's genitals in the night. In a Catholic childhood, no sin is greater than the desire to masturbate (masturbation itself being completely out of the question). I'm sure that's the reason behind my pervy childhood imagination.

Terrified of thinking traditional sexy thoughts, I spent hours at night imagining things I felt to be far away from sex. Just innocent things like spankings, torture, kidnappings, restraints. Thanks to a good old Catholic education, I was virtually led by the sinful hand into the world of fetishism. Here, sex was cerebral and through a particular fetish, sex can merely be everyday contact with the object of de-contextualised desire.

It wasn't until years later that I began to realise that my innocent thoughts may have had something to do with sex after all. When children are developing sexual feelings, and mainstream sex is taboo, then obviously these feelings are going to manifest themselves in a less (to the untrained eye) obvious way. In some ways this is not unrecognised or even unwanted by Catholics. A London Sunday newspaper recently ran an interview with a nun who chose to live her life in solitude. The interviewer asked her why she chose to live in such an unnaturally sexless way. The nun's reply was that the reporter must have a very narrow view of sexuality. The nun claimed that she was living a very sexual life, because all touch and smell and awareness was sexual and didn't begin or end with

intercourse. Words which could have come right out of a perv's mouth.

A masochist may well live like this nun, leading a full sexual life in a non-traditional sexual way. In this life, devotion is the offering up of oneself to a master or mistress, seclusion is the rites of bondage and the vow of silence is submission to the gag.

Catholicism has always portrayed the love for God as a masochistic love, for it is the love of the unobtainable. The first medieval religious lyrics portrayed the emotional pain of loving as one and the same with physical pain. The woman had her master in Jesus, and the man his mistress in the Virgin Mary. Similarly, the Catholic church has always endorsed ritual as a means of accessing this love for the divine. The pomp and theatre, role-playing and suspension of disbelief integral to the pervy experience can be found each Sunday at Mass. The turning of blood into wine and the burning of candles to a background of eerie music make it look like a scene straight out of 'Torture Garden'.

The fetish scene imitates Catholicism in many ways. There are seven sacraments in the Catholic church: Baptism, Penance, the Eucharist, Confirmation, Matrimony, Holy Orders, and the Anointing of the Sick (formerly Extreme Unction). Each of these has its own celebratory ritual, and each is analogous to some stage of life in the fetish community.

Take Baptism, when your guardians take you as a baby to have your head doused with water and become a member of the church. This is preferably done as soon as possible, for if you die first, you end up perpetually in limbo and can never make it to Heaven. Baptism on the fetish scene is the first visit to a fetish club and is quite often a baptism of fire.

Penance begins with the first Confession, where you learn the art of developing enough sins fit for telling a priest. It takes a bit of practice to get the sins quite right. Once, the usual 'didn't tidy my room', 'swore at my mother' stuff didn't quite flow for me and, as I'd not been able to think of anything substantial to tell him, the priest didn't give me any penance to do. I was mortified and cried for hours. The next time I went, I

pretended that I had stolen a box of chocolates. I got a big lecture, five 'Our Fathers' and a surge of happiness. On the fetish scene, this is akin to revealing your pervery to your grandparents.

First Holy Communion is when the girls get up in white dresses like bridal gowns, the boys wear red sashes, and you all partake of the Eucharist and of a bit of transubstantiation together. Then you enjoy your first consumption of flesh and blood (if you believe in the magic). For SM-ers it is analogous to the first real SM experience that transcends all past sexual moments.

Then there is Confirmation. This happens at around twelve years of age: now you are an adult who can confirm your own faith and become a fully responsible member of the church. For the perv, the equivalent is realising that the fetish scene really is the way forward. You're on a couple of mailing lists, you read the magazines, you build a dungeon and you realise that most of your new friends are perverts.

Then there's Marriage: finding the person you really want to be with for the rest of your life and deciding to have kids, or else being so desperate by now for a shag that you take the first person who comes along. This is like deciding on your favourite fetish and deciding upon a very expensive, life-lasting piece of equipment to indulge it.

Holy Orders is the alternative to this (though only for the men). You become a priest and dedicate the rest of your life to spreading God's word among the populace. On the fetish scene, you become a club runner, magazine publisher or SM rights campaigner. Then there's the Last Rites. A blessing for the body on its imminent departure from the soul which is about to wend its merry way to (it is hoped) Heaven. And for the perv? It's Fetish Fatigue.

Of course, today's masochists have no reason to fear that they will go anywhere other than Heaven. In fact, if I hadn't turned out a perv, I'm sure I would be on my way to Hell, for I would never have found another lifestyle which emulates so perfectly the rules of Catholicism. Once a Catholic, always a perv.

A couple of hundred years ago, in small villages in England, the priest would deal out spankings to the penitents who came to him for confession. Apparently, the queues of girls ready to confess would stretch all the way out of the church and down the lane. This didn't last very long and church attendance seems to have been dwindling ever since.

Today, masochists are continuing the Catholic search for purity and honour, bearing pain and acting out rites of servitude and worship. They are the new martyrs, accepting the torment of their 'adversaries' with humility and grace while personally ritualising the experience and upholding the old truths of unconditional love and devotion.

With Church membership dwindling, women clamouring for equal rights and churches being closed, it must be comforting for Rome to know that pervery is carrying the votive flame forward.

Julia Collings grew up in Derbyshire and read English at Christ Church, Oxford. She now lives in Camden (or the Bloomsbury Borders, as she prefers to call it) and is assistant editor of SKIN TWO, *the glossy magazine dedicated to SM and fetish fashion. Her writing ranges from sexual politics to travel reports on the underbelly of America. She's often found on television and radio, bringing her findings to a very suspecting audience.*

'We must see our rituals for what they are: completely arbitrary things, tired of games and irony. It is good to be dirty and bearded, to have long hair, to look like a girl when one is a boy (and vice versa); one must put in play, show up, transform and reverse the systems which quietly order us about.'

Michel Foucault

Nine inch nails

We're all going on a nutter's holiday
Jessica Berens

Sebastian Horsley, a painter, is dark, six foot tall, and smokes Consulate. He lives in a two-room flat in Soho, London. In one room there is an easel and some books by Baudelaire. In the other there is a bed which is too small for him and a bedside chest on which there is a gun. The only other possessions are some stacked leather suitcases and a rack of neatly-arranged Savile Row suits. There is nowhere to eat and nowhere for a guest to sit. This is the home of a man who is consciously on show to the world but who does not want the world to visit him. It is a place in which one can imagine going mad. On his thirty-eighth birthday, Sebastian Horsley went to the Philippines in order to be crucified.

'I suppose I should talk you through the history of it. I've known about it for years. Every year the newspapers run things about it like, *Nutters in the Philippines Get Crucified*. How it started I have yet to find out; perhaps somebody woke up one morning and said, "I know, let's get everyone crucified." You would have thought that it started hundreds of years ago but actually Ricardo started banging 'em up thirty years ago. Now it's a tradition. Ricardo is Filipino. He only knows two words in English: "No problem."

'San Fernando is a tiny little village – the houses cost a thousand quid or something. [The people] are simple – totally

264 // INAPPROPRIATE BEHAVIOUR

useless but God-fearing – and the reason they get crucified is
for their religious beliefs. They make pacts – like one chap, his
mother was dying from cancer and he figured if he offered
himself up to God she would survive – and there's a guy called
Bob who has been crucified about ten times. He does it every
year to reaffirm his faith. He says, "I have never seen rich peo-
ple crucified." They have never crucified anybody from outside
their community: they did it once about three years ago – some
Japanese chap – he used it in a porn film and they were
mortified.

'I offered myself up to be crucified and they refused. On
those grounds: that they don't crucify people from outside. I
was kind of heart-broken at the time because I knew I had to
do it. I came back to England and I just hatched the plan. It
took months of to-ing and fro-ing and, "No, we can't do this."
They just thought I was mad.

'I wrote to the chap from the tourist board and sent all my
catalogues and my press cuttings. About four years ago I did a
show about the great white shark and, in order to do it, I went
into the water with the shark. I explained to them that, in order
to get close to the subject, I wanted to go through the same
experience. And then I bribed them too. I said, "Look, I'll sell
a painting here on the British market and I'll pay you." I said
I'd give them a thousand quid, which to them is a lot of money,
but in the end I gave them the envelope and I didn't tell them
at the time, but I gave them two thousand quid. I doubled it. I
like the idea of paying for it; it's like paid sex. Anyway, when I
got there they had all my press cuttings out and they were read-
ing them all, so that was basically what swung it. I think if I had
just given them the money it wouldn't have happened. It hap-
pened because of the art as well.

'They got me to sign an affidavit. "I Sebastian Horsley blah
blah, I am a national artist . . . based in London . . . engaged in
the art of painting . . . draw inspiration from reality . . . I am
ready to suffer the physical, emotional and psychological con-
sequences . . ." So that was that. The date was set and I went
over with Dennis Morris and Sarah Lucas.

'Dennis Morris had worked with the Sex Pistols and Marley

and rang me after he saw a piece in the newspaper. We had been friends anyway. I was in three punk bands – The Fauves, The Void, and Rhythm of Life. We were so bad I can't understand why we weren't popular. But the Sex Pistols had meant as much to me as Bacon or Baudelaire or Burroughs.

'I asked Sarah Lucas to film it. I had always really liked her; she has a lot of integrity. I was not really aware of her work and I'm sure she is not aware of mine because, you know, artists are not really interested in anything apart from themselves.

'I had been approached by a production company who wanted to film it, but I turned it down, which is preposterous for me because I am an egomaniac and I love being in the newspapers, but I had been advised not to do it by doctors and by my family. If it had gone wrong it wouldn't have been funny any more. So I said no. I was very conscious that people might see it as a publicity stunt. I do a lot of things for effect, which is not to say I am superficial but merely that I know how to put across ideas. It is an English thing that you can't wear a feather boa and read the Bible. I was conscious of people saying, "Oh, here we go."

'The thing about pain is that you don't normally have a chance to prepare for it. With this I had two months of knowing. It was an interesting place to be sober. I had nightmares and daymares and terrible anxiety about why was I doing it. I think an artist has to be prepared to make a fool of himself – the artist is somewhere between a performing seal and a suicide – but I was worried that this was an act of wanton self-destruction and I was taking it too far, even for me.

'As someone who has spent his life on a sensation safari I was also worried that it was just another hit. Since I've come off drugs I don't feel anything any more and I would rather feel pain than nothing. For me true excitement is the confrontation of death and the skilful defiance of it. Perhaps I needed to find new, non-narcotic ways of risking my life. Being crucified was a way of consoling myself for no longer being able to set a bad example. Will Self thought it was a relapse and that by the time I got off the cross I would be back on drugs. I wasn't, actually. I'm not going back to drugs. I'm not.

'I was ten months clean. Off crack and heroin and I felt that I was coming to this point where in order to save Sebastian I had to destroy Sebastian. The whole image of the crucifixion is about death and rebirth – OK, I didn't actually physically die but you can see from the photos that I did metaphorically die, and that was really what I was looking for.

'I don't believe in God and I don't like him either. I think you are born and I think you die. I have a pragmatic nature but I yearn to believe. I'm from Hull. Real life was never enough for me. My grandfather was a practising Quaker. My father wasn't. My father was a drunk and a nihilist. Pure nihilist. But nihilism, if you like, is the beginning of faith, anyway. For Nietzche, Kierkegaard, any of those people, you have to go down the road of despair to come up with anything. It is only when you feel pain that you know you are a creature who will die.

'I subscribe to the Kierkegaardian idea of the personality – that we construct a personality to fend off death. We use character traits – he calls them secret psychoses – to barter with the outside world. Strip them away and you've got this howling of fear and terror of existence. When you go through an experience like a crucifixion, what you are left with is that essence, because the personality is gone.

The crucifixion was a favourite form of execution because it was a controlled way of dying. The longer people looked at the death of someone else the more pleasure they could have in sensing the security and good fortune of their own survival. It took days. They broke Christ's legs but he died of suffocation.

'I believe that life is futile and that we have to somehow get through it, but that in order to get through it we have to elevate ourselves up onto some grand dais. We are what we pretend to be. I am a dandy at heart. I also believe in art. Art is religious: the act of painting is a devotional thing; for me it is the highest calling.

'I wanted to test the boundaries of reality, that was really what I was trying to do. We use our personalities as scarecrows to frighten away reality. We define ourselves not only by desire but by disgust and it is only in extreme situations that reality

reveals itself. That was what I was hoping for. I was also hoping to get rid of Sebastian.

'There was an artist called Benvenuto Cellini. He crucified a living man to study the play of muscles in his death agony. The Pope granted him Absolution. That is taking things further than I would like to and, anyway, it doesn't interest me to see someone else suffer. I wanted to suffer myself, you know, because if we don't suffer, how do we know that we live?

'I don't think we should be embarrassed by pain – only by failure to grow. We have this thing about pain and we all shy from it, but not everything that makes us feel better is good for us – alcohol etc – so it follows that not everything that hurts is bad. Maybe pain is a necessary stage on the road to anything valuable. People have said that I have led my life in a dangerous way. Well, I haven't particularly, but anything valuable is dangerous. I am trying to grow up a bit. I'm knocking forty now; maybe it is a bit infantile, this whole kind of thing, but fuck it, you know.

'My theory is that the way you cope with the depths will ascertain the heights that you reach – they are intimately connected – and if you have a lust for life you are also going to have a lust for death. Death is the only muse of art. It is not that I want to die, it is just that nothing gives life its vitality and intensity as the acute knowledge of one's demise into nothingness. That is what gives it the edge. That is what gives it its twist.

'An artist has to go to every extreme to stretch his sensibility through excess and suffering – in order to feel and communicate more – the point about artists is that they articulate – everyone has these feelings and everyone has these anxieties – the artist is the person who lives those out for us – you could say art is a way of living out your insanity – that insanity is the oxygen of art. But I don't think this is an insane thing to do. I think it is a deeply poetic thing to do.

'I am good at suffering. It is one of my few talents.

'I have been a sexual masochist, but I'm not any more, actually. When I was younger I got involved with a Glaswegian gangster and had this very masochistic relationship, and then

another one with beatings and whippings – that kind of stuff – getting your head flushed down the toilet. Just general abuse. I don't know whether it released me. It just seemed like the thing to do at the time.

'I'm not a fag but I like the idea of being dominated. I like the idea of being told what to do and I like the idea of being humiliated. Somehow for me humiliation, to a certain extent, hits the spot.

'So I wasn't going into it for the physical pain. The whole point about being beaten and all that kind of stuff is not about pain really – it's about surrendering – and, of course, by being crucified you are doing that – surrendering. You lie on a cross and someone who you have never met before bangs fucking nails into you. Anything could have gone wrong. If you don't risk anything you risk everything. I wanted to raise my game as a painter. I wanted to get to the point where I was metaphorically painting my own blood and if that makes me an incurable romantic then that is what I am . . . deeply romantic.

'The whole trip lasted ten days. When their own people do it at Easter there are film crews from all over the world and a carnival atmosphere with Coke stands and things. It's almost vaudeville. But when I did it, I was the only one.

'There have been accidents. One guy was in hospital for three months afterwards. I don't know the exact details but basically the nails went through the wrong part of the hand. I was advised to have a health check-up by the doctor, but I didn't. If you're gonna die, you're gonna die. When it comes there is fuck all you can do about it.

'We had a "Last Supper" the evening before in the village. Some Filipino muck. I only had a few hours' sleep. There was a kind of spiritual cyclone around me. On the morning I was calm. I was relieved that the day had come and the pain would be over after lunch. I was oscillating between anxiety about the

pain and total embarrassment – you see the photos where I am standing around in that loin cloth – I'm just totally embarrassed. When I got to the cross I turned to Sarah and said, "I don't want to do this, it's too big for me."

'My way of getting round it had been to think it would be like injecting your hand. Then the fucking nails started going through . . . I had wanted to think of something really beautiful – of Rachel and that I loved her and all the rest of it – but the pain was so overwhelming. I just remember the nail going through and thinking, oh shit – this is the end.

'The first one went in quite smoothly – maybe three bangs: kuk kuk kuk – but the second one was about six or seven hits. I don't know what happened but bang, bang, bang, right through. It was pain that I had never, ever experienced and I passed out. Then they raised the cross and I was just slipping in and out of consciousness. I could hear Dennis firing the shutters, then my eyes began to fill up with water, or tears, so I couldn't really see.

'The body produces endorphins to combat pain, and as a drug addict I can recognise them as morphine. A mild hallucinogen is also produced by the body – I don't know what it is because I'm not a doctor – but colours get richer, skies darken, so if I was a religious person I would say to you, "Yes, I saw God, yes, I saw the light . . ." The pain is so intense that you go into pain mode. It is only after the event that you can look back and romanticise. One of the reasons I made notes was so that I when I came back I didn't overstate what had happened. I wanted the brutality of fact. No one has ever been up there for more than twenty minutes. They bring the cross down and pull the nails out. Then they dress the wounds and bandage you.

'I couldn't eat lunch, I was exhausted and I was gutted and despondent. I felt that it had been a mistake, a wanton act of self-destruction. I just thought, you stupid cunt. The next day I started to get the benefits. I had this really quiet pride, not arrogance but pride that I had been through it. I had survived and I had this wonderful story to tell myself. It gave me an intimate knowledge of myself. I thought, "I can go through some-

thing like that and I can survive." It gave me a quiet confidence. It centred me and made me feel humble. I felt this wonderful privilege that I was probably the first artist in history to go through something like that and it was a story that only I could tell.

'Why hasn't anyone done this before? We are in the twenty-first century and I am the first artist to get crucified? I mean, brilliant and great and I suppose it is good for my career and stuff, but how can you paint the crucifixion without being crucified? To me it makes perfect sense to get close to it.

'Sarah said afterwards that the crucifixion was pure sex.

'I came back and my phone was ringing from all over the world. Nick Cave called me and said that he had wanted to tell me that I was making a terrible mistake and to advise me strongly not to do it. He thought I might regret it for the rest of my life but, even if I did regret it, it would be better than not having any feeling about it at all.

'The press phoned me up every day, but I didn't want to talk to them. The nice thing was I didn't care any more how other people interpreted it. There were a hell of a lot of doubting Thomases. Men particularly had a problem with it – that I was a threat to them somehow. Other artists didn't like it. You may think this is an arrogant thing to say but I think they felt it was the real thing. Women seemed to like it.

'It has raised my game and it has taken me to this really romantic place when I'm painting. This is not some painting of what it would appear to be to be crucified. It is from intimate knowledge of what it was like to go through that. I can still feel the wound in this hand, as a lump, but it is not painful. I kept the bandages on for three weeks, partly because I had to and partly as a reminder, a statement, you know.

'The first month I walked through the streets, and people would say things to me like, "I don't believe you were crucified.

Show me the wounds. Show me the nails." They were belliger-ent but I didn't react to it. I just sat there. OK, fine. But now if someone said that to me I would say, "Fuck you. I'll show you the nails."

'I was centred and I still have glimpses of that, but it recedes. Am I a different person now? I am and I'm not, you know. I still wake up anxious. I oscillate between I am God and I am a Worm. I haven't quite conquered the middle bit.'

Sebastian Horsley's writings can be found in The Erotic Review.

Educational reading

1. **Dressed to Kill: The Link Between Breast Cancer and Bras**
 By Sydney Ross Singer and Soma Grosmager

2. **Herbal Abortion: The Fruit of the Tree of Knowledge**
 By Unit M. Tianal

3. **After the Funeral: The Posthumous Adventures of Famous Corpses**
 By Edwin Murphy

4. **What Your Doctor Can't Tell You About Cosmetic Surgery**
 By Joyce D. Nash. PhD

5. **Monsieur d'Eon is a Woman: A Tale of Political Intrigue**
 By Gary Kates

6. **My Alphabet**
 By Trevor Brown

7. **An Abbreviated History of Castration**
 By Gary Taylor

8. **The Discovery of the Art of the Insane**
 By John MacGregor